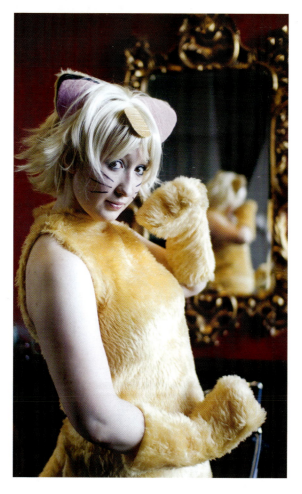

ABLAZE

Photography by
Rob Dunlop and
Peter Lumby

Foreword by
Sonia Leong

Introduction by
Rob Dunlop

Cover Models:

Front (left to right): Back (left to right):

Darrin plays Haseo Kerry plays Silk Spectre
(from .hack) (from Watchmen)
Joanna plays Roy Mustang Kelly plays Darth Talon
(from Fullmetal Alchemist) (from Star Wars)
Louise plays LeBlanc Robin plays Zuki
(from Final Fantasy X-2) (original character)

Cosplay Fever

Published in the UK
by Ablaze Media Ltd.
London, England

cosplayfever@gmail.com
www.cosplayfever.com

PRINTED IN SPAIN
ISBN: 978-0-9543008-3-8

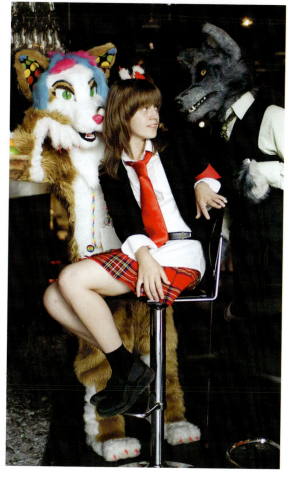

ROB DUNLOP PETER LUMBY

Foreword

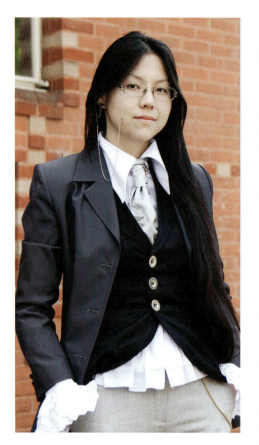

What you have in your hands is a celebration of creativity, dedication and bravery. Cosplay can be anything from a casual hobby between friends through to astounding and near-impossible works of art in motion. It touches people from all walks of life: bringing a smile to a little girl's face if she recognises a cosplayer as a fairytale princess; inciting a whoop of joy from a teenager who thought he was the only one who knew about that particular videogame; invoking hushed whispers of awe from a crowd when the entire cast of an anime or manga is brought to life. As both a cosplayer and a manga artist, I was so thrilled when someone cosplayed Juliet from my own *Manga Shakespeare: Romeo and Juliet*.

My first venture into cosplay was back in 2000 when I was visiting my boyfriend (now husband) during the summer as he was finishing his degree. The Cambridge University Comics and Animation Society had a garden party, which we decided to attend as Misato and Kaji from *Neon Genesis Evangelion*. It was fair to describe our first attempt as very casual; we simply chose the most suitable clothing from our own wardrobes. Thankfully we didn't have to do anything drastic to our hair as we resembled the characters closely enough – this was a winning principle of mine which has stuck with me ever since.

The next instance was anything but casual. When my husband surprised me with two memberships to AnimeCon 2001 at the Liverpool Adelphi, I was incredibly thankful for my recent excursion to Japan, where I'd bought vast amounts of traditional Japanese clothing and souvenirs. This made for a very authentic looking Kaoru in full fighting gear from *Rurouni Kenshin* that was awarded "Best in Show".

Over the next seven years, I met and befriended many cosplayers, but cosplaying took a back seat as I pursued my career and developed my wardrobe into the thing of beauty and great expense it is today: filled with bespoke, boutique and designer labels in the Gothic, Lolita and Aristocrat aesthetic.

2008 was when I jumped back in with a vengeance; a veritable baptism of fire. I decided to "crossplay" Abel Nightroad from *Trinity Blood*. I didn't anticipate spending £200 on materials or over 100 hours on crafting, sewing and sourcing. Or it being mentioned in *The Observer*. But damn, I looked good.

So it's been full speed ahead ever since. And my husband hasn't been able to escape – he started it, after all! He has patiently tolerated my fussing and fawning to become a partner in crime, wearing the costumes I make for him so we can turn up to an event as a duo.

Why did I get into it? Many will give this answer: *because I wanted to join in the fun*. If the components of a cosplay are easy to come by or affordable and if you bring a smile to people's faces as they recognise your character, then why not?

And after my long hiatus, why did I return to cosplay? I'm sure that I'm not alone when I say: *because I loved that character*. When you decide to spend far too much time and money on a complicated cosplay, you REALLY have to love what you're doing, as you will be cursing, crying and tearing your hair out every step of the way.

But all the meticulous/ ingenious/ insane cosplayers out there will understand. The moment you step into the room and everyone turns to look at you; when everyone wants to take your photograph; when a fan of the series you're cosplaying squeals with delight and their eyes light up; when your fellow cosplayers in equally jaw-dropping outfits praise you; when you see the results of a good photo-shoot... it all becomes worth it.

The UK cosplay scene is perfect for cosplayers of all skill levels – the community is incredibly supportive yet encourages friendly competition. There are many newcomers who are encouraged and advised by the more experienced. And just when you think you're getting pretty good at this, you get floored by seeing someone else's truly spectacular creation – usually worn without any egotistical attitude whatsoever. It is very humbling, yet so inspiring!

The guys behind this wonderful project are true fans of this art-form and have captured many beautiful photographs for all to enjoy. *Cosplay Fever* showcases some stunning examples of cosplay, many of which will never be seen again as the cosplayers strive towards ever more challenging creations... and I greatly anticipate seeing these documented in future volumes. I hope that you all will join me in admiring the talent on display here, while supporting the cosplayers of tomorrow as they aspire to even greater achievements.

Sonia Leong

Sonia Leong is a prolific and highly-praised professional comic artist and illustrator specialising in the Anime/Manga style. A winner in Tokyopop's UK *Rising Stars of Manga* competition (2005/06) and winner in *NEO* Magazine's 2005 Manga Competition, her first graphic novel was the popular *Manga Shakespeare: Romeo and Juliet*. She illustrates the *Manga Life* series of self-help comic books (Infinite Ideas), and her work appears in *Domo: The Manga* (Tokyopop/Big Tent). Sonia has been involved in many instructional art books, including *Draw Manga* (New Holland) by Sweatdrop Studios, a leading UK comic collaborative. She is a core member of the group and her most recent works with Sweatdrop include *Once Upon a Time...*, *Love Stuffing vol. 1* and *Aya Takeo vol. 1*.

Sonia is also a fervent fashionista who loves the Gothic and Lolita style.

More info is available on Sonia's official website: www.fyredrake.net

Introduction

If you've ever been to an anime or comic convention, then you know there are plenty of amazing things to see. You may spot crowds of youths in brightly coloured fantasy costumes, entire families dressed as characters from their favourite movies, pirates chatting with cardboard robots, or aliens sharing a joke with elven princesses. It's a unique experience.

Peter Lumby and I have been attending these events for a little over seven years. Comic book readers may have heard of Tozzer, a series of graphic novels which we create and publish. We've been producing Tozzer since 2002. Pete draws the pictures, I write the words, and together we sell the books at events across the UK. We distribute the titles through book and comic shops too, but nothing can replace the experience of meeting readers face-to-face.

When we started out, the people we met at comic conventions would generally wear regular, casual attire: combats, T-shirt, trainers, that kind of thing. Nothing particularly remarkable. These days, however, we often find ourselves talking to a different breed of convention-goer, an exotic, fascinating breed. A breed now known as "cosplayers."

The word "cosplay" was coined in the eighties to describe the activity of "costume role-play". On its most basic level, this involves dressing up as a character then pretending to be them. Although cosplaying began in America at sci-fi conventions, it was in Japan where it really took off and developed into a major subculture, and there are still more cosplayers in Japan than in any other country. It is therefore no surprise that many of the costumes worn by cosplayers are from Japanese characters, most notably from anime, manga and video games. However, there are now hundreds of thousands of cosplayers all across the globe, who wear costumes from a broad range of both Western and Japanese media.

Sometimes cosplayers buy their costumes, sometimes they make them, but they invariably wear them with pride and conviction. Once a cosplayer dons their costume, they adopt the personalities of the characters they are portraying. In this way, they are actors, they are performers, and when a camera

is pointed at them, they are models. Those who make their own costumes could be regarded as fashion designers, tailors, painters or even sculptors.

Making costumes may prove difficult, but cosplayers face other challenges too. Even if they buy their outfits, there is the time and effort spent on preparation (including hair, make-up and wig styling), the expense involved, the task of travelling to venues and of course the courage required to actually wear the costumes in public. Yet cosplay's popularity continues apace.

So what's the attraction? Naturally, there are the social benefits. Cosplay is a great way to meet people and make new friends. If you're dressed as an anime character, for example, then that says a lot about the kind of culture you might be interested in, and fans of the character will want to meet you, congratulate you and quite possibly hug you.

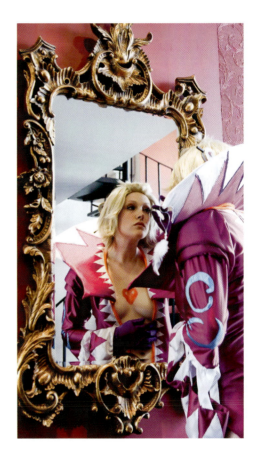

Another reason people cosplay goes beyond the social dimension. They do it so they can forget about their regular lives and become someone else, if only for a day. They can transform into someone powerful and exciting, sexy and alluring or just cute and quirky. No matter what the attributes of the character they are playing, the process of adopting an alter-ego is liberating. Those who are usually shy can tap into the strength of their character and completely come out of their shell. The simple act of wearing a costume can infuse the cosplayer with a level of energy and confidence which is greatly empowering. That is a benefit that most people would relish.

Plenty of cosplayers are the opposite of shy. For these extraverted individuals, cosplay gives them the perfect excuse to let their true selves come to the surface. Although they may be confident and charismatic before they don their costume, cosplaying allows them the freedom to take their passions to a greater level of self-expression.

Cosplaying can also make a person feel special. Dressing up in a stunning costume and having crowds of admirers showering you with compliments has obvious appeal. It's like making an effort to look good at a party or a nightclub - but multiply the

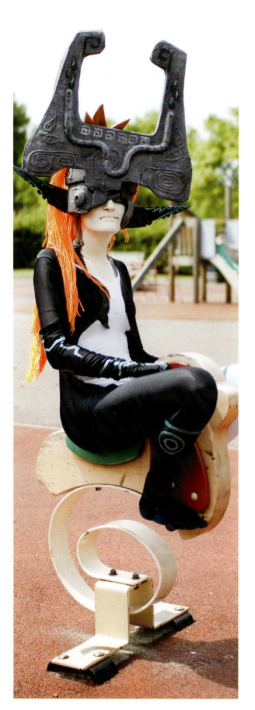

effect by a thousand. The encircling photographers and eager fans can make cosplayers feel like celebrities. It's easy to see how addictive that could become.

There's also the competitive aspect, especially among those who make their own costumes. They love to show off their creations, but they are also competing against other cosplayers, sometimes for cash prizes at competitions and masquerades. A little friendly competition can be fun, and many people thrive on it. They are also competing against themselves, of course, trying to outshine their previous efforts with their latest spectaculars.

To the uninitiated, cosplay may seem bizarre. And, I must admit, when we started taking photos of cosplayers around five years ago, it was from a somewhat bemused perspective. We weren't using the photos to spread awareness of cosplay, we were just posting the images on tozzer.com and giving them funny captions. Then, at some point, we began to realise that we were in fact watching the growth of a genuine art-form. I'm not sure what caused this shift in our attitude, but it may have been after a fan decided to dress up as one of the characters from our own Tozzer comics. To me, that was the ultimate compliment, and it was humbling to think about how much work must have gone into the design and creation of the costume.

Cosplay is an art-form, but it's not like the art you'd see in a gallery or museum. There are no static sculptures or dusty paintings here. The art of cosplay is alive, and because of that it is tragically, yet wonderfully temporary. Costumes are created over months, then worn over days and almost immediately discarded, shelved, or irreparably damaged through simple wear and tear. These amazing creations are rarely designed to last. Cosplayers tend to focus on their future cosplays, not their past ones. And so, as they step into the limelight with their newest creations, someone should be there. Someone should capture this fleeting moment, as the caterpillar becomes a butterfly, because within hours, all that will remain will be a quickly-fading memory.

Towards the end of 2008, it occurred to Pete and I that the cosplay phenomenon deserved to be seen by a wider audience. So we decided to document this extraordinary pastime, in the hope that other non-cosplayers would share our fascination. We also hope that Cosplay Fever, and the beautiful, creative people inside it, gives inspiration to the cosplay community, and perhaps even the cosplayers of the future.

This volume covers the UK scene from March till July of 2009. Although most of the costumes you see here are based on pre-existing characters, some of them are original inventions from the imagination of the cosplayer. There are also costumes which are not based on a character at all, such as those in the Lolita style. These are included because, in our minds, they adhere to the spirit of cosplay. During the development of this book, we have seen literally thousands of costumes, and we only wish we could show you them all. Those wanting to see more can view additional images on cosplayfever.com.

If you're a cosplayer, then the next time you see a couple of guys with cameras, clipboards and Cosplay Fever badges, why not give us a wave, strike a pose, and help make the world a more cosplay-friendly place?

If, like Pete and I, you have never cosplayed before, then I hope you enjoy the extraordinary talent on display in the pages that follow. After all, you don't have to be a part of cosplay to truly appreciate its beauty.

Rob Dunlop

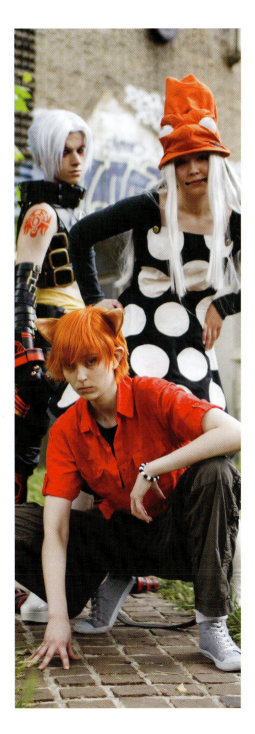

strike a pose

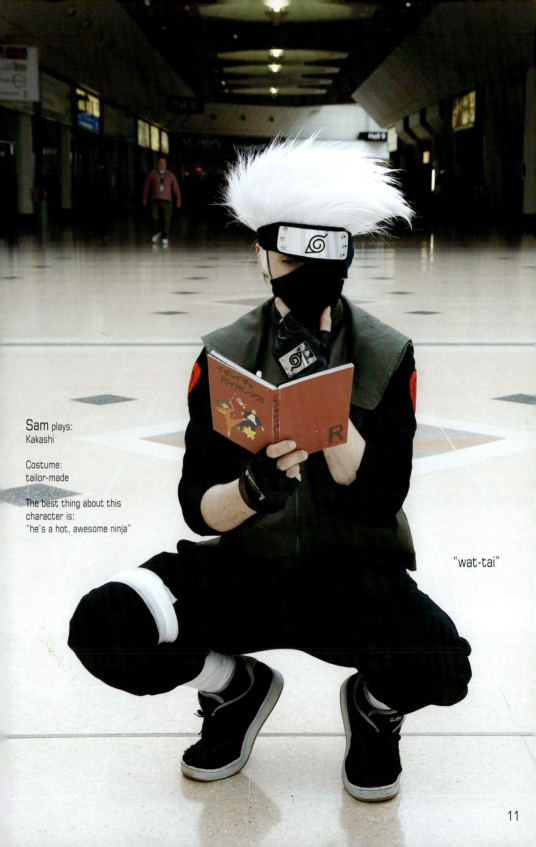

Sam plays:
Kakashi

Costume:
tailor-made

The best thing about this
character is:
"he's a hot, awesome ninja"

"wat-tai"

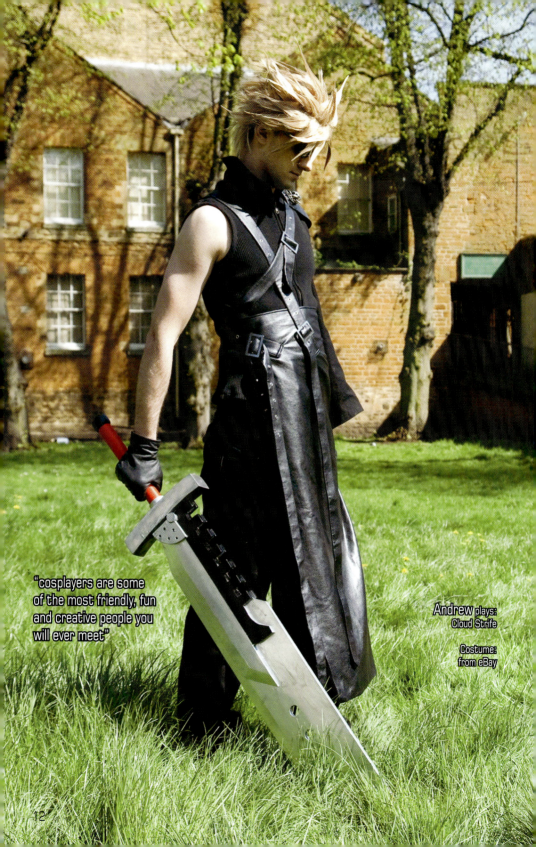

"cosplayers are some of the most friendly, fun and creative people you will ever meet"

Andrew plays:
Cloud Strife

Costume:
from eBay

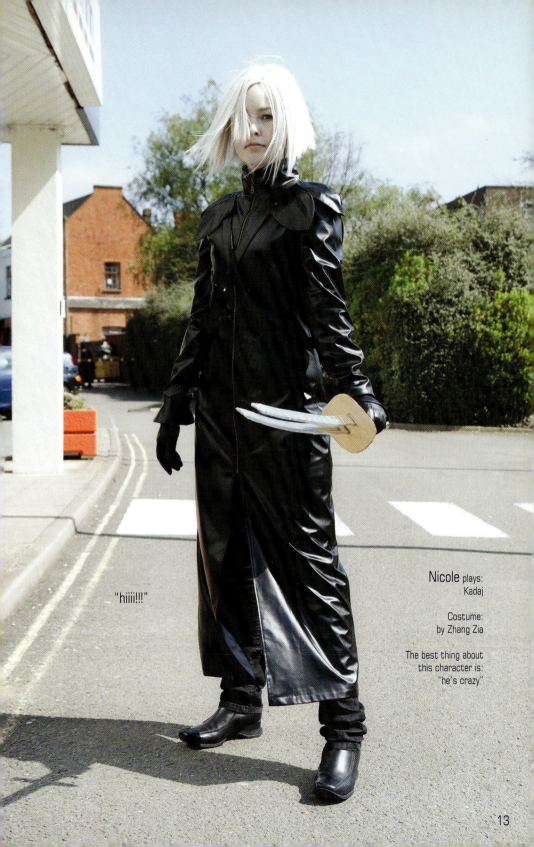

"hiiii!!!"

Nicole plays:
Kadaj

Costume:
by Zhang Zia

The best thing about
this character is:
"he's crazy"

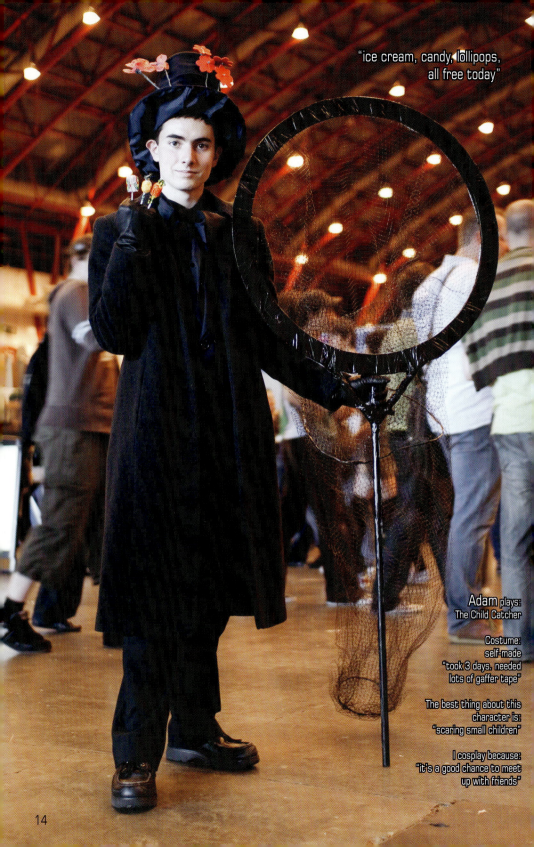

"ice cream, candy, lollipops,
all free today"

Adam plays:
The Child Catcher

Costume:
self-made
"took 3 days, needed
lots of gaffer tape"

The best thing about this
character is:
"scaring small children"

I cosplay because:
"it's a good chance to meet
up with friends"

14

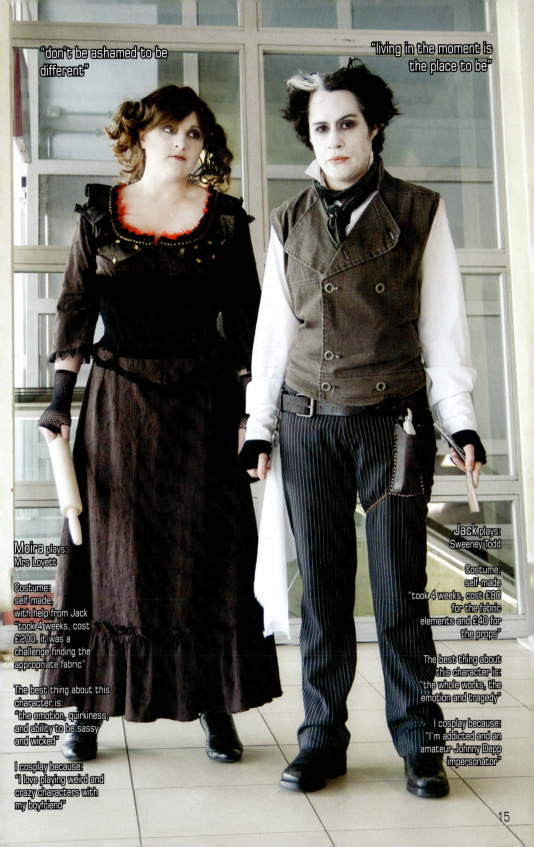

"don't be ashamed to be different"

"living in the moment is the place to be"

Moira plays:
Mrs Lovett

Costume:
self-made,
with help from Jack
"took 4 weeks, cost
£200. it was a
challenge finding the
appropriate fabric"

The best thing about this
character is:
"the emotion, quirkiness,
and ability to be sassy
and wicked"

I cosplay because:
"I love playing weird and
crazy characters with
my boyfriend"

Jack plays:
Sweeney Todd

Costume:
self-made
"took 4 weeks, cost £80
for the fabric
elements and £40 for
the props"

The best thing about
this character is:
"the whole works, the
emotion and tragedy"

I cosplay because:
"I'm addicted and an
amateur Johnny Depp
impersonator"

15

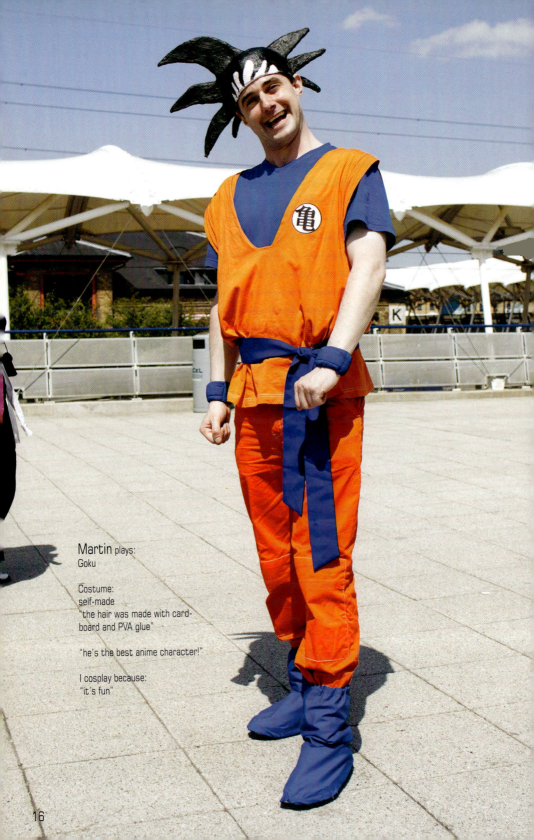

Martin plays:
Goku

Costume:
self-made
"the hair was made with card-
board and PVA glue"

"he's the best anime character!"

I cosplay because:
"it's fun"

16

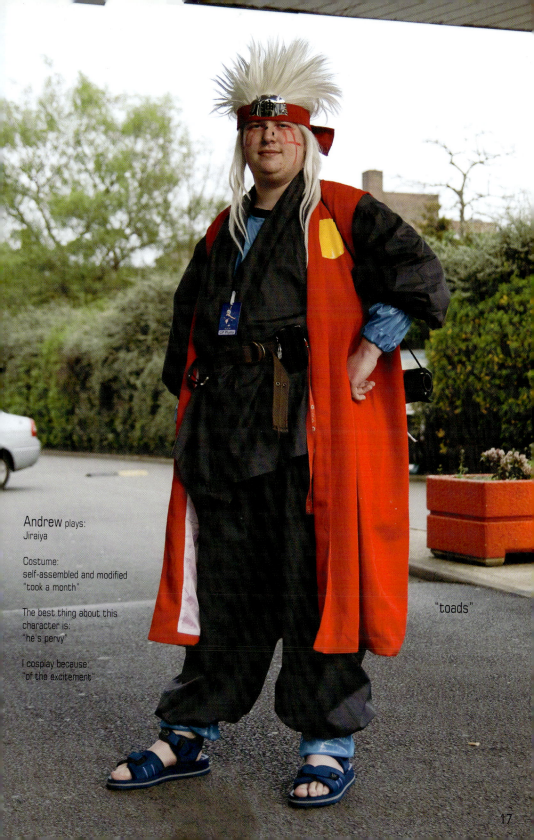

Andrew plays:
Jiraiya

Costume:
self-assembled and modified
"took a month"

The best thing about this
character is:
"he's pervy"

I cosplay because:
"of the excitement"

"toads"

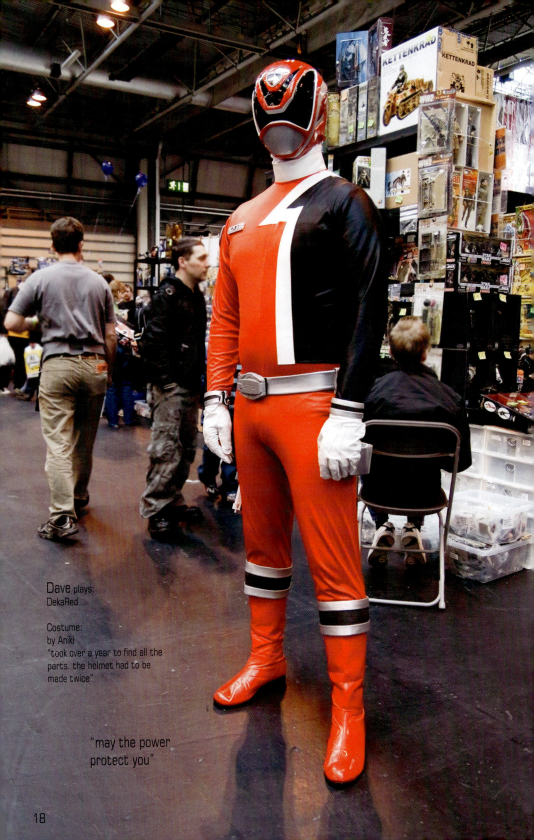

Dave plays:
DekaRed

Costume:
by Aniki
"took over a year to find all the
parts. the helmet had to be
made twice"

"may the power
protect you"

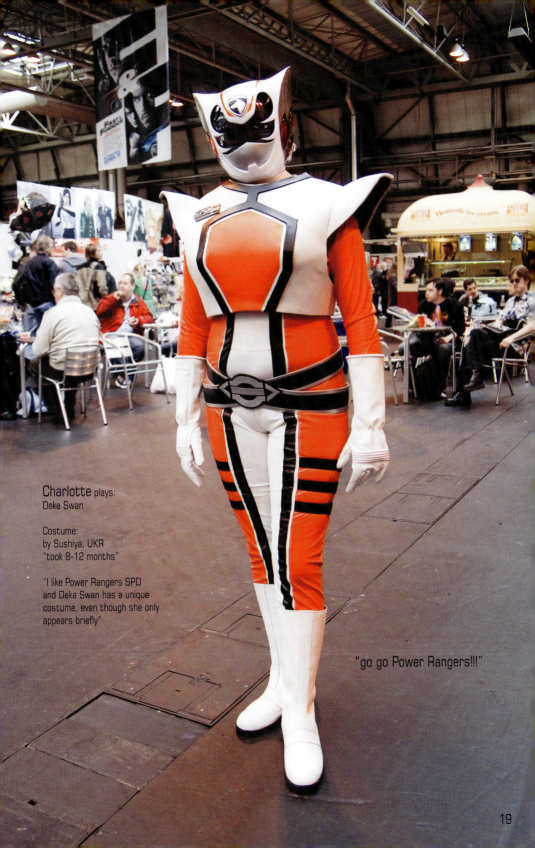

Charlotte plays:
Deka Swan

Costume:
by Sushiya, UKR
"took 8-12 months"

"I like Power Rangers SPD
and Deka Swan has a unique
costume, even though she only
appears briefly".

"go go Power Rangers!!!"

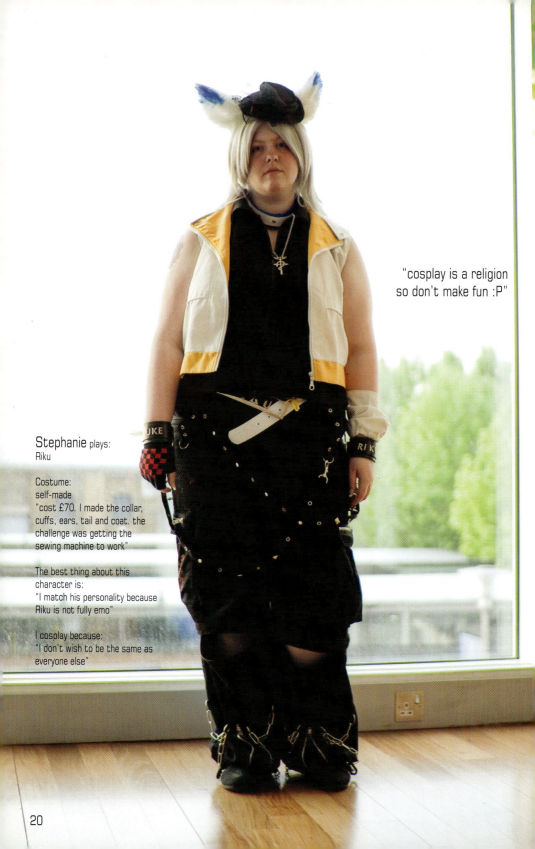

"cosplay is a religion
so don't make fun :P"

Stephanie plays:
Riku

Costume:
self-made
"cost £70. I made the collar,
cuffs, ears, tail and coat. the
challenge was getting the
sewing machine to work"

The best thing about this
character is:
"I match his personality because
Riku is not fully emo"

I cosplay because:
"I don't wish to be the same as
everyone else"

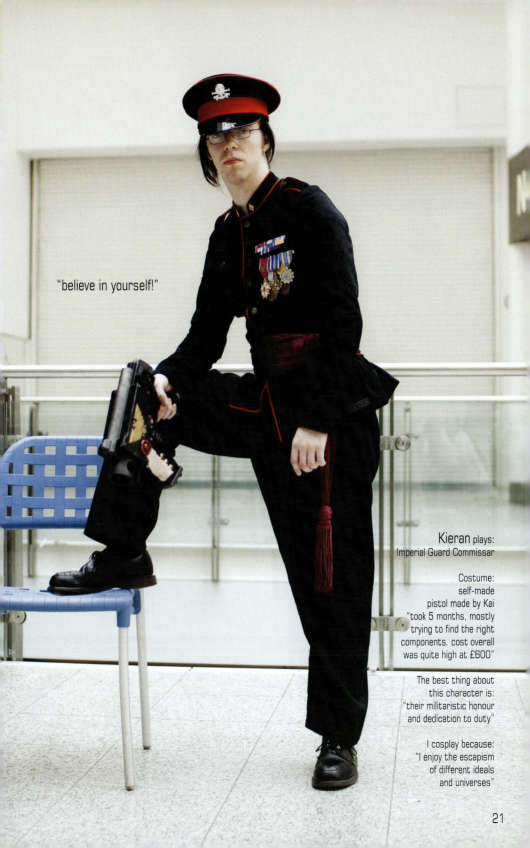

"believe in yourself!"

Kieran plays:
Imperial Guard Commissar

Costume:
self-made
pistol made by Kai
"took 5 months, mostly
trying to find the right
components. cost overall
was quite high at £600"

The best thing about
this character is:
"their militaristic honour
and dedication to duty"

I cosplay because:
"I enjoy the escapism
of different ideals
and universes"

21

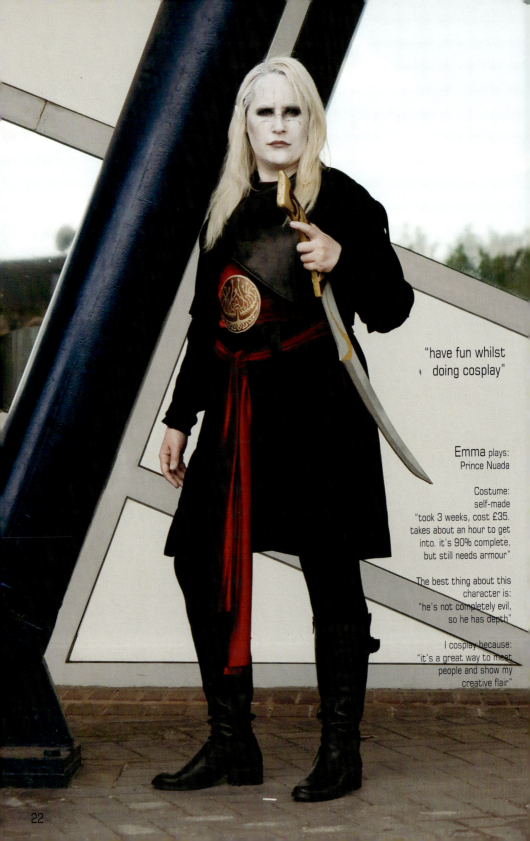

"have fun whilst doing cosplay"

Emma plays:
Prince Nuada

Costume:
self-made
"took 3 weeks, cost £35.
takes about an hour to get
into. it's 90% complete,
but still needs armour"

The best thing about this
character is:
"he's not completely evil,
so he has depth"

I cosplay because:
"it's a great way to meet
people and show my
creative flair"

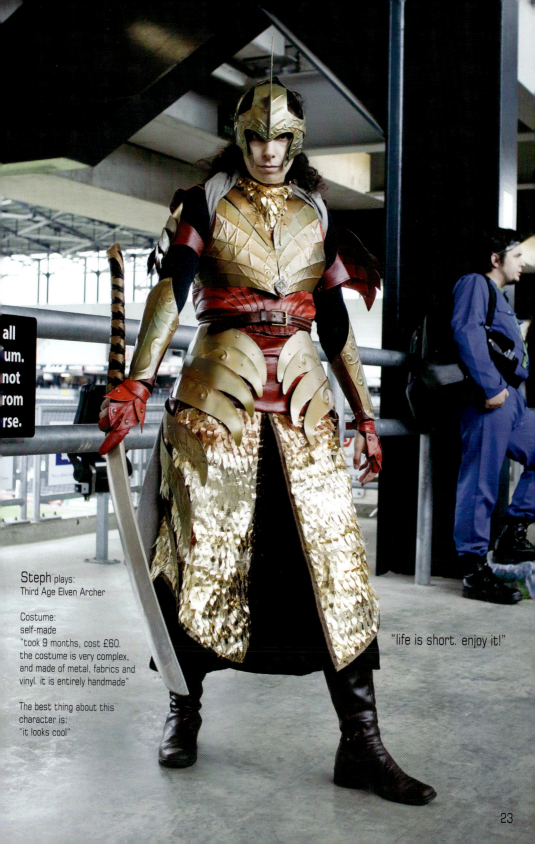

Steph plays:
Third Age Elven Archer

Costume:
self-made
"took 9 months, cost £60.
the costume is very complex,
and made of metal, fabrics and
vinyl. it is entirely handmade"

The best thing about this
character is:
"it looks cool"

"life is short. enjoy it!"

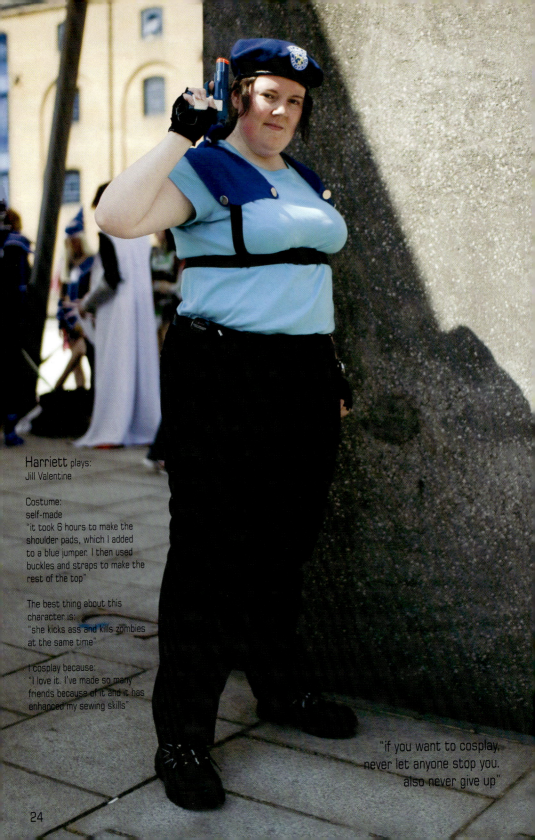

Harriett plays:
Jill Valentine

Costume:
self-made
"it took 6 hours to make the
shoulder pads, which I added
to a blue jumper. I then used
buckles and straps to make the
rest of the top"

The best thing about this
character is:
"she kicks ass and kills zombies
at the same time"

I cosplay because:
"I love it. I've made so many
friends because of it and it has
enhanced my sewing skills"

"if you want to cosplay,
never let anyone stop you,
also never give up"

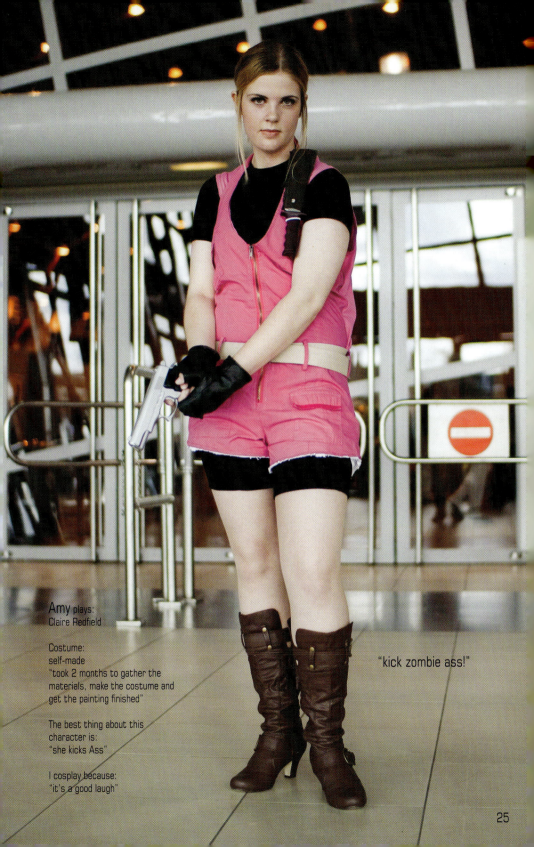

Amy plays:
Claire Redfield

Costume:
self-made
"took 2 months to gather the
materials, make the costume and
get the painting finished"

The best thing about this
character is:
"she kicks Ass"

I cosplay because:
"it's a good laugh"

"kick zombie ass!"

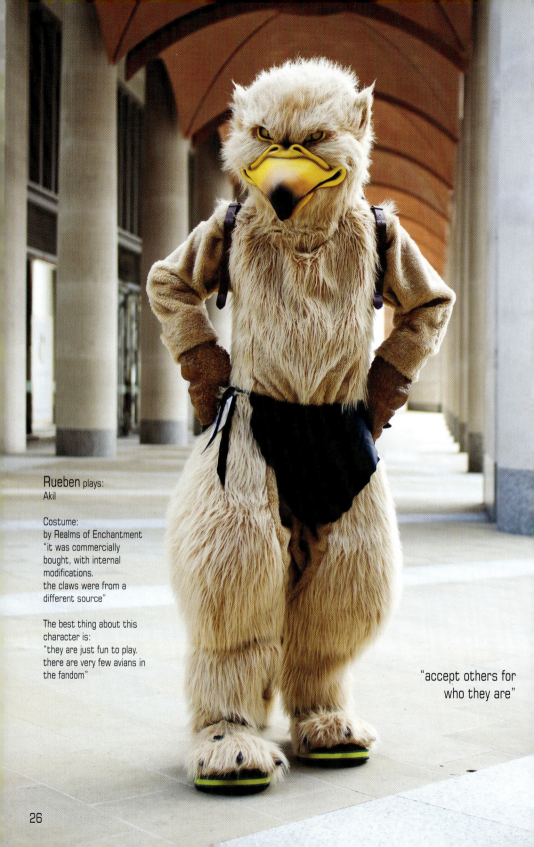

Rueben plays:
Akil

Costume:
by Realms of Enchantment
"it was commercially
bought, with internal
modifications.
the claws were from a
different source"

The best thing about this
character is:
"they are just fun to play.
there are very few avians in
the fandom"

"accept others for
who they are"

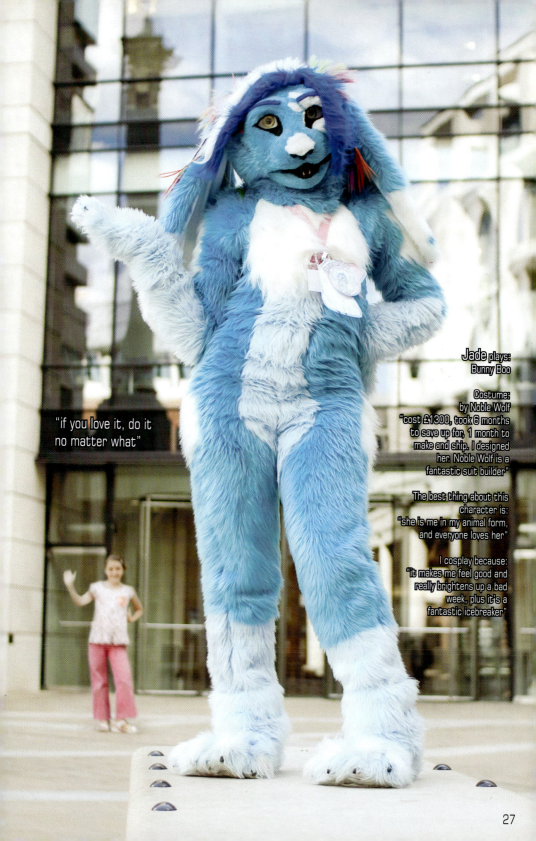

"if you love it, do it
no matter what"

Jade plays:
Bunny Boo

Costume:
by Noble Wolf
"cost £1300, took 6 months
to save up for, 1 month to
make and ship. I designed
her. Noble Wolf is a
fantastic suit builder"

The best thing about this
character is:
"she is me in my animal form,
and everyone loves her"

I cosplay because:
"it makes me feel good and
really brightens up a bad
week, plus it's a
fantastic icebreaker"

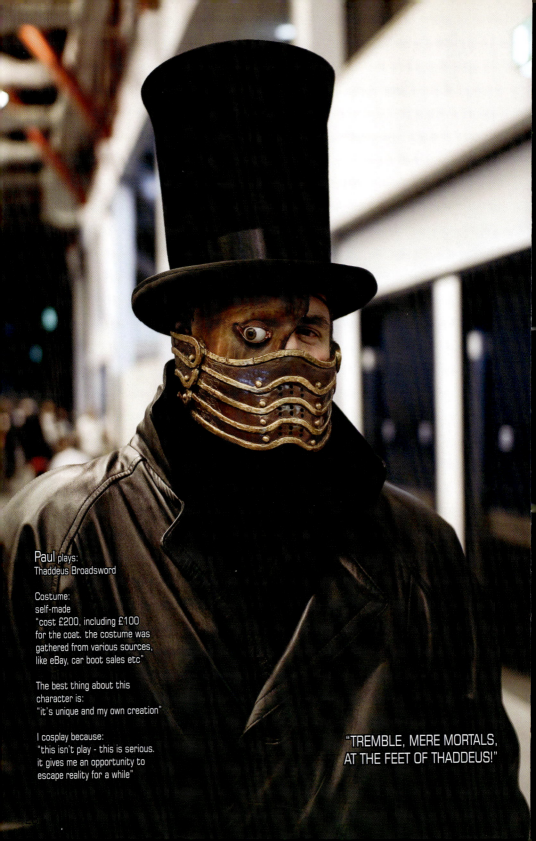

Paul plays:
Thaddeus Broadsword

Costume:
self-made
"cost £200, including £100
for the coat. the costume was
gathered from various sources,
like eBay, car boot sales etc"

The best thing about this
character is:
"it's unique and my own creation"

I cosplay because:
"this isn't play - this is serious.
it gives me an opportunity to
escape reality for a while"

"TREMBLE, MERE MORTALS,
AT THE FEET OF THADDEUS!"

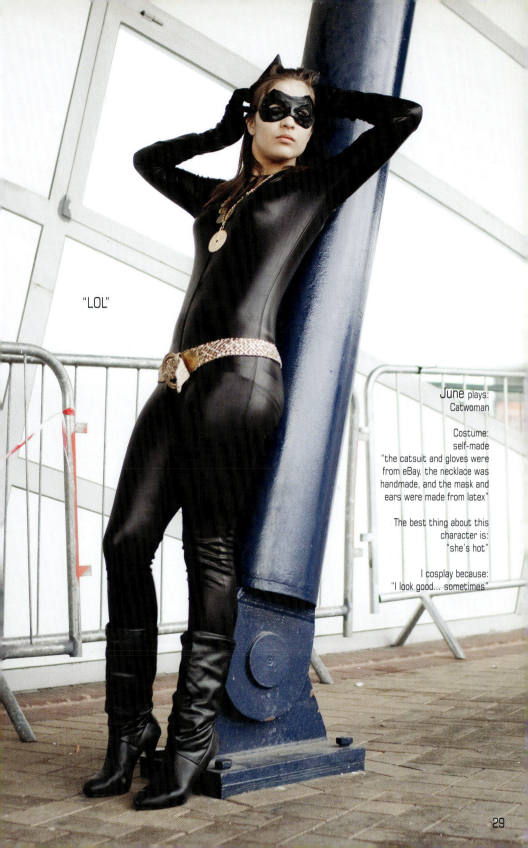

"LOL"

June plays:
Catwoman

Costume:
self-made
"the catsuit and gloves were
from eBay. the necklace was
handmade, and the mask and
ears were made from latex"

The best thing about this
character is:
"she's hot"

I cosplay because:
"I look good... sometimes"

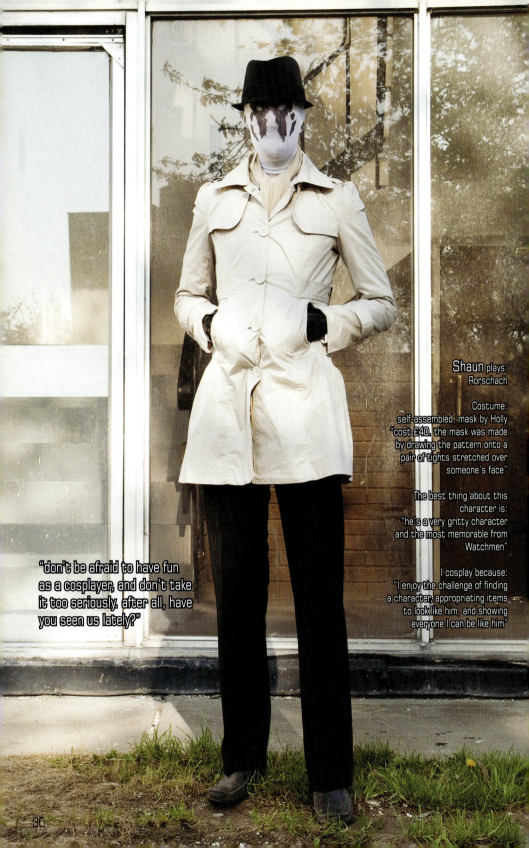

Shaun plays:
Rorschach

Costume:
self-assembled; mask by Holly
"cost £40. the mask was made
by drawing the pattern onto a
pair of tights stretched over
someone's face"

The best thing about this
character is:
"he's a very gritty character
and the most memorable from
Watchmen"

I cosplay because:
"I enjoy the challenge of finding
a character, appropriating items
to look like him, and showing
everyone I can be like him"

"don't be afraid to have fun
as a cosplayer, and don't take
it too seriously. after all, have
you seen us lately?"

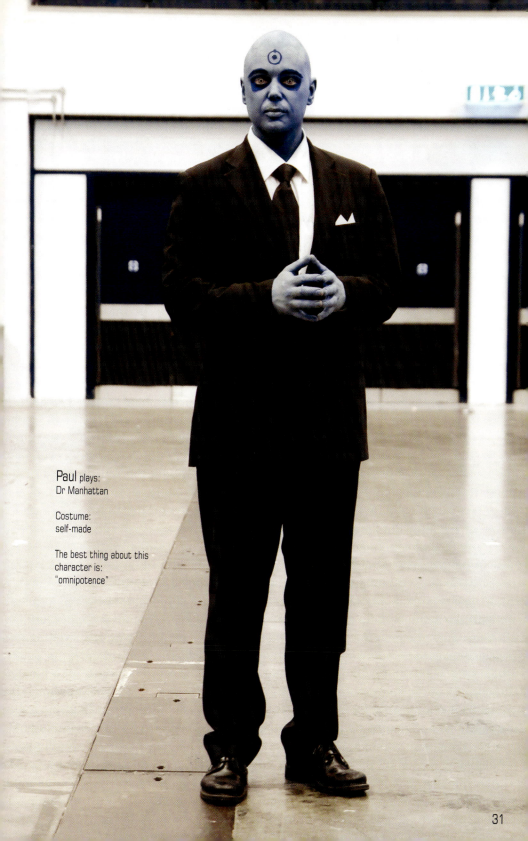

Paul plays:
Dr Manhattan

Costume:
self-made

The best thing about this
character is:
"omnipotence"

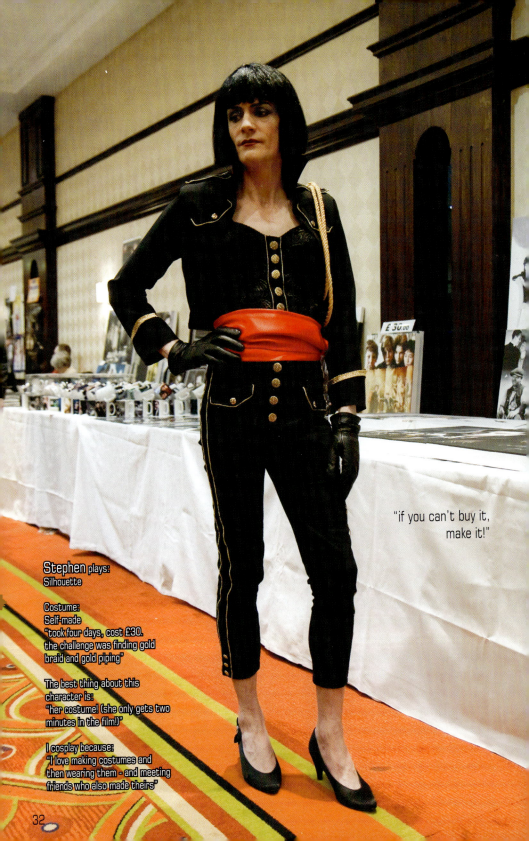

"if you can't buy it,
make it!"

Stephen plays:
Silhouette

Costume:
Self-made
"took four days, cost £30.
the challenge was finding gold
braid and gold piping"

The best thing about this
character is:
"her costume! (she only gets two
minutes in the film!)"

I cosplay because:
"I love making costumes and
then wearing them - and meeting
friends who also made theirs"

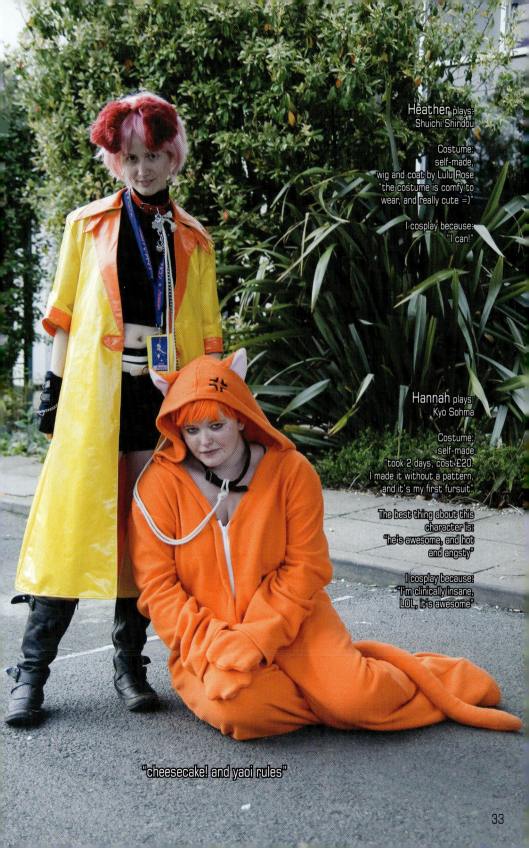

Heather plays:
Shuichi Shindou

Costume:
self-made,
wig and coat by Lulu Rose
"the costume is comfy to
wear, and really cute =)"

I cosplay because:
"I can!"

Hannah plays:
Kyo Sohma

Costume:
self-made
"took 2 days, cost £20.
I made it without a pattern,
and it's my first fursuit"

The best thing about this
character is:
"he's awesome, and hot
and angsty"

I cosplay because:
"I'm clinically insane,
LOL, it's awesome"

"cheesecake! and yaoi rules"

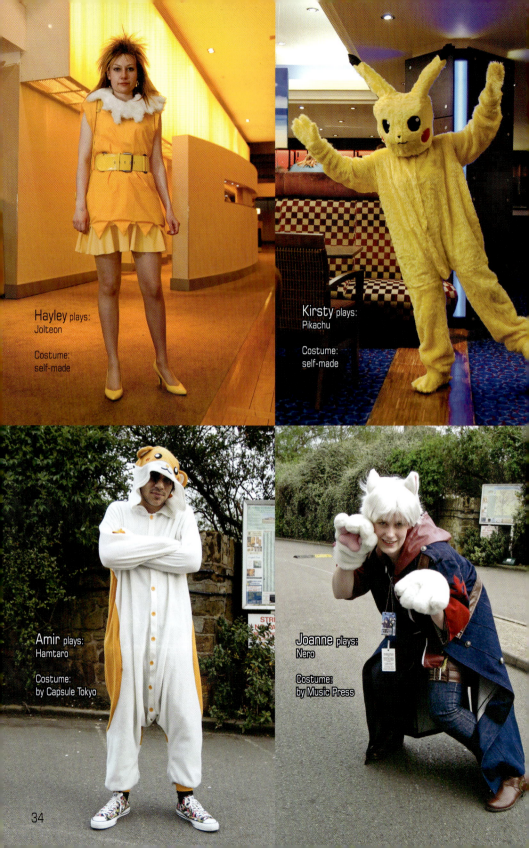

Hayley plays:
Jolteon

Costume:
self-made

Kirsty plays:
Pikachu

Costume:
self-made

Amir plays:
Hamtaro

Costume:
by Capsule Tokyo

Joanne plays:
Nero

Costume:
by Music Press

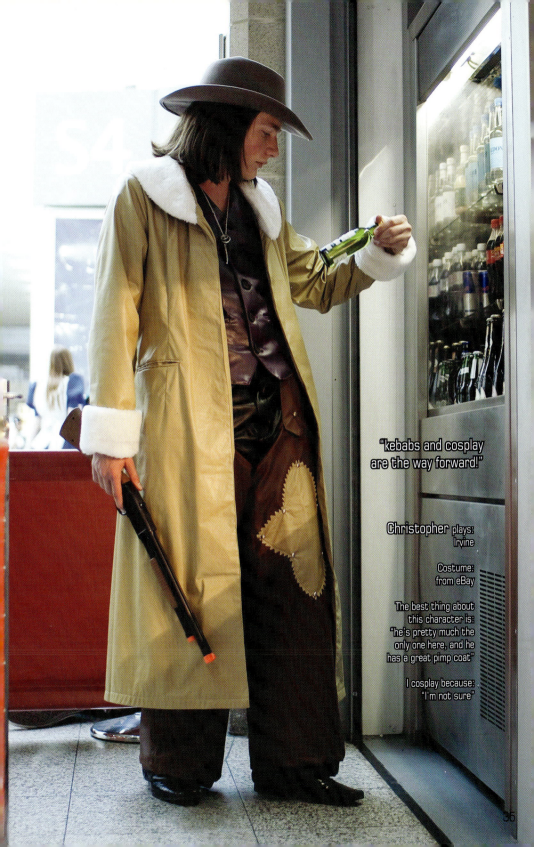

"kebabs and cosplay are the way forward!"

Christopher plays:
Irvine

Costume:
from eBay

The best thing about
this character is:
"he's pretty much the
only one here, and he
has a great pimp coat"

I cosplay because:
"I'm not sure"

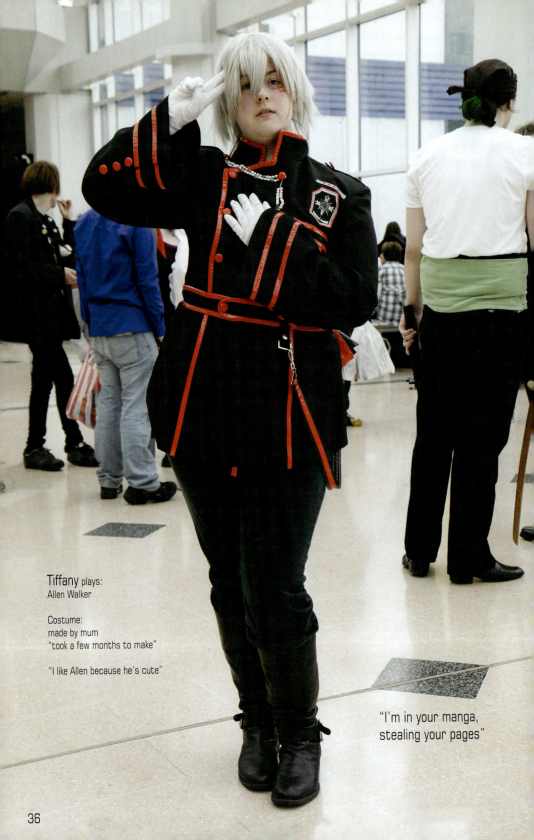

Tiffany plays:
Allen Walker

Costume:
made by mum
"took a few months to make"

"I like Allen because he's cute"

"I'm in your manga,
stealing your pages"

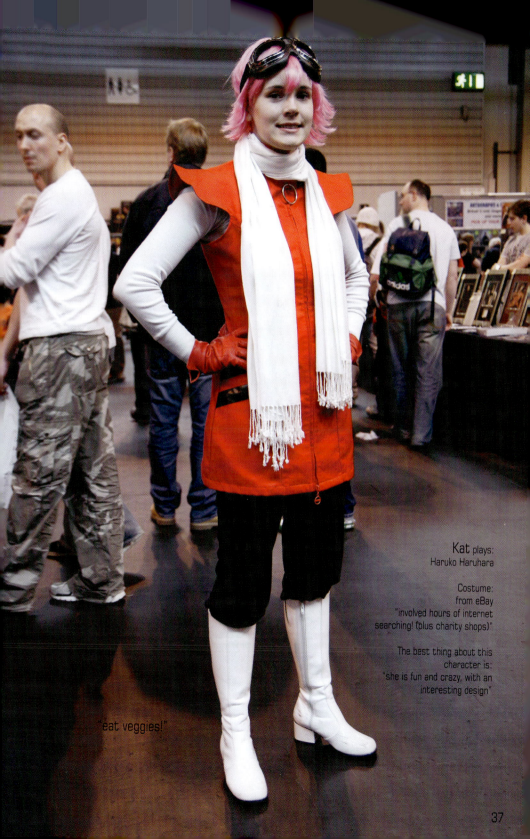

"eat veggies!"

Kat plays:
Haruko Haruhara

Costume:
from eBay
"involved hours of internet
searching! (plus charity shops)"

The best thing about this
character is:
"she is fun and crazy, with an
interesting design"

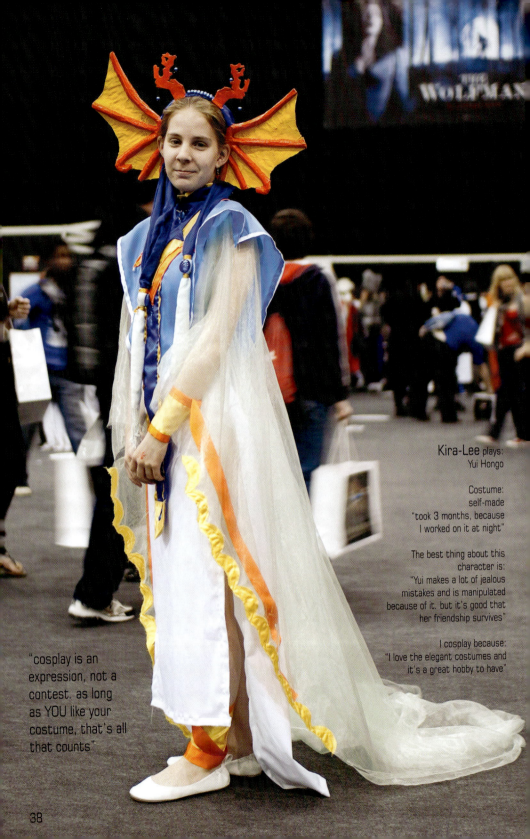

Kira-Lee plays:
Yui Hongo

Costume:
self-made
"took 3 months, because
I worked on it at night"

The best thing about this
character is:
"Yui makes a lot of jealous
mistakes and is manipulated
because of it. but it's good that
her friendship survives"

I cosplay because:
"I love the elegant costumes and
it's a great hobby to have"

"cosplay is an
expression, not a
contest. as long
as YOU like your
costume, that's all
that counts"

38

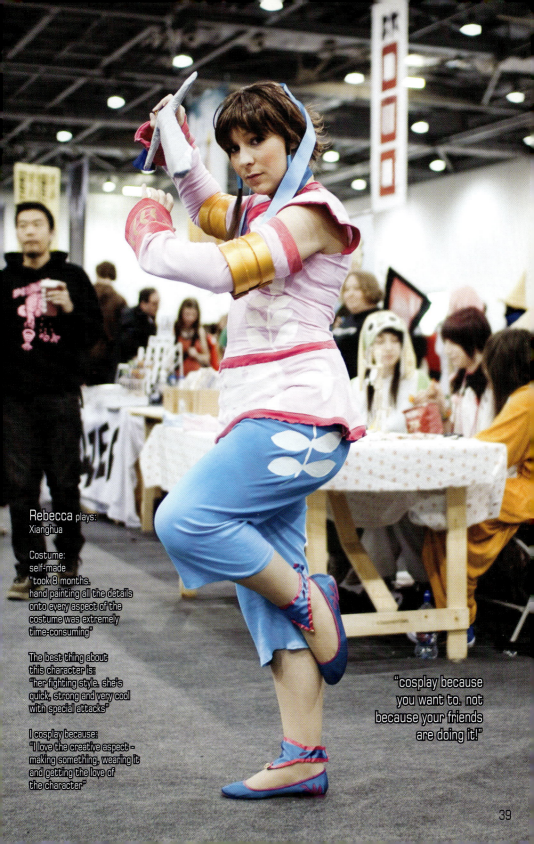

Rebecca plays:
Xianghua

Costume:
self-made
"took 8 months.
hand painting all the details
onto every aspect of the
costume was extremely
time-consuming"

The best thing about
this character is:
"her fighting style. she's
quick, strong and very cool
with special attacks"

I cosplay because:
"I love the creative aspect –
making something, wearing it
and getting the love of
the character"

"cosplay because
you want to. not
because your friends
are doing it!"

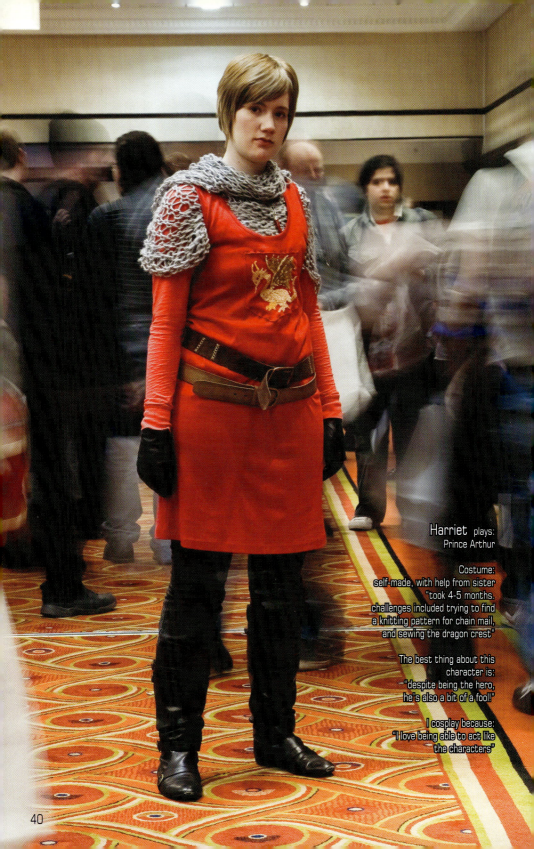

Harriet plays:
Prince Arthur

Costume:
self-made, with help from sister
"took 4-5 months.
challenges included trying to find
a knitting pattern for chain mail,
and sewing the dragon crest"

The best thing about this
character is:
"despite being the hero,
he's also a bit of a fool!"

I cosplay because:
"I love being able to act like
the characters"

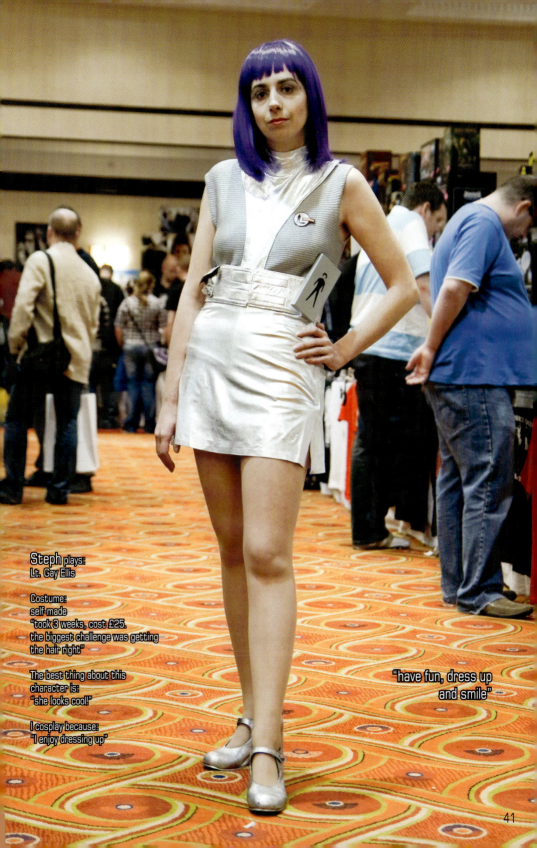

Steph plays:
Lt. Gay Ellis

Costume:
self-made
"took 3 weeks, cost £25.
the biggest challenge was getting
the hair right"

The best thing about this
character is:
"she looks cool!"

I cosplay because:
"I enjoy dressing up"

"have fun, dress up
and smile"

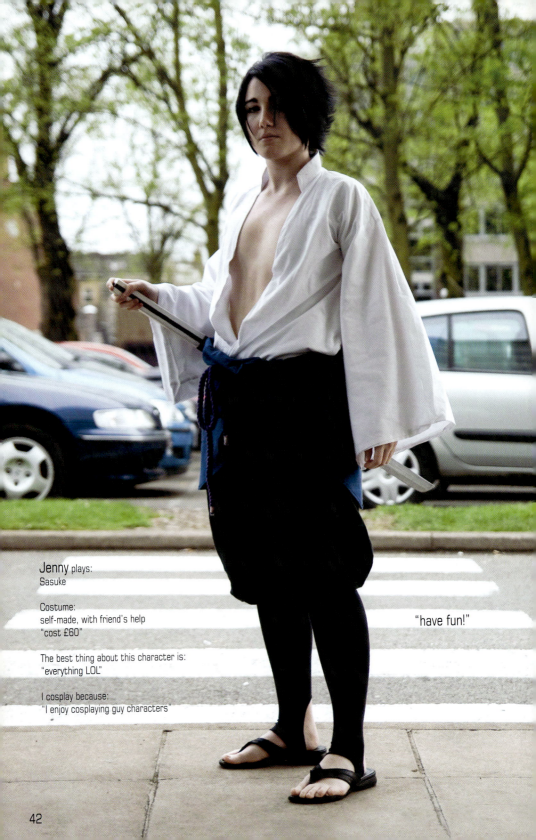

Jenny plays:
Sasuke

Costume:
self-made, with friend's help
"cost £60"

The best thing about this character is:
"everything LOL"

I cosplay because:
"I enjoy cosplaying guy characters"

"have fun!"

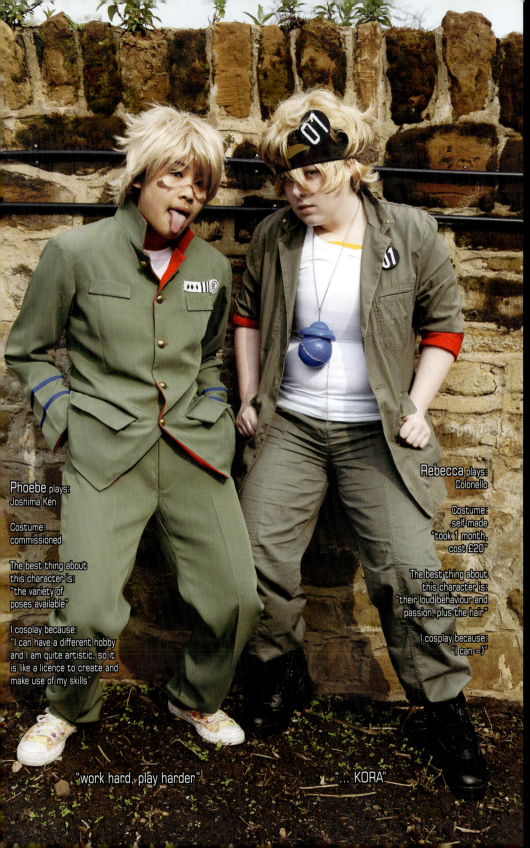

Phoebe plays:
Joshima Ken

Costume:
commissioned

The best thing about
this character is:
"the variety of
poses available"

I cosplay because:
"I can have a different hobby
and I am quite artistic, so it
is like a licence to create and
make use of my skills"

Rebecca plays:
Colonello

Costume:
self-made
"took 1 month,
cost £20"

The best thing about
this character is:
"their loud behaviour and
passion, plus the hair"

I cosplay because:
"I can =)"

"work hard, play harder" "... KORA"

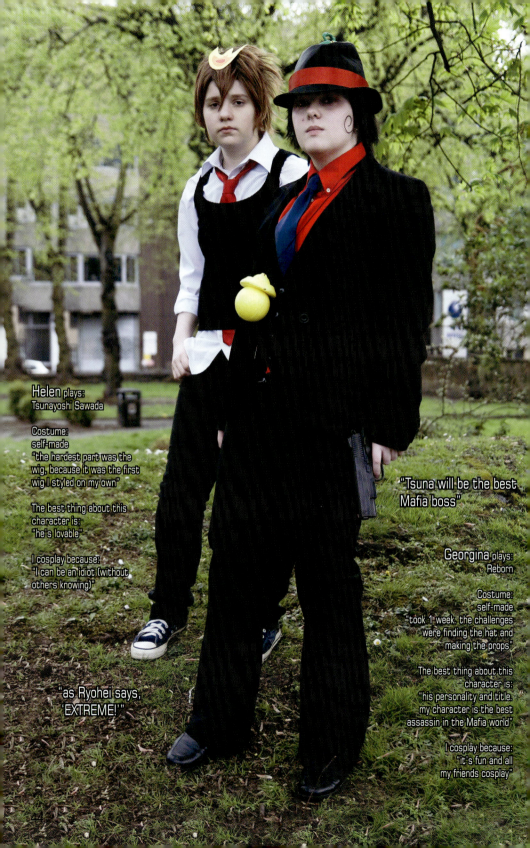

Helen plays:
Tsunayoshi Sawada

Costume:
self-made
"the hardest part was the
wig, because it was the first
wig I styled on my own"

The best thing about this
character is:
"he's lovable"

I cosplay because:
"I can be an idiot (without
others knowing)"

"as Ryohei says,
'EXTREME!'"

"Tsuna will be the best
Mafia boss"

Georgina plays:
Reborn

Costume:
self-made
"took 1 week. the challenges
were finding the hat and
making the props"

The best thing about this
character is:
"his personality and title.
my character is the best
assassin in the Mafia world"

I cosplay because:
"it's fun and all
my friends cosplay"

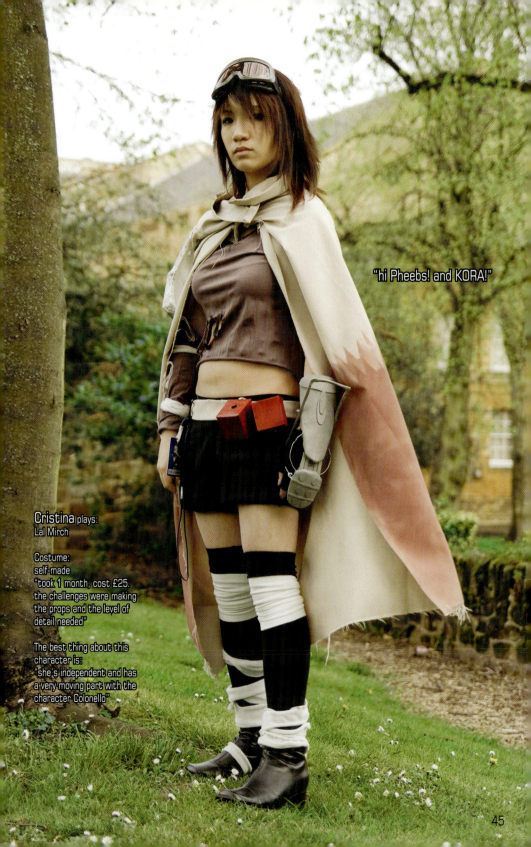

"hi Pheebs! and KORA!"

Cristina plays:
Lal Mirch

Costume:
self-made
"took 1 month, cost £25.
the challenges were making
the props and the level of
detail needed"

The best thing about this
character is:
"she's independent and has
a very moving part with the
character Colonello"

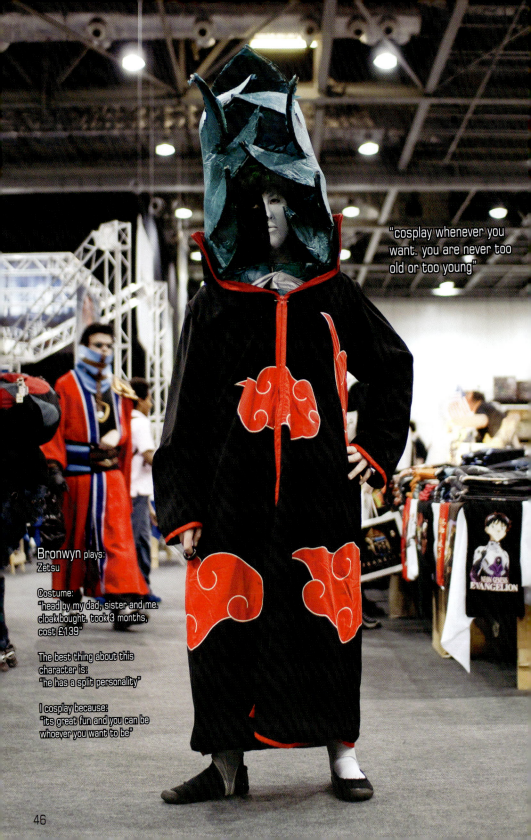

"cosplay whenever you want. you are never too old or too young"

Bronwyn plays:
Zetsu

Costume:
"head by my dad, sister and me. cloak bought. took 3 months, cost £139"

The best thing about this character is:
"he has a split personality"

I cosplay because:
"its great fun and you can be whoever you want to be"

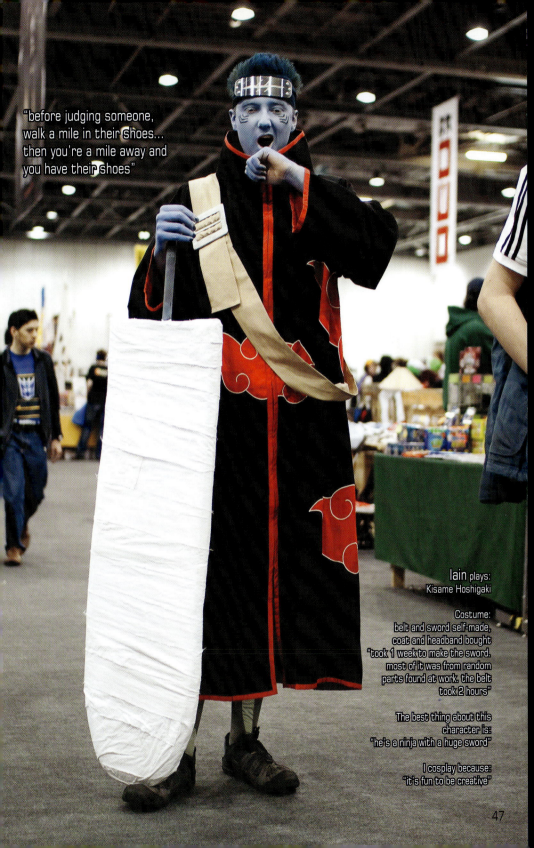

"before judging someone, walk a mile in their shoes... then you're a mile away and you have their shoes"

Iain plays:
Kisame Hoshigaki

Costume:
belt and sword self-made,
coat and headband bought
"took 1 week to make the sword.
most of it was from random
parts found at work. the belt
took 2 hours"

The best thing about this
character is:
"he's a ninja with a huge sword"

I cosplay because:
"it's fun to be creative"

47

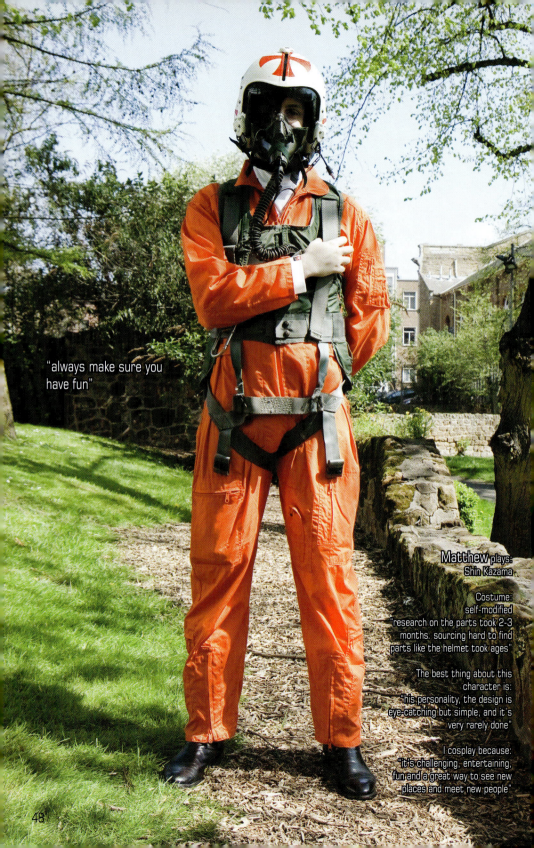

"always make sure you have fun"

Matthew plays:
Shin Kazama

Costume:
self-modified
"research on the parts took 2-3
months. sourcing hard to find
parts like the helmet took ages"

The best thing about this
character is:
"his personality, the design is
eye-catching but simple, and it's
very rarely done"

I cosplay because:
"it's challenging, entertaining,
fun and a great way to see new
places and meet new people"

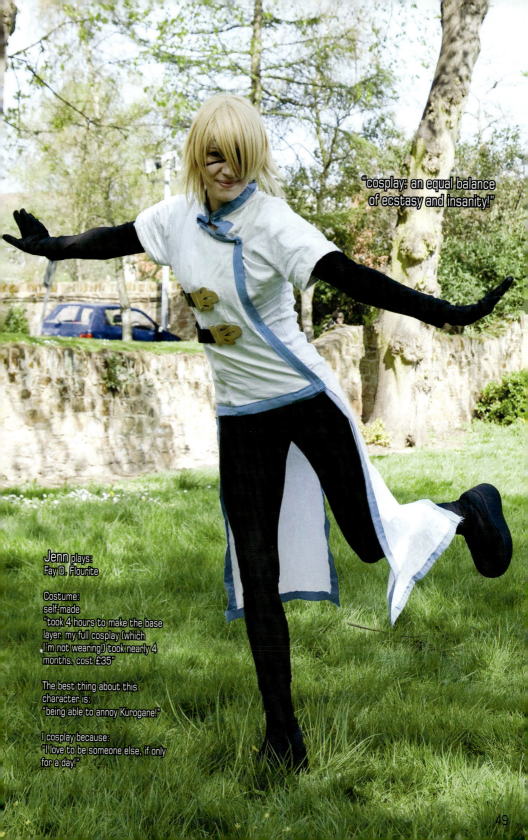

"cosplay: an equal balance
of ecstasy and insanity!"

Jenn plays:
Fay D. Flourite

Costume:
self-made
"took 4 hours to make the base
layer. my full cosplay (which
I'm not wearing!) took nearly 4
months. cost £35"

The best thing about this
character is:
"being able to annoy Kurogane!"

I cosplay because:
"I love to be someone else, if only
for a day!"

49

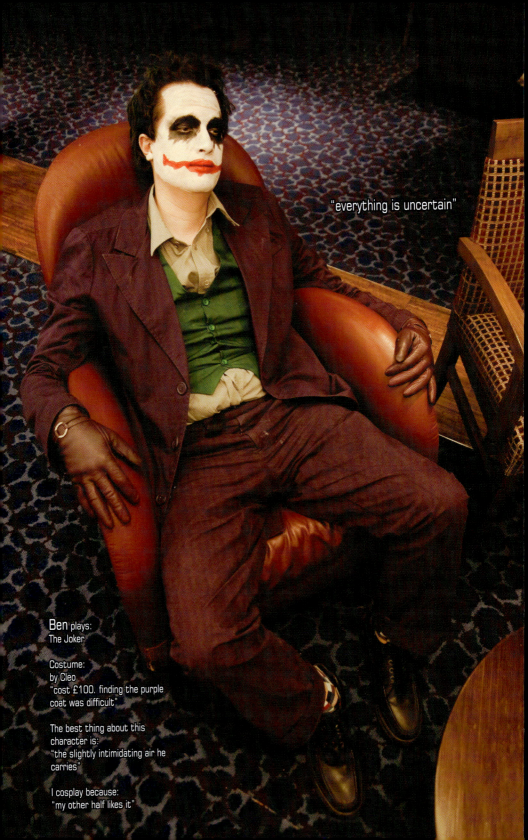

"everything is uncertain"

Ben plays:
The Joker

Costume:
by Cleo
"cost £100. finding the purple
coat was difficult"

The best thing about this
character is:
"the slightly intimidating air he
carries"

I cosplay because:
"my other half likes it"

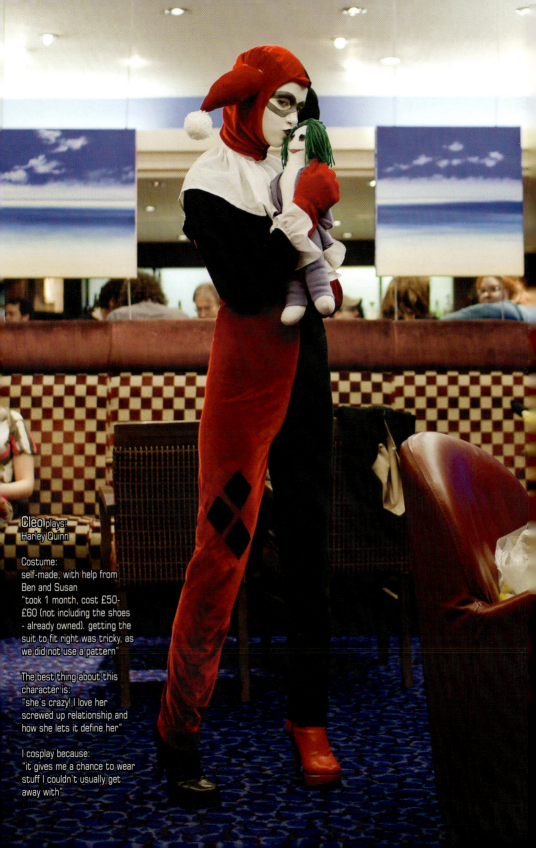

Cleo plays:
Harley Quinn

Costume:
self-made, with help from
Ben and Susan
"took 1 month, cost £50-
£60 (not including the shoes
- already owned). getting the
suit to fit right was tricky, as
we did not use a pattern"

The best thing about this
character is:
"she's crazy! I love her
screwed up relationship and
how she lets it define her"

I cosplay because:
"it gives me a chance to wear
stuff I couldn't usually get
away with"

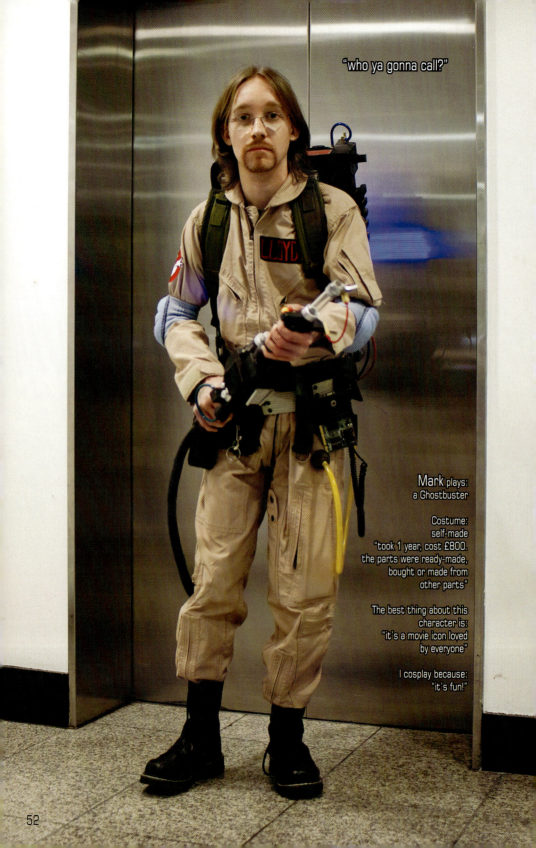

"who ya gonna call?"

Mark plays:
a Ghostbuster

Costume:
self-made
"took 1 year, cost £800.
the parts were ready-made,
bought or made from
other parts"

The best thing about this
character is:
"it's a movie icon loved
by everyone"

I cosplay because:
"it's fun!"

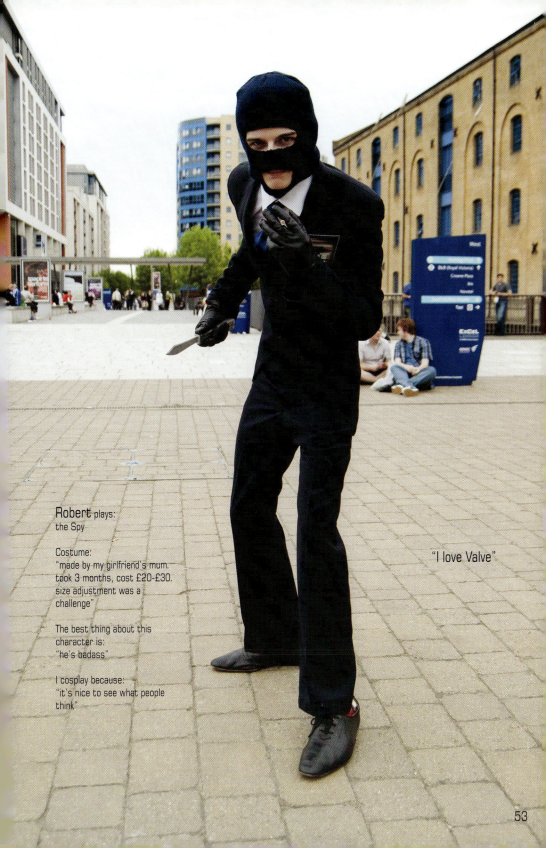

Robert plays:
the Spy

Costume:
"made by my girlfriend's mum.
took 3 months, cost £20-£30.
size adjustment was a
challenge"

The best thing about this
character is:
"he's badass"

I cosplay because:
"it's nice to see what people
think"

"I love Valve"

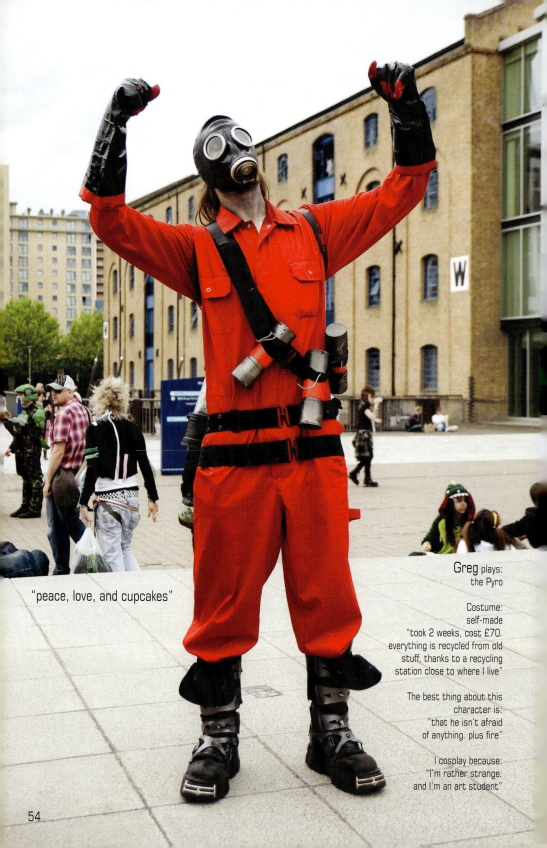

"peace, love, and cupcakes"

Greg plays:
the Pyro

Costume:
self-made
"took 2 weeks, cost £70.
everything is recycled from old
stuff, thanks to a recycling
station close to where I live"

The best thing about this
character is:
"that he isn't afraid
of anything. plus fire"

I cosplay because:
"I'm rather strange.
and I'm an art student"

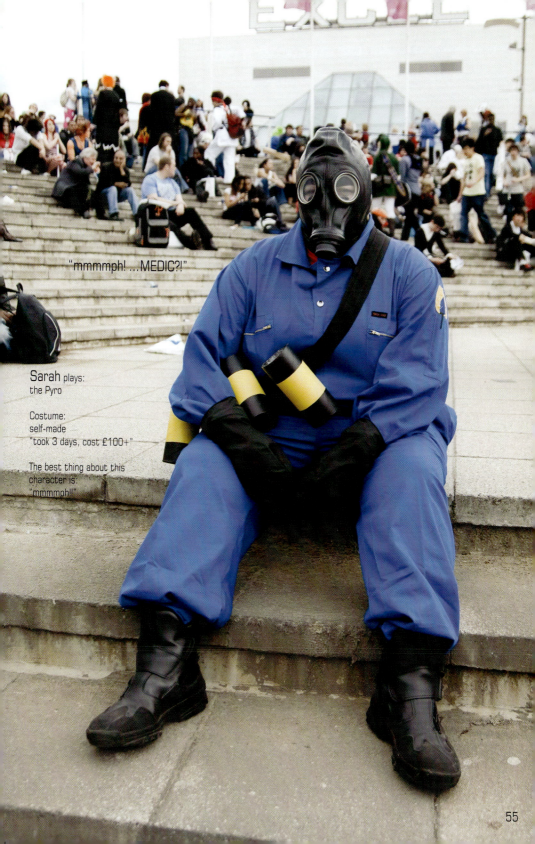

"mmmmph! ...MEDIC?!"

Sarah plays:
the Pyro

Costume:
self-made
"took 3 days, cost £100+"

The best thing about this character is:
"mmmmph!!"

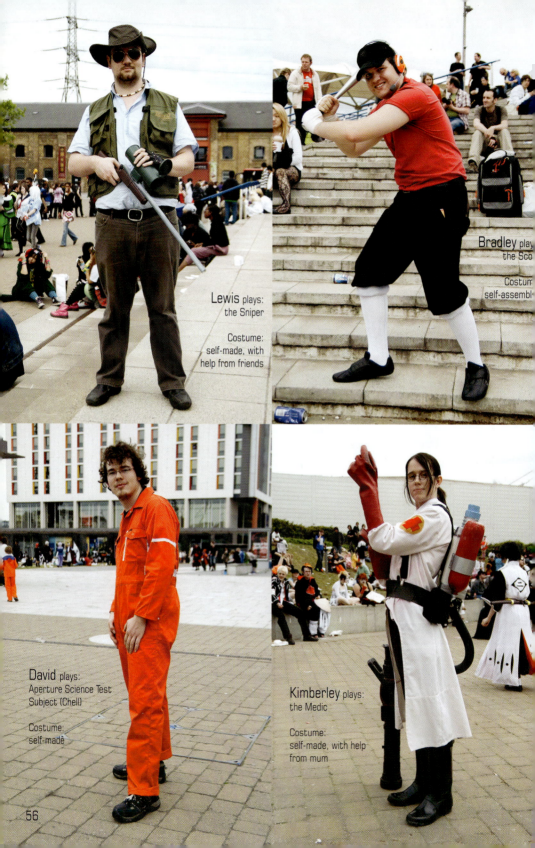

Lewis plays:
the Sniper

Costume:
self-made, with
help from friends

Bradley play
the Sco

Costum
self-assembl

David plays:
Aperture Science Test
Subject (Chell)

Costume:
self-made

Kimberley plays:
the Medic

Costume:
self-made, with help
from mum

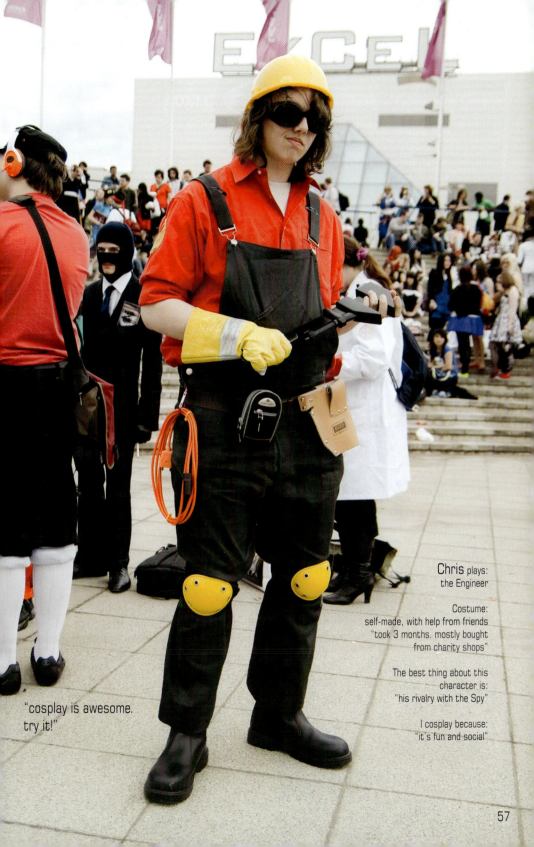

Chris plays:
the Engineer

Costume:
self-made, with help from friends
"took 3 months. mostly bought
from charity shops"

The best thing about this
character is:
"his rivalry with the Spy"

I cosplay because:
"it's fun and social"

"cosplay is awesome.
try it!"

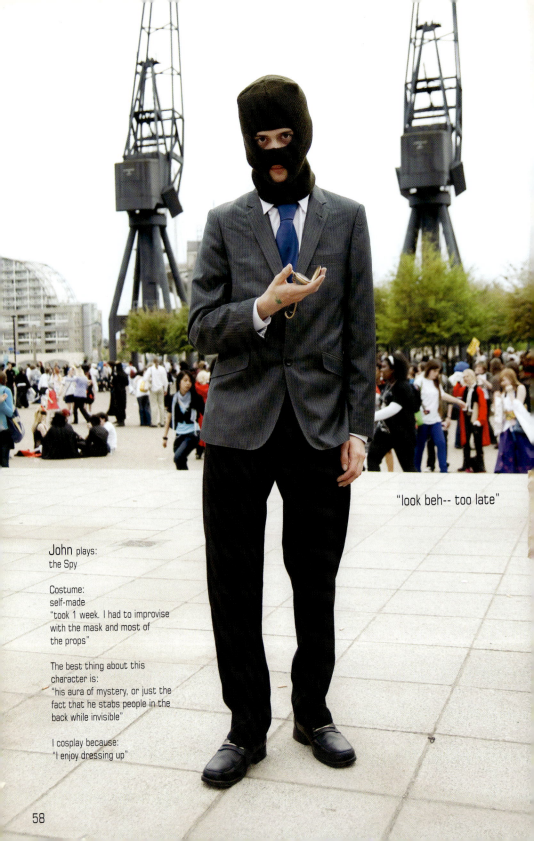

"look beh-- too late"

John plays:
the Spy

Costume:
self-made
"took 1 week. I had to improvise
with the mask and most of
the props"

The best thing about this
character is:
"his aura of mystery, or just the
fact that he stabs people in the
back while invisible"

I cosplay because:
"I enjoy dressing up"

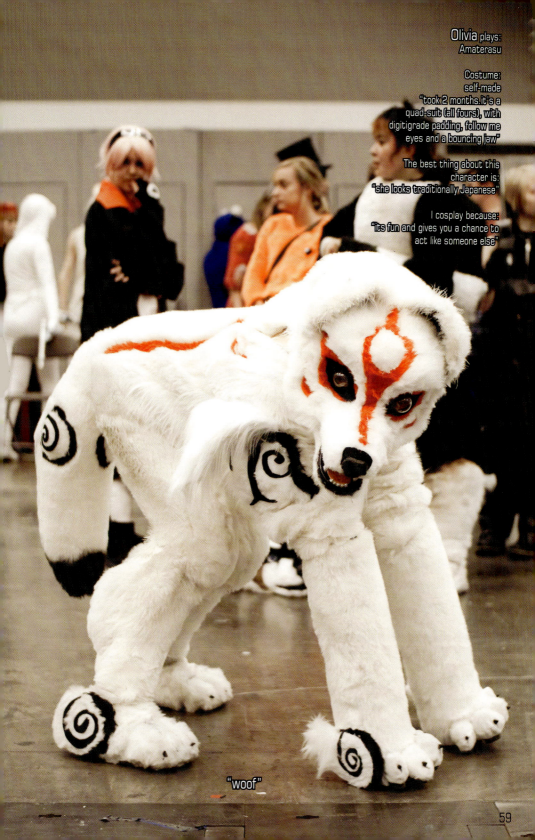

Olivia plays:
Amaterasu

Costume:
self-made
"took 2 months. it's a
quad-suit (all fours), with
digitigrade padding, follow me
eyes and a bouncing jaw"

The best thing about this
character is:
"she looks traditionally Japanese"

I cosplay because:
"its fun and gives you a chance to
act like someone else"

"woof"

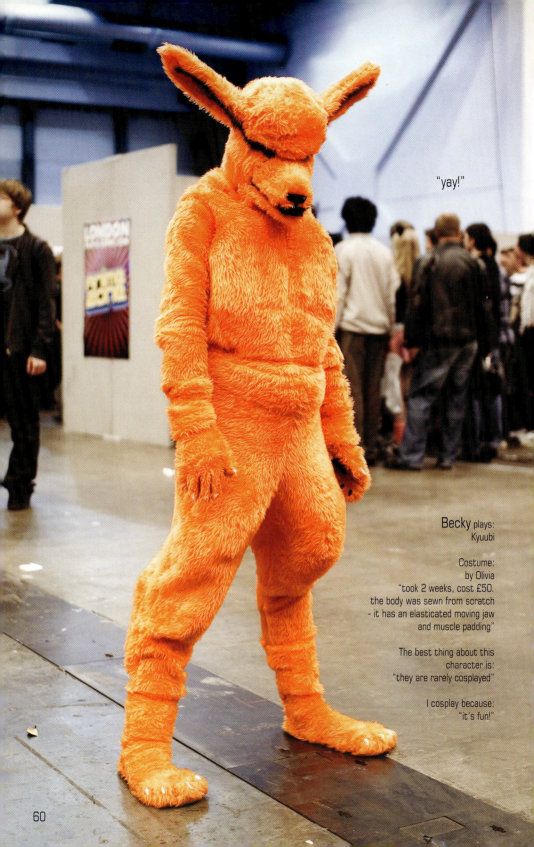

"yay!"

Becky plays:
Kyuubi

Costume:
by Olivia
"took 2 weeks, cost £50.
the body was sewn from scratch
- it has an elasticated moving jaw
and muscle padding"

The best thing about this
character is:
"they are rarely cosplayed"

I cosplay because:
"it's fun!"

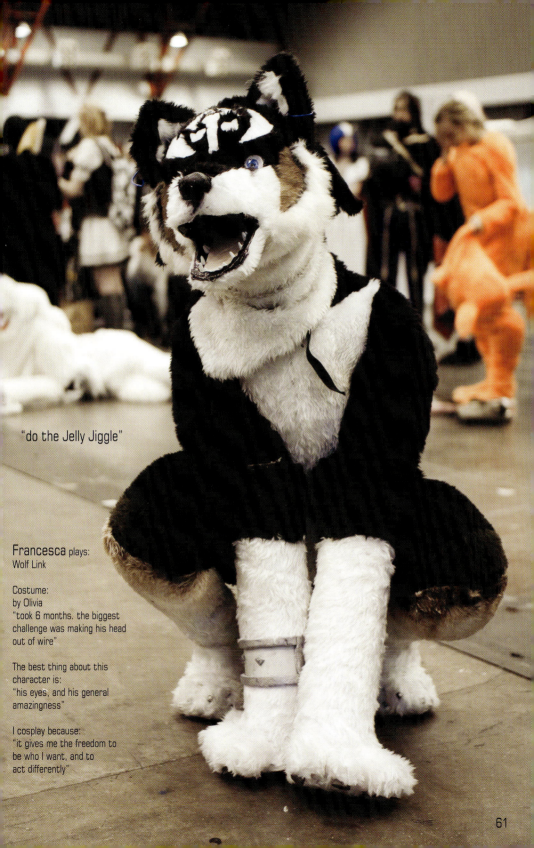

"do the Jelly Jiggle"

Francesca plays:
Wolf Link

Costume:
by Olivia
"took 6 months. the biggest
challenge was making his head
out of wire"

The best thing about this
character is:
"his eyes, and his general
amazingness"

I cosplay because:
"it gives me the freedom to
be who I want, and to
act differently"

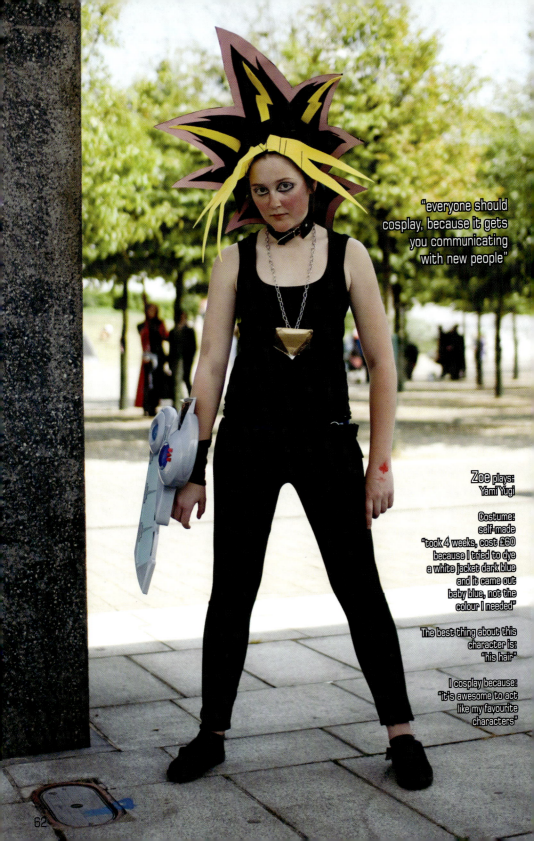

"everyone should cosplay, because it gets you communicating with new people"

Zoe plays:
Yami Yugi

Costume:
self-made
"took 4 weeks, cost £60 because I tried to dye a white jacket dark blue and it came out baby blue, not the colour I needed"

The best thing about this character is:
"his hair"

I cosplay because:
"it's awesome to act like my favourite characters"

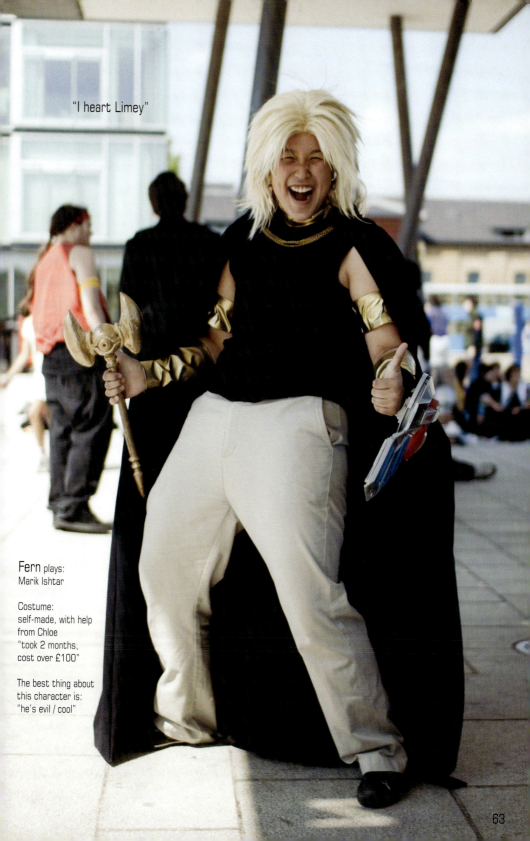

"I heart Limey"

Fern plays:
Marik Ishtar

Costume:
self-made, with help
from Chloe
"took 2 months,
cost over £100"

The best thing about
this character is:
"he's evil / cool"

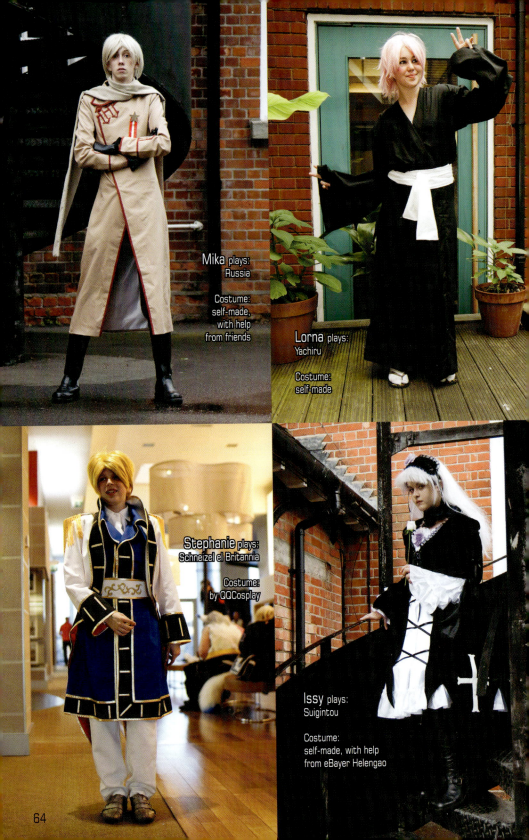

Mika plays:
Russia

Costume:
self-made,
with help
from friends

Lorna plays:
Yachiru

Costume:
self-made

Stephanie plays:
Schneizel el Britannia

Costume:
by QQCosplay

Issy plays:
Suigintou

Costume:
self-made, with help
from eBayer Helengao

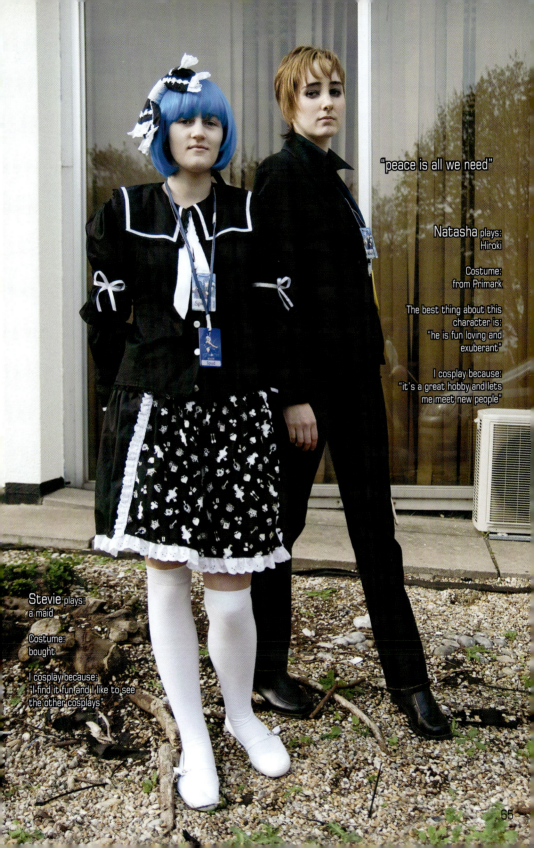

"peace is all we need"

Natasha plays:
Hiroki

Costume:
from Primark

The best thing about this
character is:
"he is fun loving and
exuberant"

I cosplay because:
"it's a great hobby and lets
me meet new people"

Stevie plays:
a maid

Costume:
bought

I cosplay because:
"I find it fun and I like to see
the other cosplays"

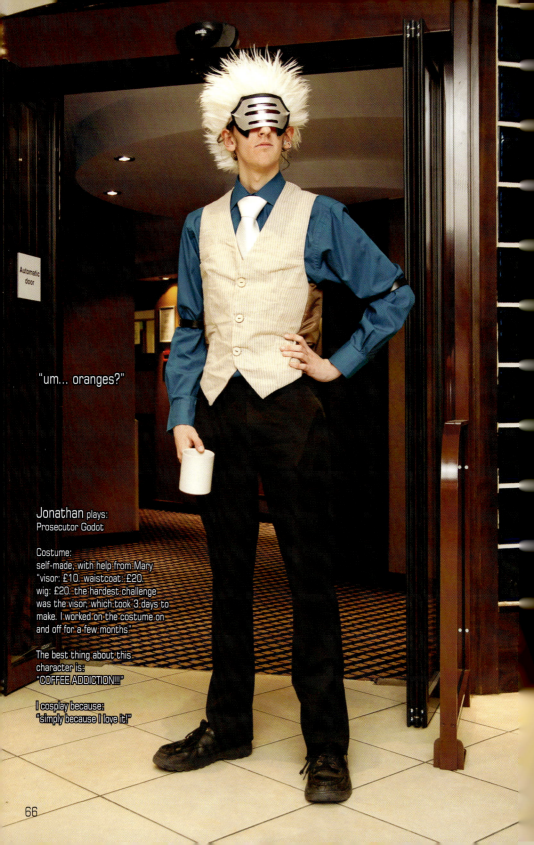

"um... oranges?"

Jonathan plays:
Prosecutor Godot

Costume:
self-made, with help from Mary
"visor: £10. waistcoat: £20.
wig: £20. the hardest challenge
was the visor, which took 3 days to
make. I worked on the costume on
and off for a few months"

The best thing about this
character is:
"COFFEE ADDICTION!!!"

I cosplay because:
"simply because I love it!"

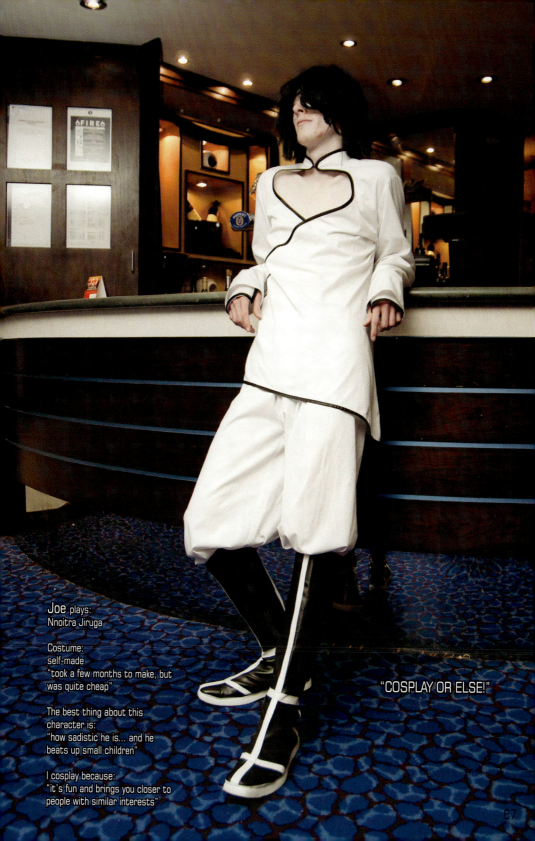

Joe plays:
Nnoitra Jiruga

Costume:
self-made
"took a few months to make, but
was quite cheap"

The best thing about this
character is:
"how sadistic he is... and he
beats up small children"

I cosplay because:
"it's fun and brings you closer to
people with similar interests"

"COSPLAY OR ELSE!"

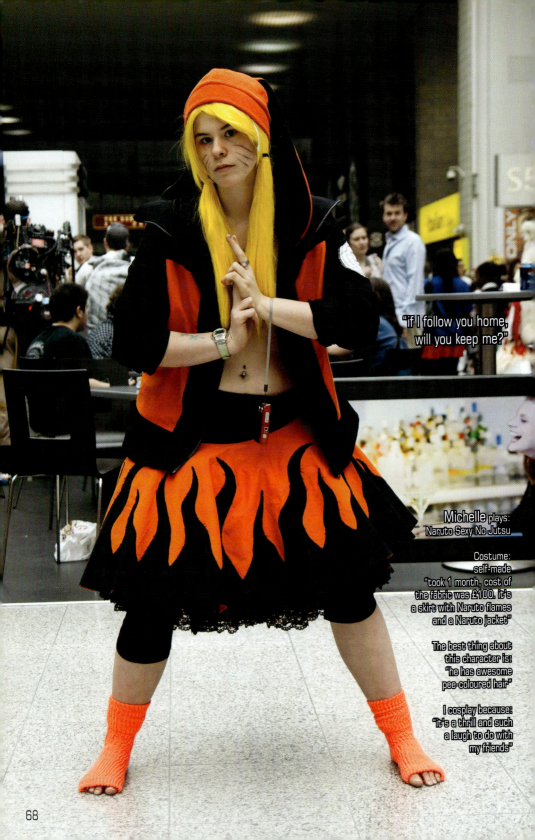

"if I follow you home,
will you keep me?"

Michelle plays:
Naruto Sexy No Jutsu

Costume:
self-made
"took 1 month, cost of
the fabric was £100. It's
a skirt with Naruto flames
and a Naruto jacket"

The best thing about
this character is:
"he has awesome
pee-coloured hair"

I cosplay because:
"it's a thrill and such
a laugh to do with
my friends"

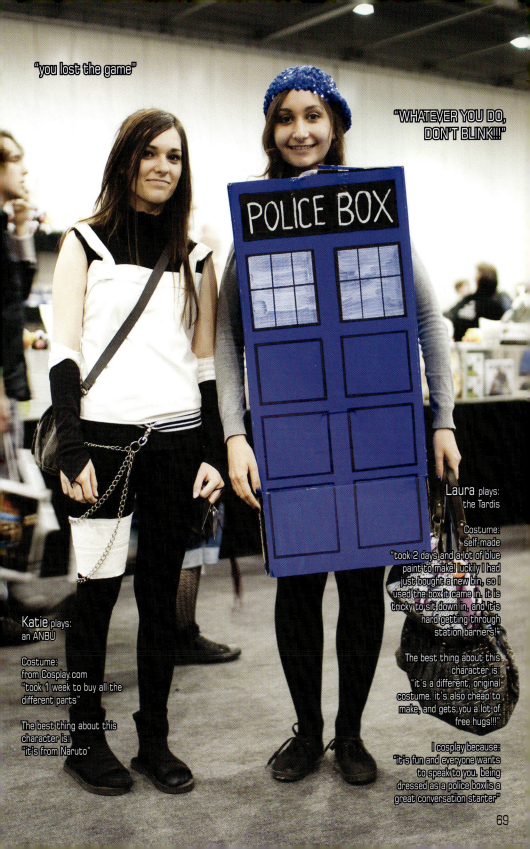

"you lost the game"

"WHATEVER YOU DO, DON'T BLINK!!!"

Laura plays:
the Tardis

Costume:
self-made
"took 2 days and a lot of blue
paint to make! luckily I had
just bought a new bin, so I
used the box it came in. it is
tricky to sit down in, and it's
hard getting through
station barriers!"

The best thing about this
character is:
"it's a different, original
costume. it's also cheap to
make, and gets you a lot of
free hugs!!!"

I cosplay because:
"it's fun and everyone wants
to speak to you. being
dressed as a police box is a
great conversation starter"

Katie plays:
an ANBU

Costume:
from Cosplay.com
"took 1 week to buy all the
different parts"

The best thing about this
character is:
"it's from Naruto"

69

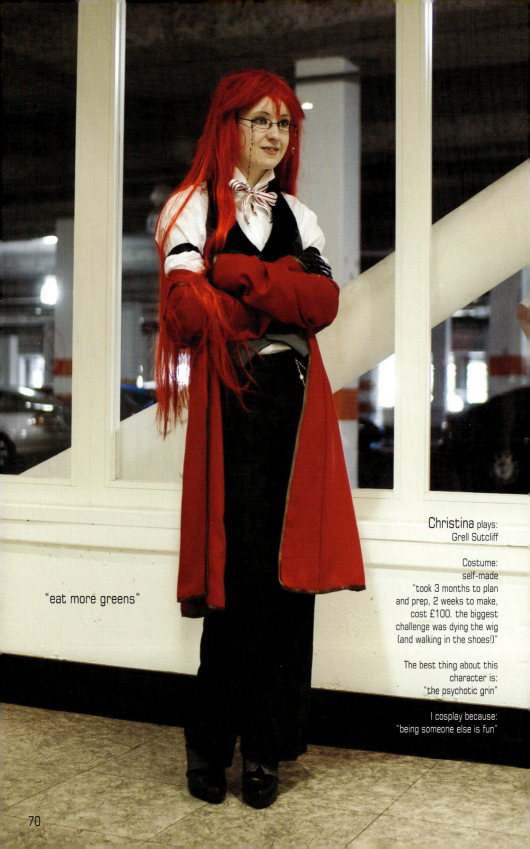

"eat more greens"

Christina plays:
Grell Sutcliff

Costume:
self-made
"took 3 months to plan
and prep, 2 weeks to make,
cost £100. the biggest
challenge was dying the wig
(and walking in the shoes!)"

The best thing about this
character is:
"the psychotic grin"

I cosplay because:
"being someone else is fun"

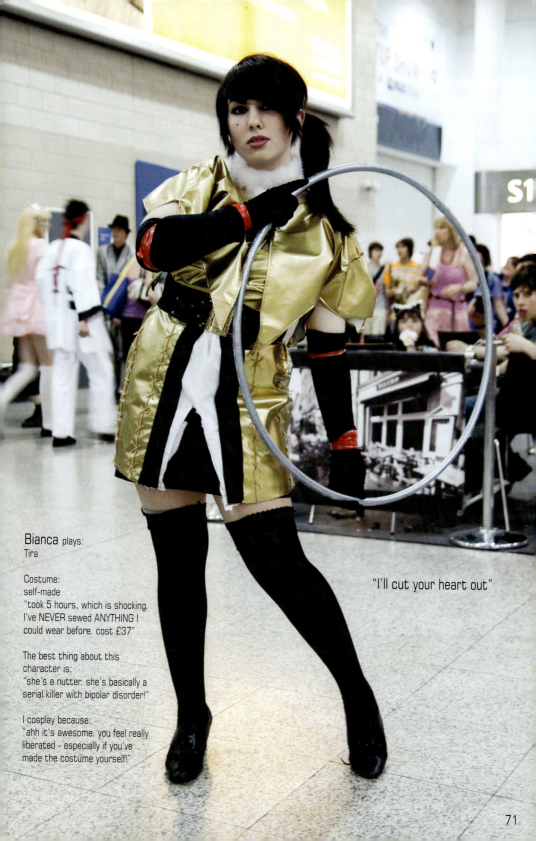

Bianca plays:
Tira

Costume:
self-made
"took 5 hours, which is shocking.
I've NEVER sewed ANYTHING I
could wear before. cost £37"

The best thing about this
character is:
"she's a nutter. she's basically a
serial killer with bipolar disorder!"

I cosplay because:
"ahh it's awesome. you feel really
liberated - especially if you've
made the costume yourself!"

"I'll cut your heart out"

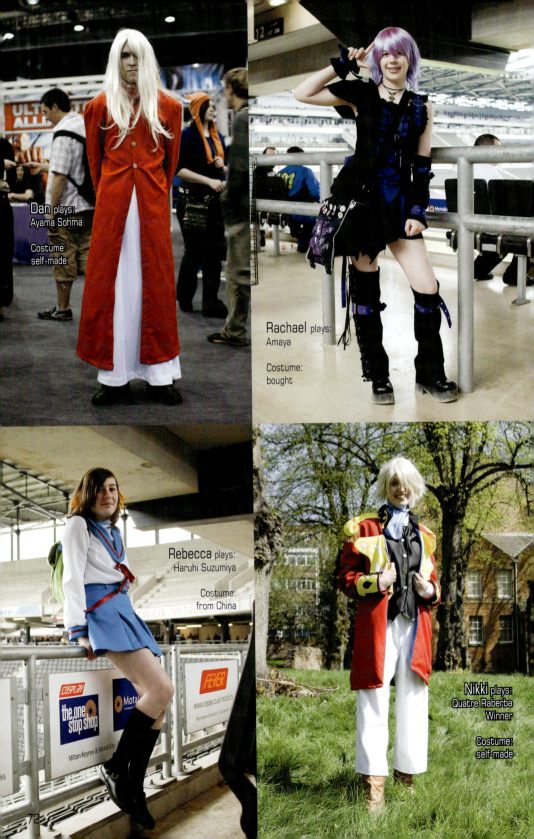

Dan plays:
Ayama Sohma

Costume:
self-made

Rachael plays:
Amaya

Costume:
bought

Rebecca plays:
Haruhi Suzumiya

Costume:
from China

Nikki plays:
Quatre Raberba
Winner

Costume:
self-made

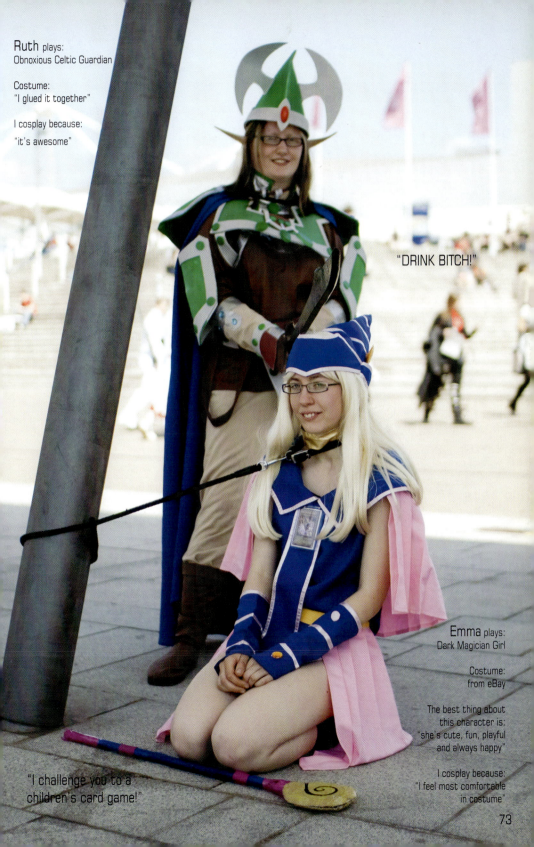

Ruth plays:
Obnoxious Celtic Guardian

Costume:
"I glued it together"

I cosplay because:
"it's awesome"

"DRINK BITCH!"

Emma plays:
Dark Magician Girl

Costume:
from eBay

The best thing about
this character is:
"she's cute, fun, playful
and always happy"

I cosplay because:
"I feel most comfortable
in costume"

"I challenge you to a
children's card game!"

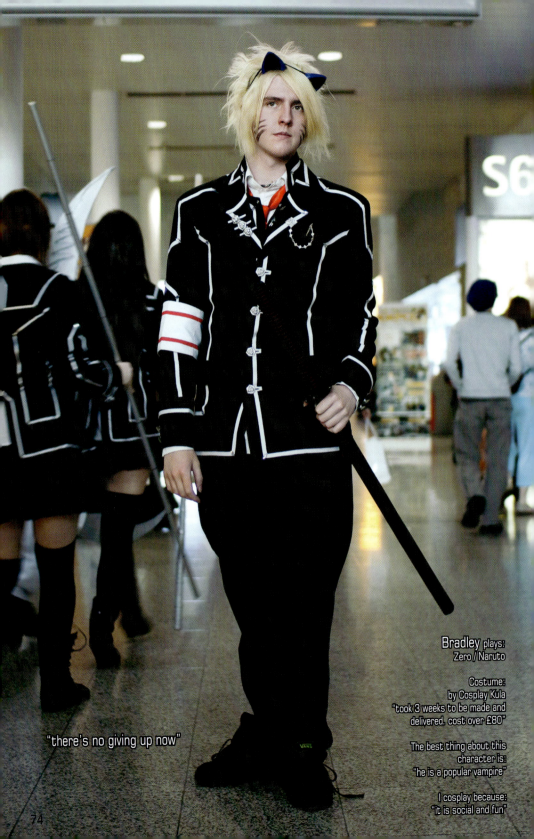

Bradley plays:
Zero / Naruto

Costume:
by Cosplay Kula
"took 3 weeks to be made and
delivered. cost over £80"

The best thing about this
character is:
"he is a popular vampire"

I cosplay because:
"it is social and fun"

"there's no giving up now"

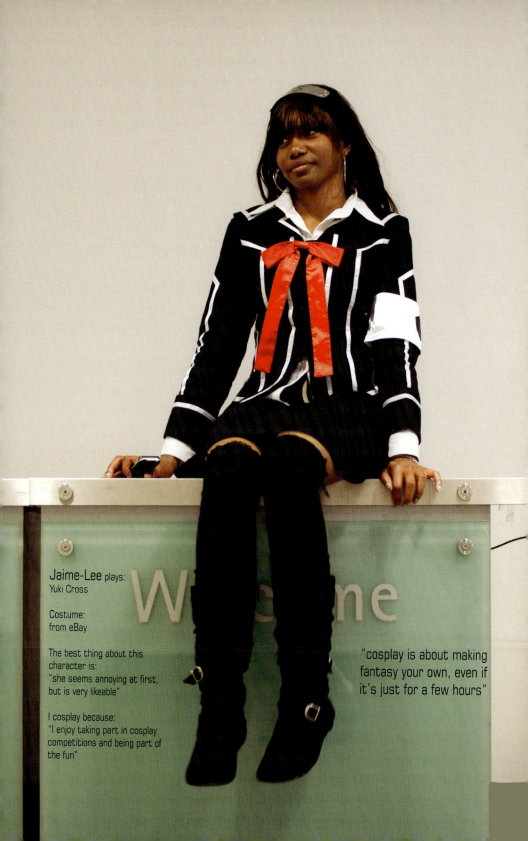

Jaime-Lee plays:
Yuki Cross

Costume:
from eBay

The best thing about this
character is:
"she seems annoying at first,
but is very likeable"

I cosplay because:
"I enjoy taking part in cosplay
competitions and being part of
the fun"

"cosplay is about making
fantasy your own, even if
it's just for a few hours"

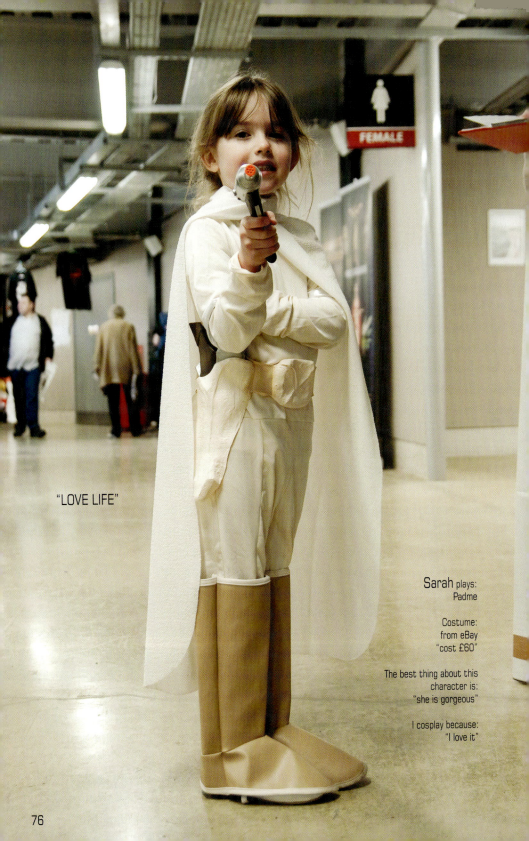

"LOVE LIFE"

Sarah plays:
Padme

Costume:
from eBay
"cost £60"

The best thing about this
character is:
"she is gorgeous"

I cosplay because:
"I love it"

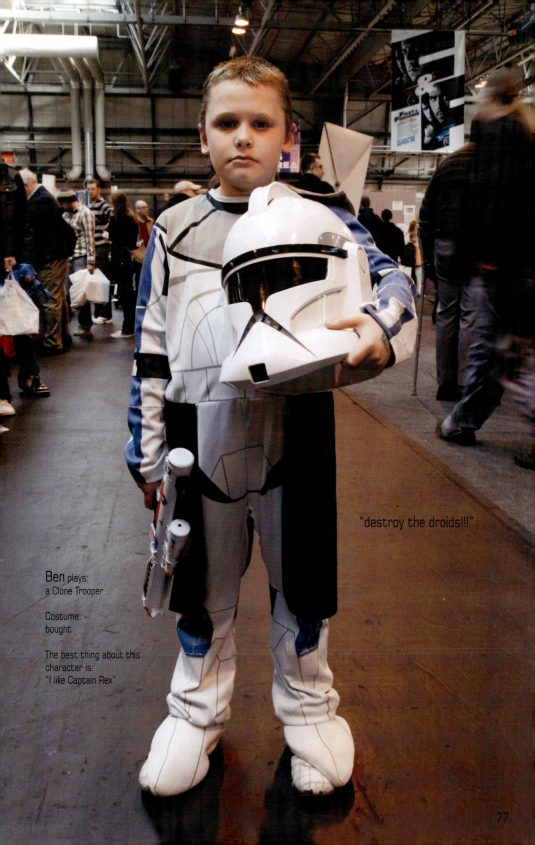

"destroy the droids!!!"

Ben plays:
a Clone Trooper

Costume:
bought

The best thing about this
character is:
"I like Captain Rex"

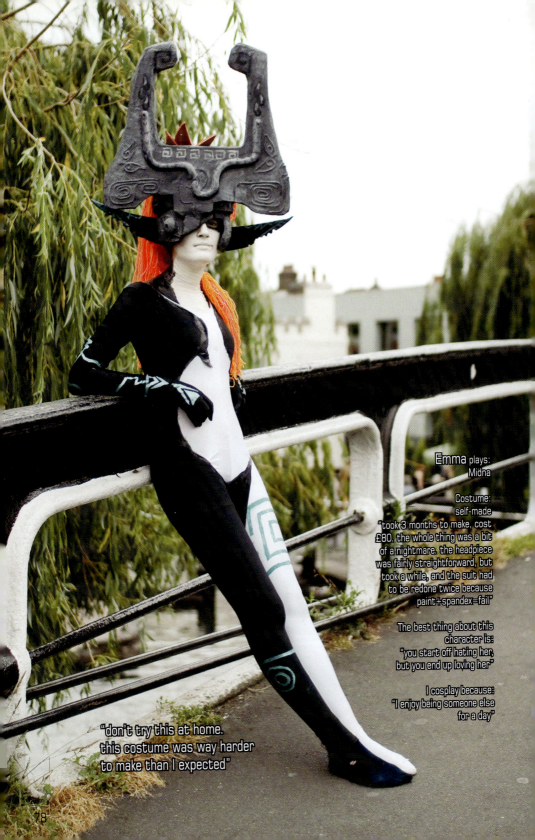

Emma plays:
Midna

Costume:
self-made
"took 3 months to make, cost
£80. the whole thing was a bit
of a nightmare. the headpiece
was fairly straightforward, but
took a while, and the suit had
to be redone twice because
paint+spandex=fail"

The best thing about this
character is:
"you start off hating her,
but you end up loving her"

I cosplay because:
"I enjoy being someone else
for a day"

"don't try this at home.
this costume was way harder
to make than I expected"

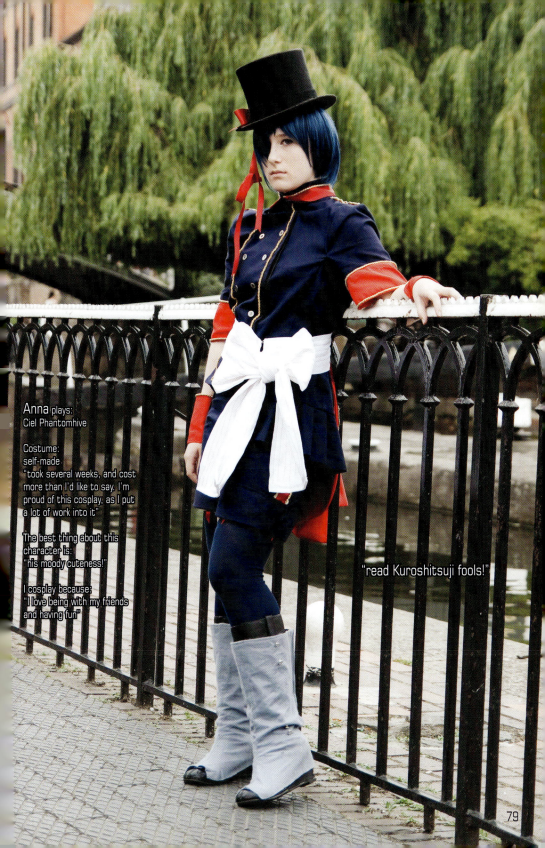

Anna plays:
Ciel Phantomhive

Costume:
self-made
"took several weeks, and cost more than I'd like to say. I'm proud of this cosplay, as I put a lot of work into it"

The best thing about this character is:
"his moody cuteness!"

I cosplay because:
"I love being with my friends and having fun"

"read Kuroshitsuji fools!"

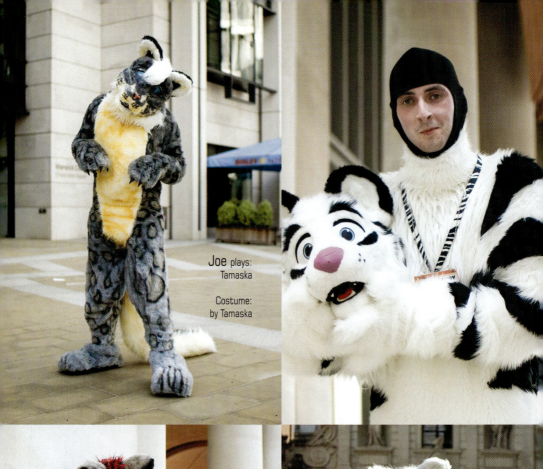

Joe plays:
Tamaska

Costume:
by Tamaska

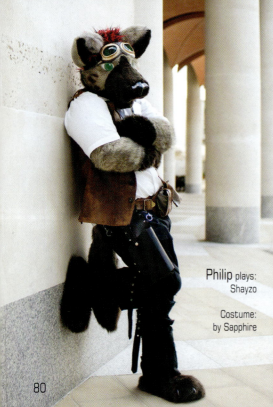

Philip plays:
Shayzo

Costume:
by Sapphire

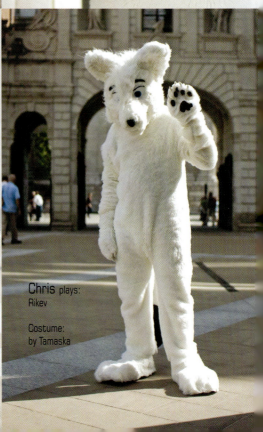

Chris plays:
Rikev

Costume:
by Tamaska

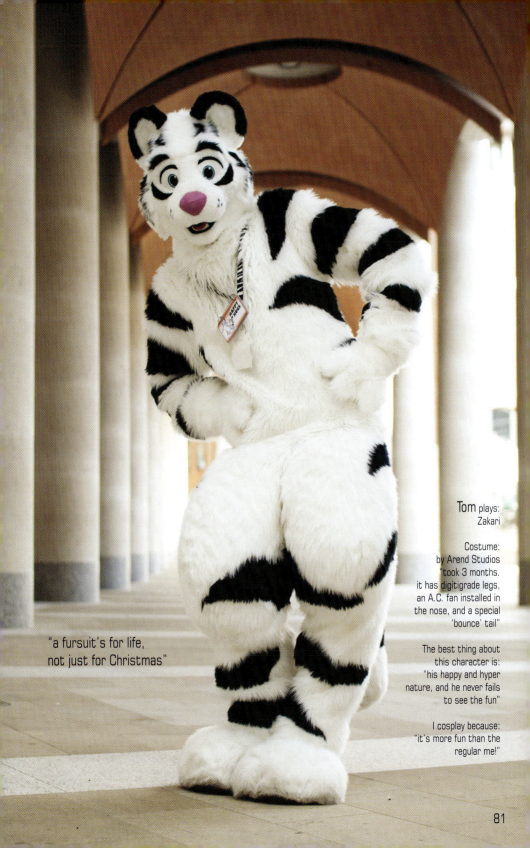

"a fursuit's for life,
not just for Christmas"

Tom plays:
Zakari

Costume:
by Arend Studios
"took 3 months.
it has digitigrade legs,
an A.C. fan installed in
the nose, and a special
'bounce' tail"

The best thing about
this character is:
"his happy and hyper
nature, and he never fails
to see the fun"

I cosplay because:
"it's more fun than the
regular me!"

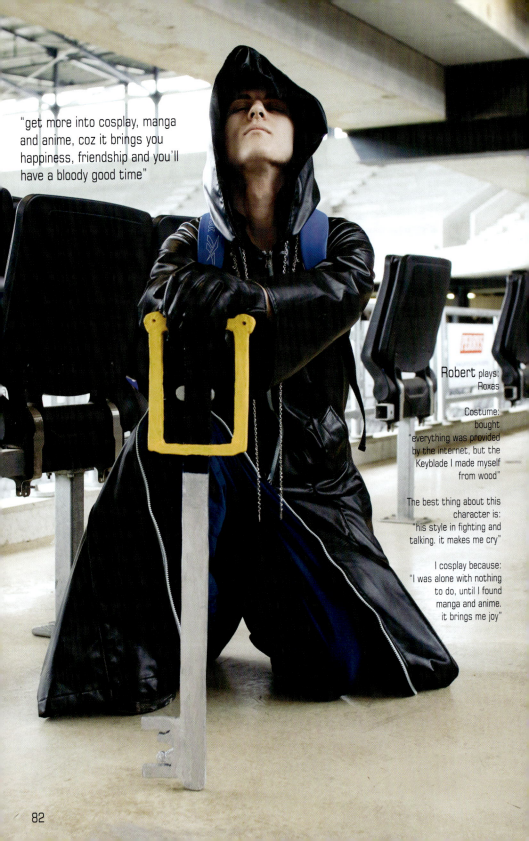

"get more into cosplay, manga and anime, coz it brings you happiness, friendship and you'll have a bloody good time"

Robert plays:
Roxas

Costume:
bought
"everything was provided by the internet, but the Keyblade I made myself from wood"

The best thing about this character is:
"his style in fighting and talking. it makes me cry"

I cosplay because:
"I was alone with nothing to do, until I found manga and anime. it brings me joy"

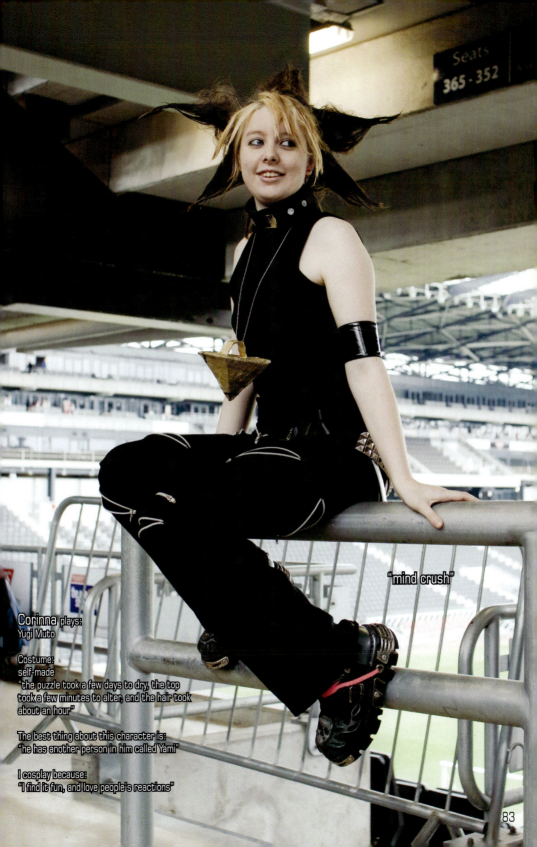

"mind crush"

Corinna plays:
Yugi Muto

Costume:
self-made
"the puzzle took a few days to dry, the top
took a few minutes to alter, and the hair took
about an hour"

The best thing about this character is:
"he has another person in him called Yami"

I cosplay because:
"I find it fun, and love people's reactions"

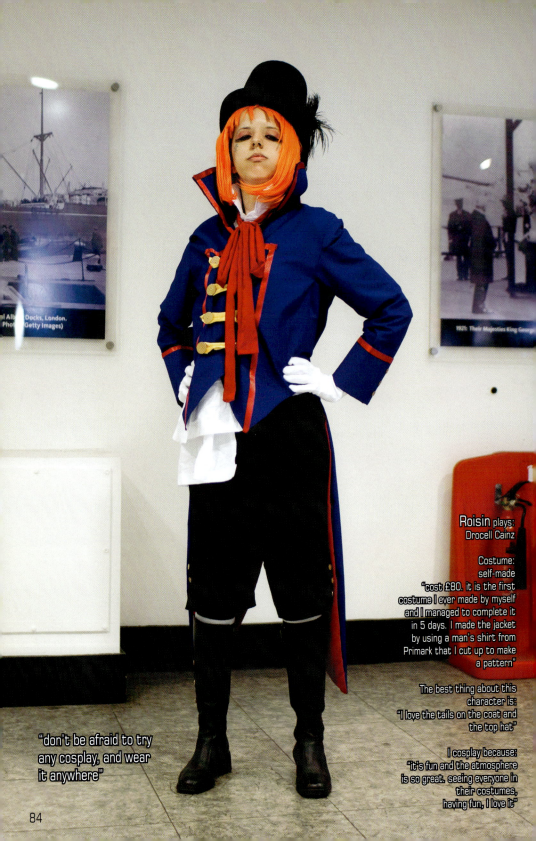

Roisin plays:
Drocell Cainz

Costume:
self-made
"cost £80. it is the first
costume I ever made by myself
and I managed to complete it
in 5 days. I made the jacket
by using a man's shirt from
Primark that I cut up to make
a pattern"

The best thing about this
character is:
"I love the tails on the coat and
the top hat"

I cosplay because:
"it's fun and the atmosphere
is so great. seeing everyone in
their costumes,
having fun, I love it"

"don't be afraid to try
any cosplay, and wear
it anywhere"

84

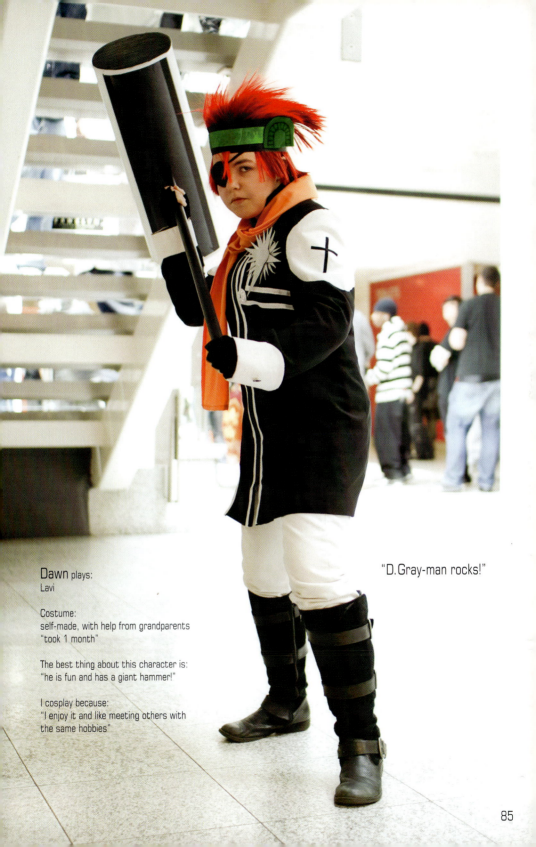

Dawn plays:
Lavi

Costume:
self-made, with help from grandparents
"took 1 month"

The best thing about this character is:
"he is fun and has a giant hammer!"

I cosplay because:
"I enjoy it and like meeting others with
the same hobbies"

"D. Gray-man rocks!"

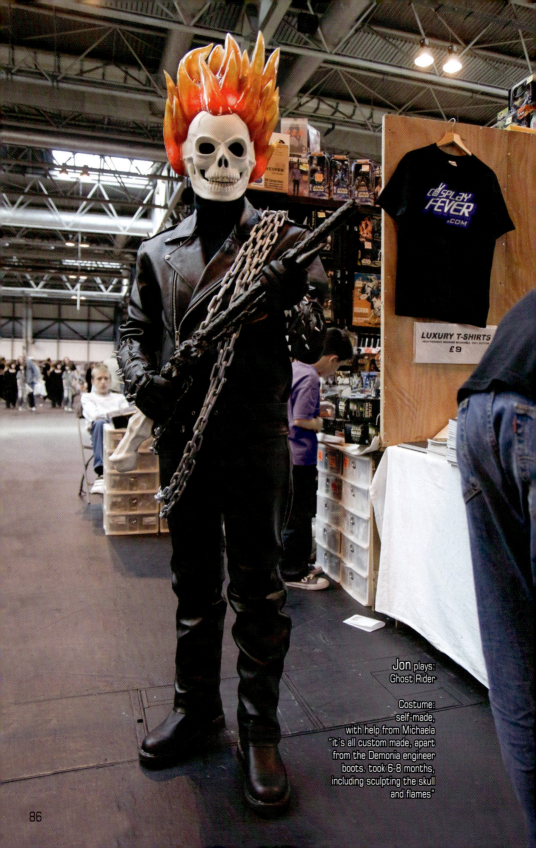

LUXURY T-SHIRTS
HEAVYWEIGHT, MACHINE WASHABLE, 100% COTTON
£9

Jon plays:
Ghost Rider

Costume:
self-made,
with help from Michaela
"it's all custom made, apart
from the Demonia engineer
boots. took 6-8 months,
including sculpting the skull
and flames"

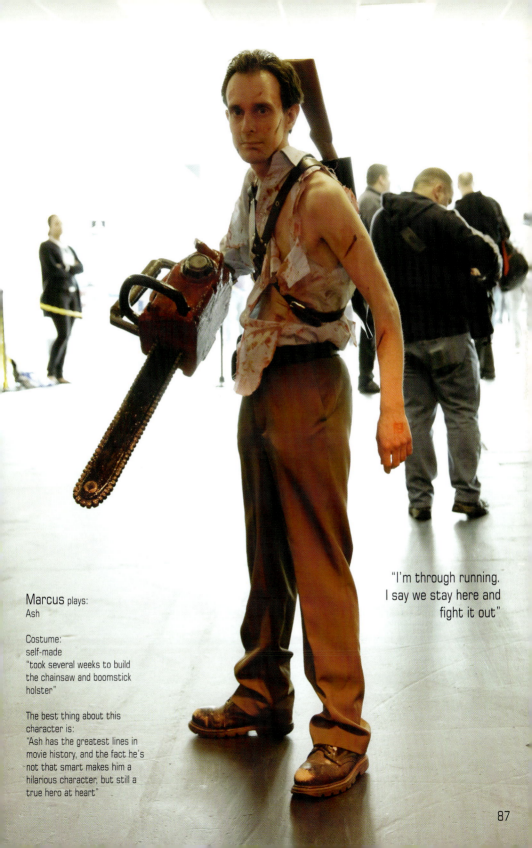

Marcus plays:
Ash

Costume:
self-made
"took several weeks to build
the chainsaw and boomstick
holster"

The best thing about this
character is:
"Ash has the greatest lines in
movie history, and the fact he's
not that smart makes him a
hilarious character, but still a
true hero at heart"

"I'm through running.
I say we stay here and
fight it out"

87

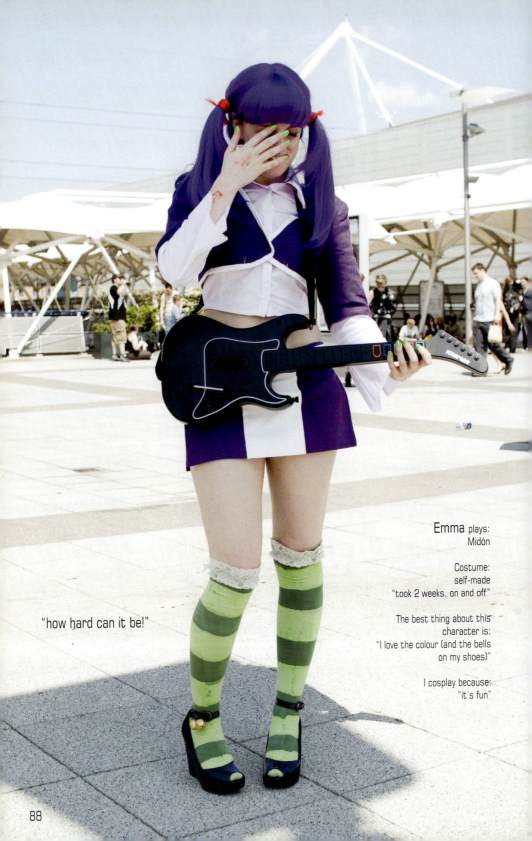

"how hard can it be!"

Emma plays:
Midón

Costume:
self-made
"took 2 weeks, on and off"

The best thing about this
character is:
"I love the colour (and the bells
on my shoes)"

I cosplay because:
"it's fun"

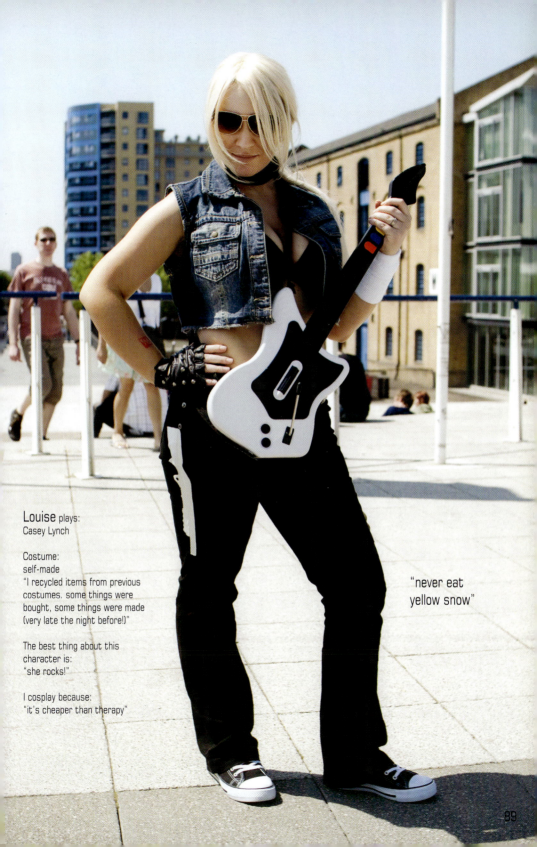

Louise plays:
Casey Lynch

Costume:
self-made
"I recycled items from previous
costumes. some things were
bought, some things were made
(very late the night before!)"

The best thing about this
character is:
"she rocks!"

I cosplay because:
"it's cheaper than therapy"

"never eat
yellow snow"

89

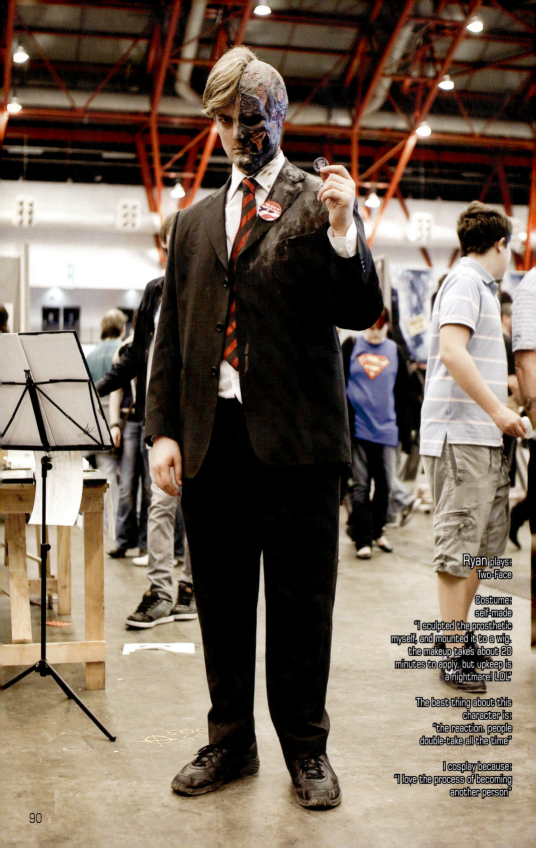

Ryan plays:
Two-Face

Costume:
self-made
"I sculpted the prosthetic
myself, and mounted it to a wig.
the makeup takes about 20
minutes to apply, but upkeep is
a nightmare! LOL"

The best thing about this
character is:
"the reaction. people
double-take all the time"

I cosplay because:
"I love the process of becoming
another person"

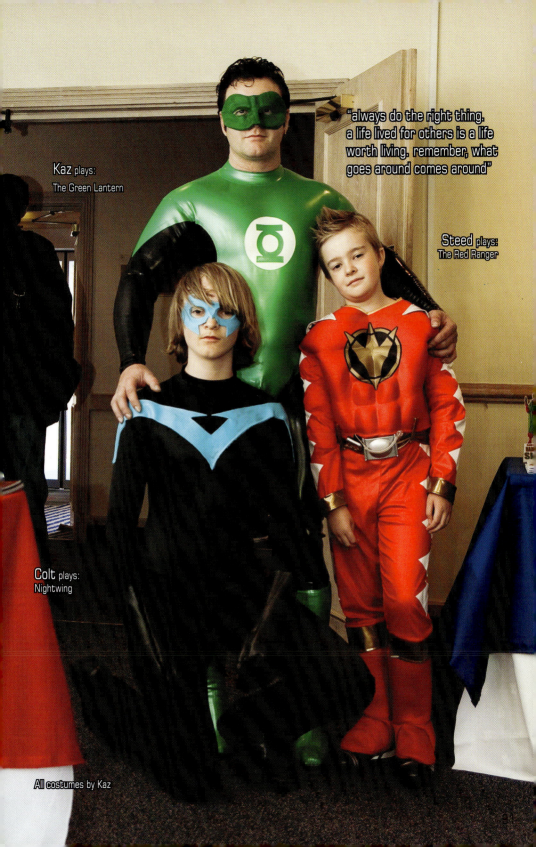

Kaz plays:
The Green Lantern

"always do the right thing.
a life lived for others is a life
worth living. remember, what
goes around comes around"

Steed plays:
The Red Ranger

Colt plays:
Nightwing

All costumes by Kaz

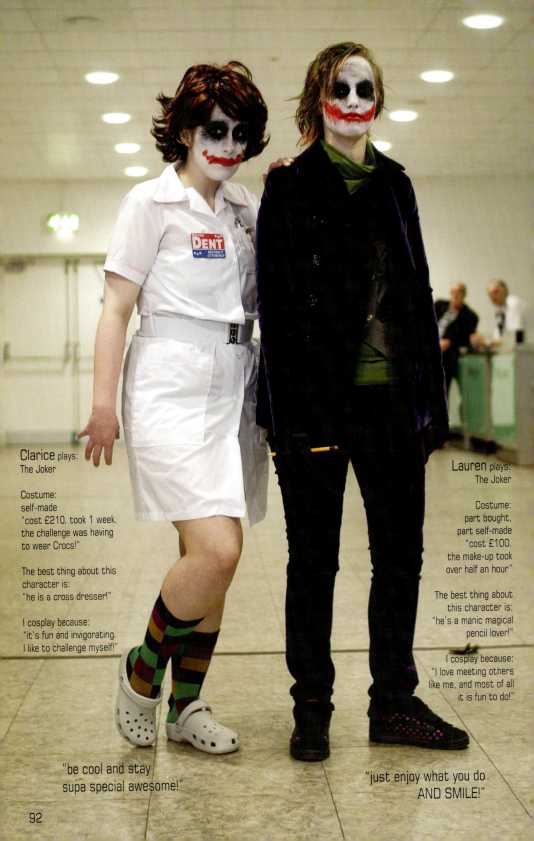

Clarice plays:
The Joker

Costume:
self-made
"cost £210. took 1 week.
the challenge was having
to wear Crocs!"

The best thing about this
character is:
"he is a cross dresser!"

I cosplay because:
"it's fun and invigorating.
I like to challenge myself!"

Lauren plays:
The Joker

Costume:
part bought,
part self-made
"cost £100.
the make-up took
over half an hour"

The best thing about
this character is:
"he's a manic magical
pencil lover!"

I cosplay because:
"I love meeting others
like me, and most of all
it is fun to do!"

"be cool and stay
supa special awesome!"

"just enjoy what you do
AND SMILE!"

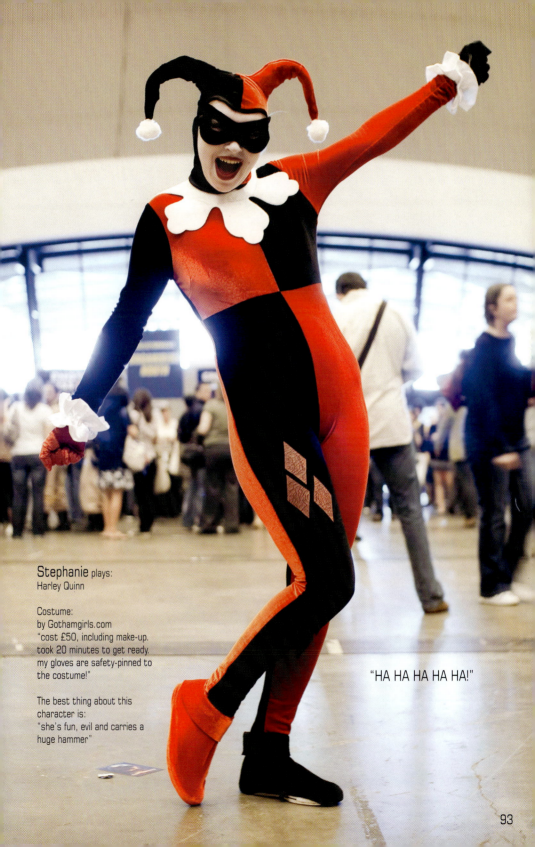

Stephanie plays:
Harley Quinn

Costume:
by Gothamgirls.com
"cost £50, including make-up.
took 20 minutes to get ready.
my gloves are safety-pinned to
the costume!"

The best thing about this
character is:
"she's fun, evil and carries a
huge hammer"

"HA HA HA HA HA!"

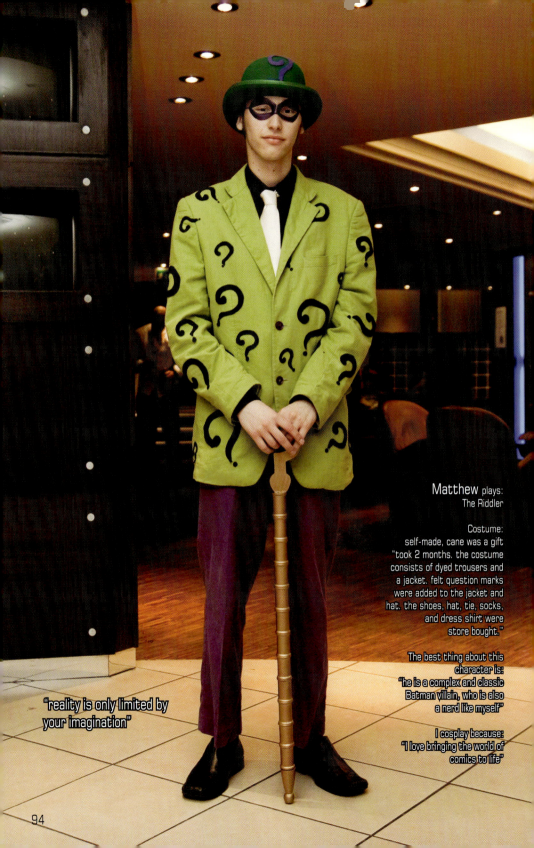

Matthew plays:
The Riddler

Costume:
self-made, cane was a gift
"took 2 months. the costume
consists of dyed trousers and
a jacket. felt question marks
were added to the jacket and
hat. the shoes, hat, tie, socks,
and dress shirt were
store bought."

The best thing about this
character is:
"he is a complex and classic
Batman villain, who is also
a nerd like myself"

I cosplay because:
"I love bringing the world of
comics to life"

"reality is only limited by
your imagination"

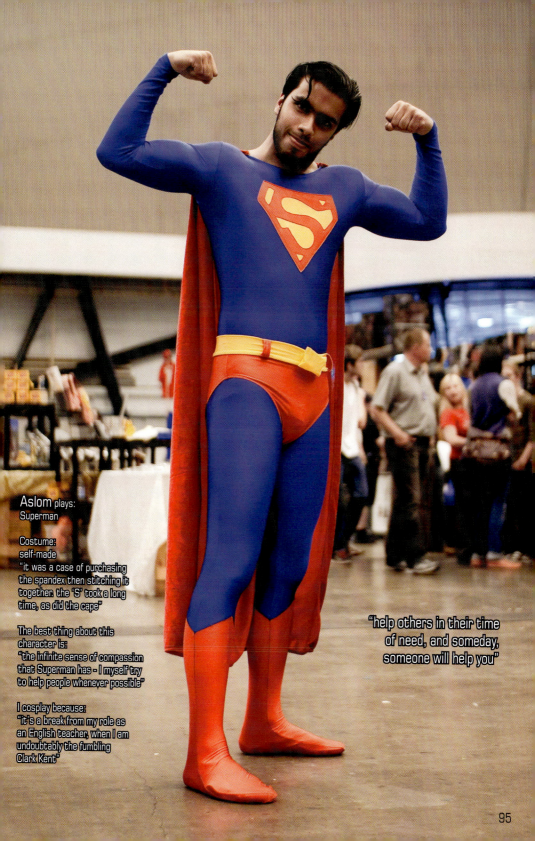

Aslom plays:
Superman

Costume:
self-made
"it was a case of purchasing the spandex then stitching it together. the 'S' took a long time, as did the cape"

The best thing about this character is:
"the infinite sense of compassion that Superman has - I myself try to help people whenever possible"

I cosplay because:
"it's a break from my role as an English teacher, when I am undoubtably the fumbling Clark Kent"

"help others in their time of need, and someday, someone will help you"

95

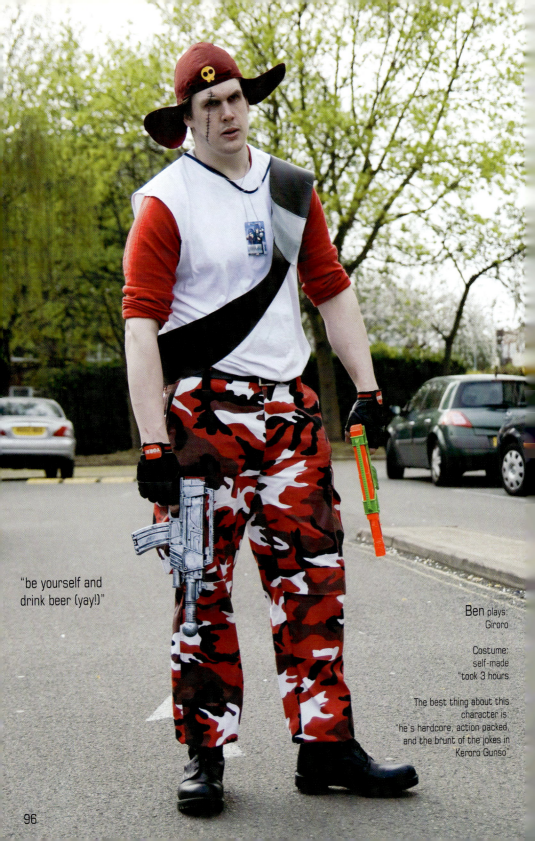

"be yourself and drink beer (yay!)"

Ben plays:
Giroro

Costume:
self-made
"took 3 hours

The best thing about this character is:
"he's hardcore, action packed, and the brunt of the jokes in Keroro Gunso"

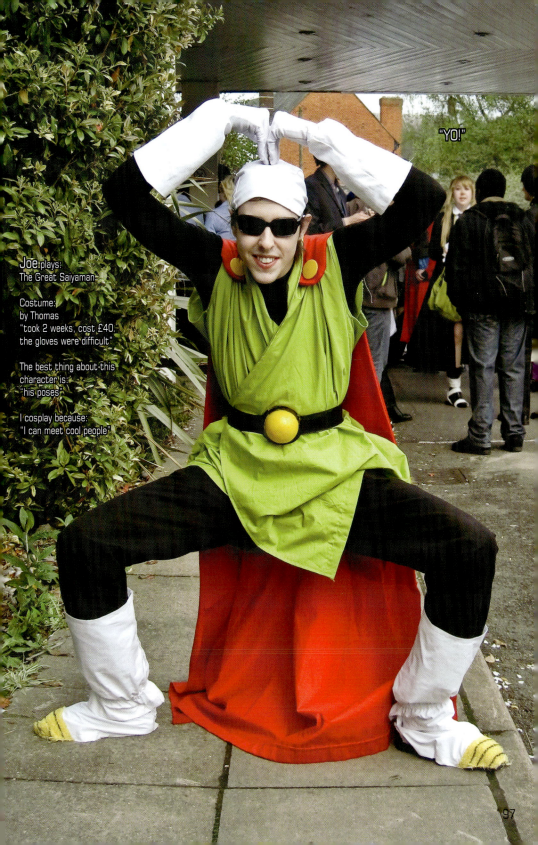

"YO!"

Joe plays:
The Great Saiyaman

Costume:
by Thomas
"took 2 weeks, cost £40.
the gloves were difficult"

The best thing about this
character is:
"his poses"

I cosplay because:
"I can meet cool people"

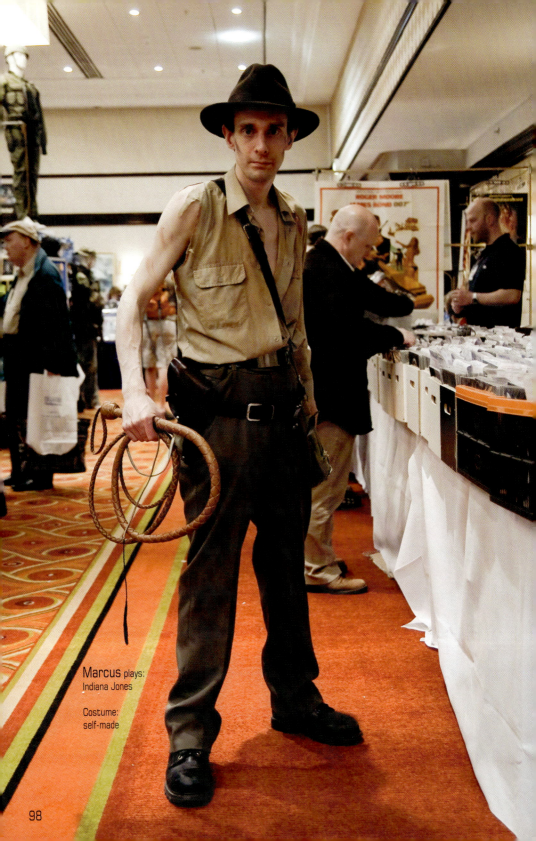

Marcus plays:
Indiana Jones

Costume:
self-made

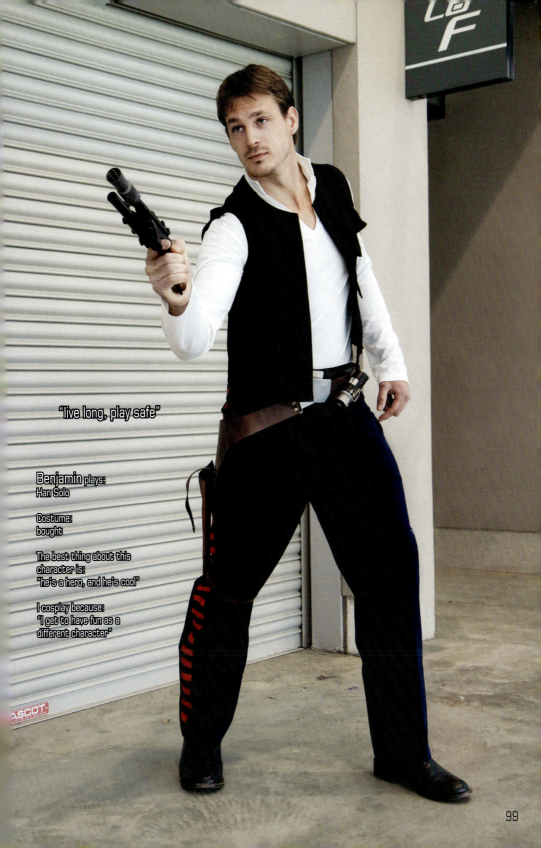

"live long, play safe"

Benjamin plays:
Han Solo

Costume:
bought

The best thing about this
character is:
"he's a hero, and he's cool"

I cosplay because:
"I get to have fun as a
different character"

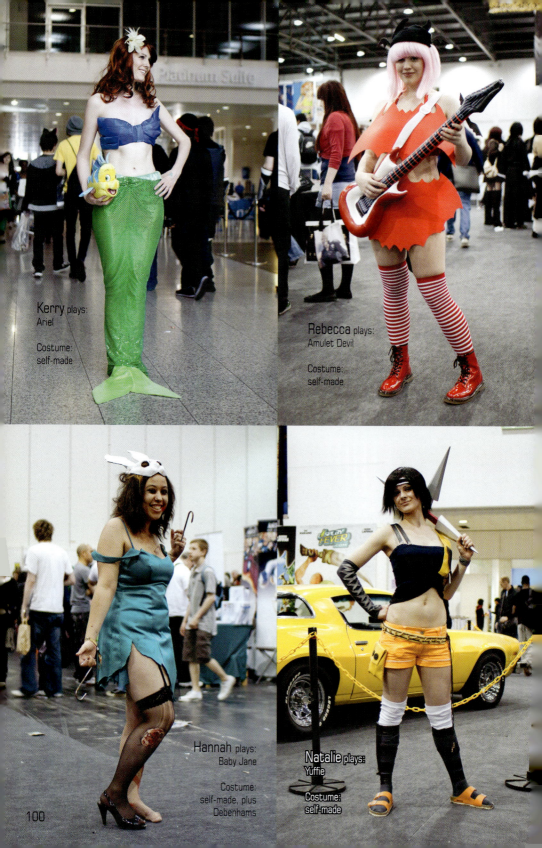

Kerry plays:
Ariel

Costume:
self-made

Rebecca plays:
Amulet Devil

Costume:
self-made

Hannah plays:
Baby Jane

Costume:
self-made, plus
Debenhams

Natalie plays:
Yuffie

Costume:
self-made

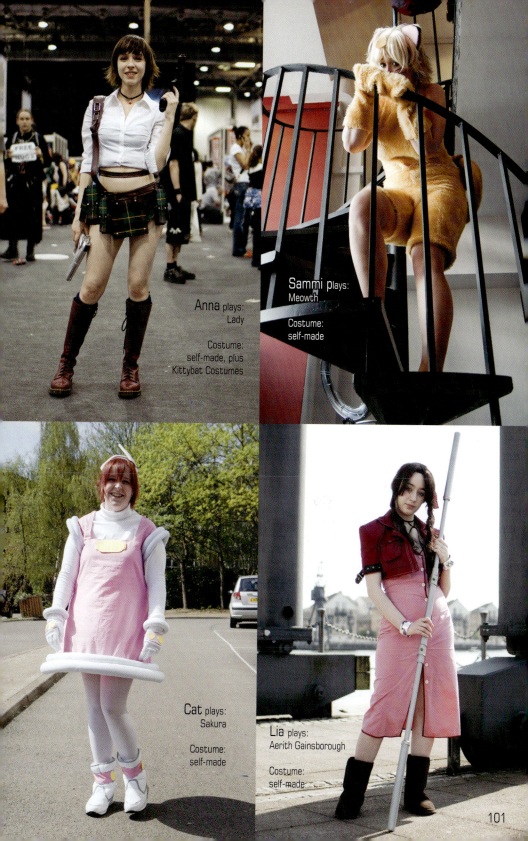

Anna plays:
Lady

Costume:
self-made, plus
Kittybat Costumes

Sammi plays:
Meowth

Costume:
self-made

Cat plays:
Sakura

Costume:
self-made

Lia plays:
Aerith Gainsborough

Costume:
self-made

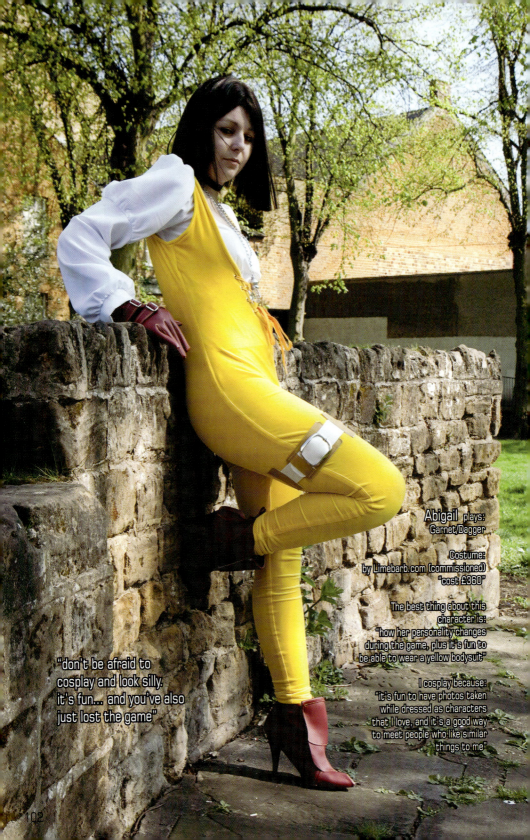

Abigail **plays:**
Garnet/Dagger

Costume:
by Limebarb.com (commissioned)
"cost £360"

The best thing about this
character is:
"how her personality changes
during the game, plus it's fun to
be able to wear a yellow bodysuit"

I cosplay because:
"it's fun to have photos taken
while dressed as characters
that I love, and it's a good way
to meet people who like similar
things to me"

"don't be afraid to
cosplay and look silly.
it's fun... and you've also
just lost the game"

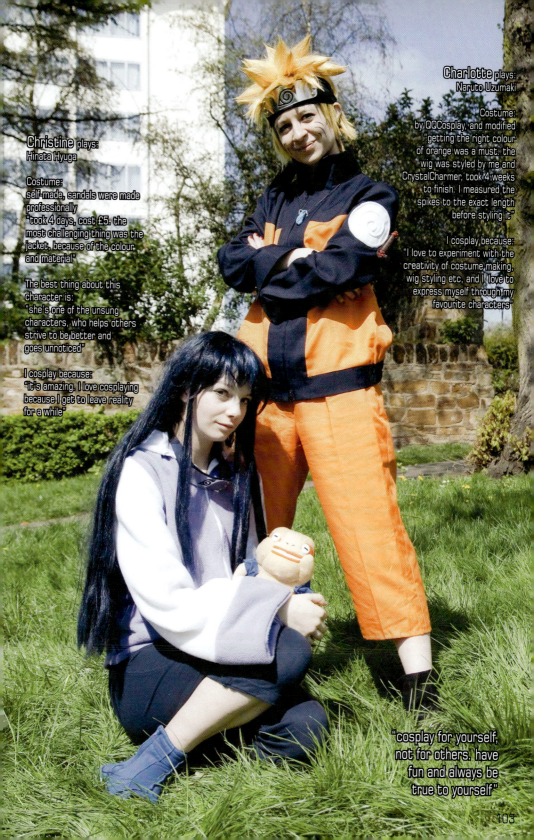

Christine plays:
Hinata Hyuga

Costume:
self-made, sandals were made professionally
"took 4 days, cost £5. the most challenging thing was the jacket, because of the colour and material"

The best thing about this character is:
"she's one of the unsung characters, who helps others strive to be better and goes unnoticed"

I cosplay because:
"it's amazing. I love cosplaying because I get to leave reality for a while"

Charlotte plays:
Naruto Uzumaki

Costume:
by QQCosplay, and modified
"getting the right colour of orange was a must. the wig was styled by me and CrystalCharmer, took 4 weeks to finish. I measured the spikes to the exact length before styling it"

I cosplay because:
"I love to experiment with the creativity of costume making, wig styling etc, and I love to express myself through my favourite characters"

"cosplay for yourself, not for others. have fun and always be true to yourself"

103

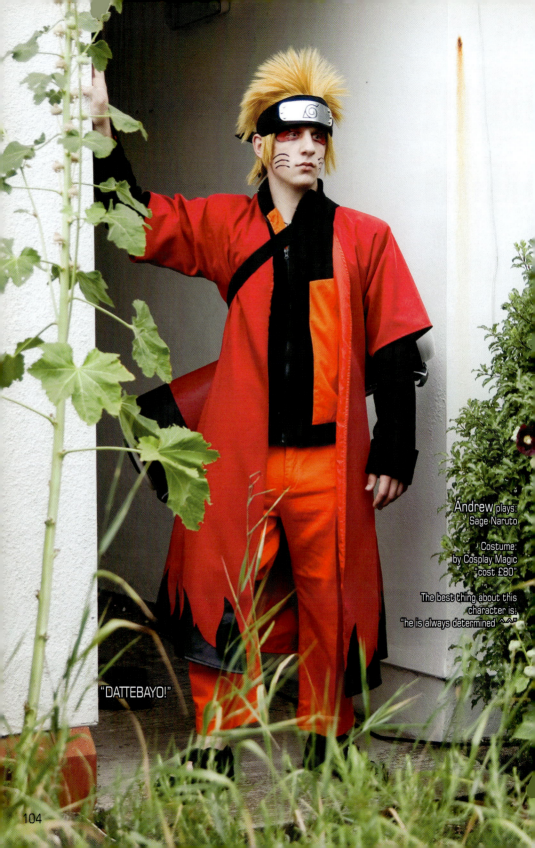

Andrew plays:
Sage Naruto

Costume:
by Cosplay Magic
"cost £80"

The best thing about this
character is:
"he is always determined ^_^"

"DATTEBAYO!"

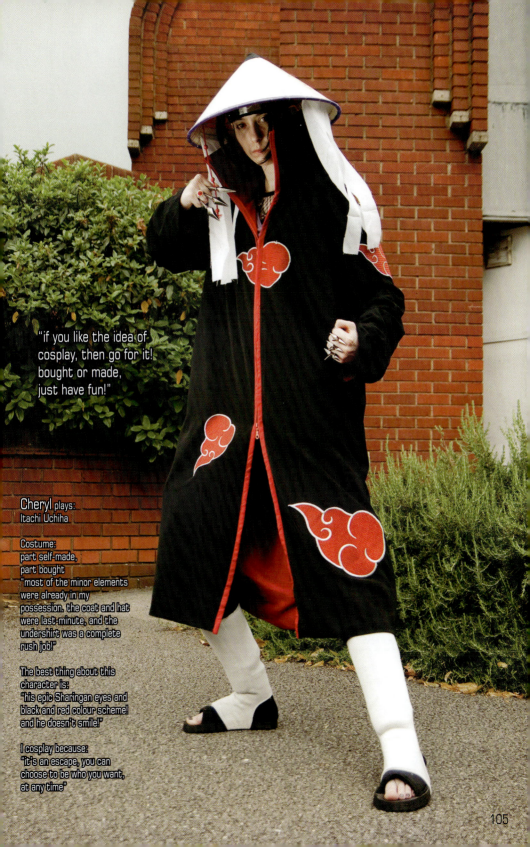

"if you like the idea of cosplay, then go for it! bought or made, just have fun!"

Cheryl plays:
Itachi Uchiha

Costume:
part self-made,
part bought
"most of the minor elements were already in my possession. the coat and hat were last-minute, and the undershirt was a complete rush job!"

The best thing about this character is:
"his epic Sharingan eyes and black and red colour scheme! and he doesn't smile!"

I cosplay because:
"it's an escape, you can choose to be who you want, at any time"

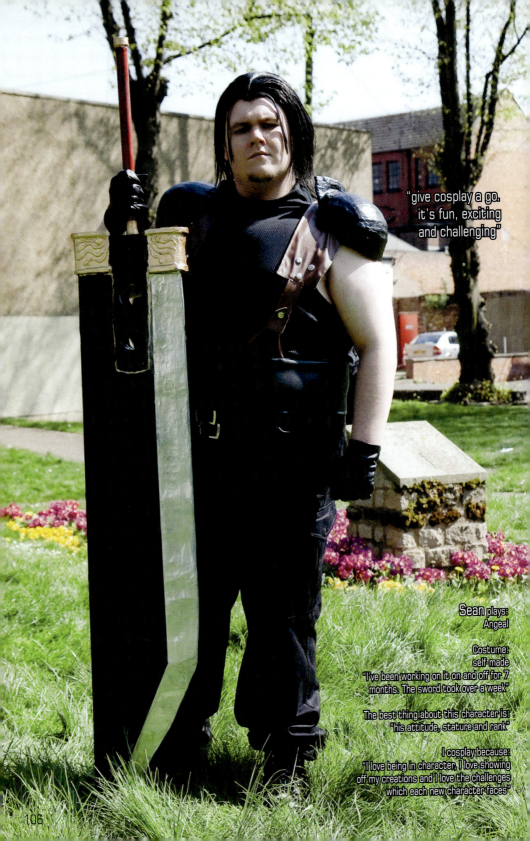

"give cosplay a go.
it's fun, exciting
and challenging"

Sean plays:
Angeal

Costume:
self-made
"I've been working on it on and off for 7
months. The sword took over a week"

The best thing about this character is:
"his attitude, stature and rank"

I cosplay because:
"I love being in character, I love showing
off my creations and I love the challenges
which each new character faces"

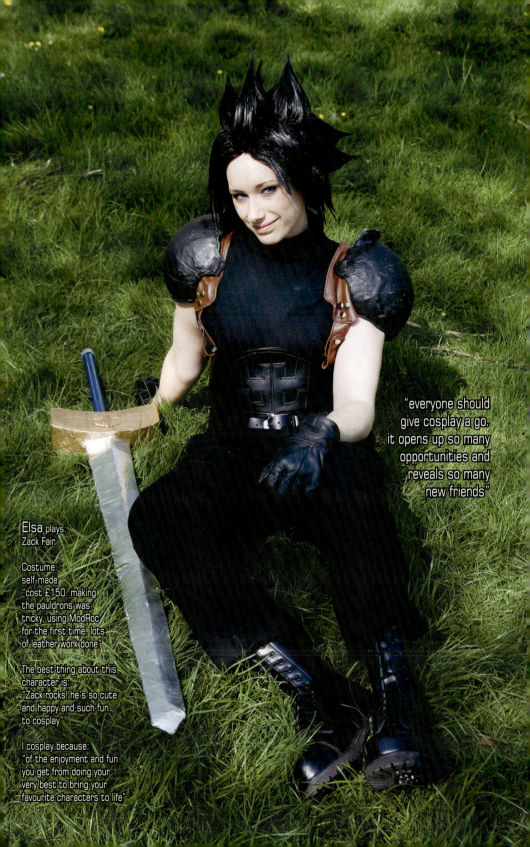

"everyone should give cosplay a go. it opens up so many opportunities and reveals so many new friends"

Elsa plays:
Zack Fair

Costume:
self-made
"cost £150. making
the pauldrons was
tricky, using ModRoc
for the first time. lots
of leather work done"

The best thing about this
character is:
"Zack rocks! he's so cute
and happy and such fun
to cosplay"

I cosplay because:
"of the enjoyment and fun
you get from doing your
very best to bring your
favourite characters to life"

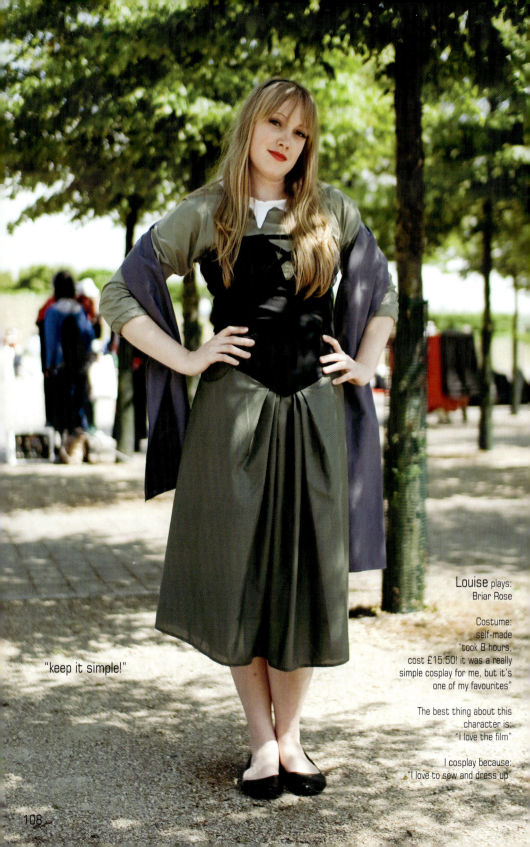

"keep it simple!"

Louise plays:
Briar Rose

Costume:
self-made
"took 8 hours,
cost £15.50! it was a really
simple cosplay for me, but it's
one of my favourites"

The best thing about this
character is:
"I love the film"

I cosplay because:
"I love to sew and dress up"

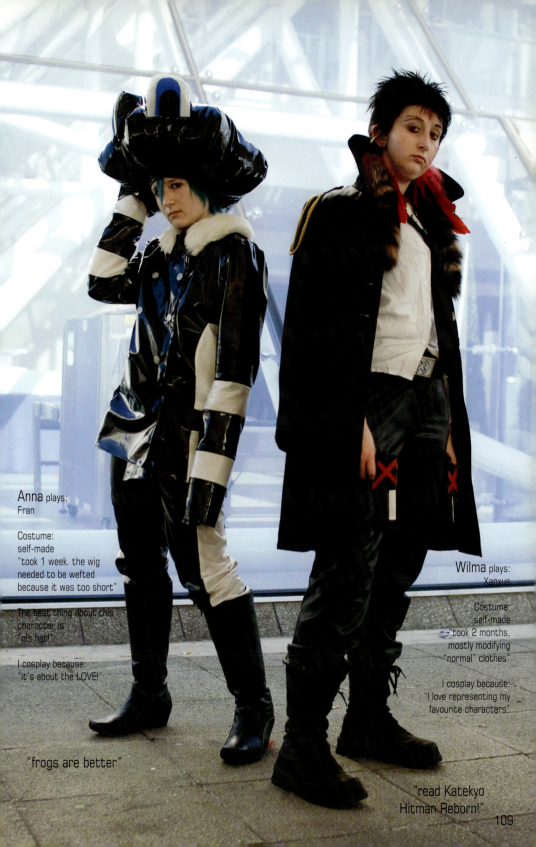

Anna plays:
Fran

Costume:
self-made
"took 1 week. the wig
needed to be wefted
because it was too short"

The best thing about this
character is:
"his hat!"

I cosplay because:
"it's about the LOVE!"

"frogs are better"

Wilma plays:
Xanxus

Costume:
self-made
"took 2 months,
mostly modifying
"normal" clothes"

I cosplay because:
"I love representing my
favourite characters"

"read Katekyo
Hitman Reborn!"

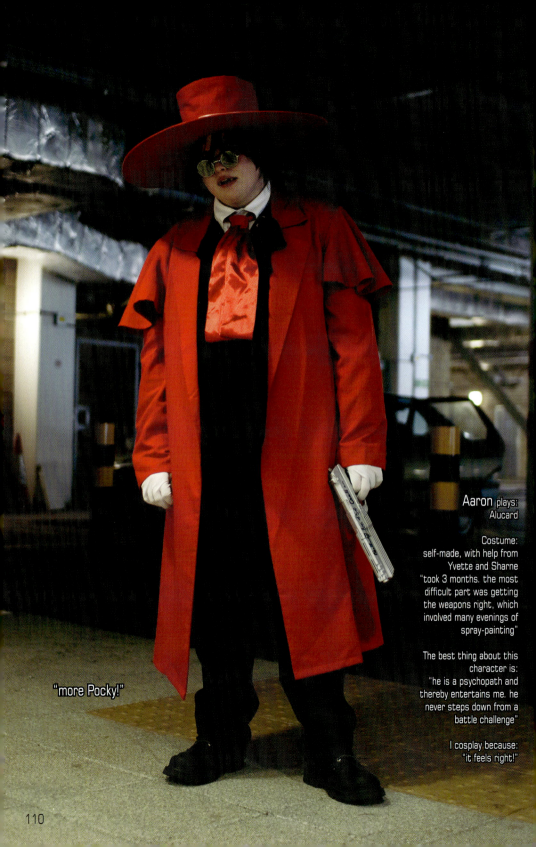

Aaron plays:
Alucard

Costume:
self-made, with help from
Yvette and Sharne
"took 3 months. the most
difficult part was getting
the weapons right, which
involved many evenings of
spray-painting"

The best thing about this
character is:
"he is a psychopath and
thereby entertains me. he
never steps down from a
battle challenge"

I cosplay because:
"it feels right!"

"more Pocky!"

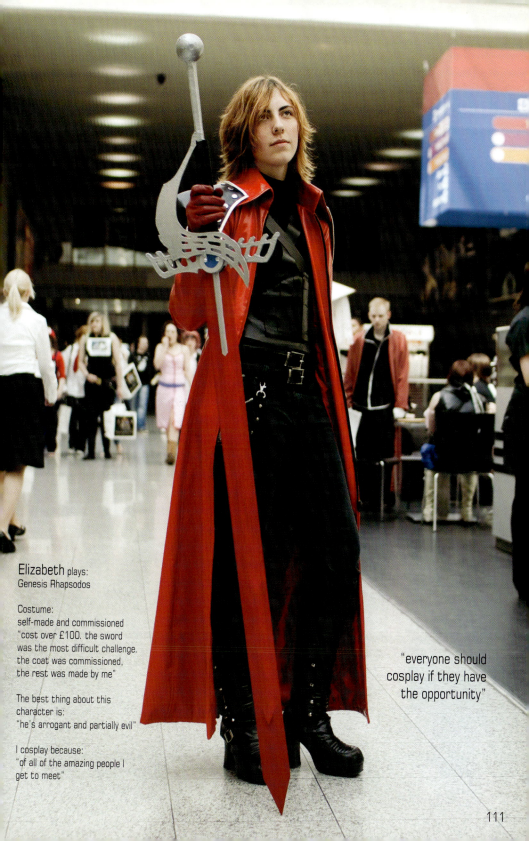

Elizabeth plays:
Genesis Rhapsodos

Costume:
self-made and commissioned
"cost over £100. the sword
was the most difficult challenge.
the coat was commissioned,
the rest was made by me"

The best thing about this
character is:
"he's arrogant and partially evil"

I cosplay because:
"of all of the amazing people I
get to meet"

"everyone should
cosplay if they have
the opportunity"

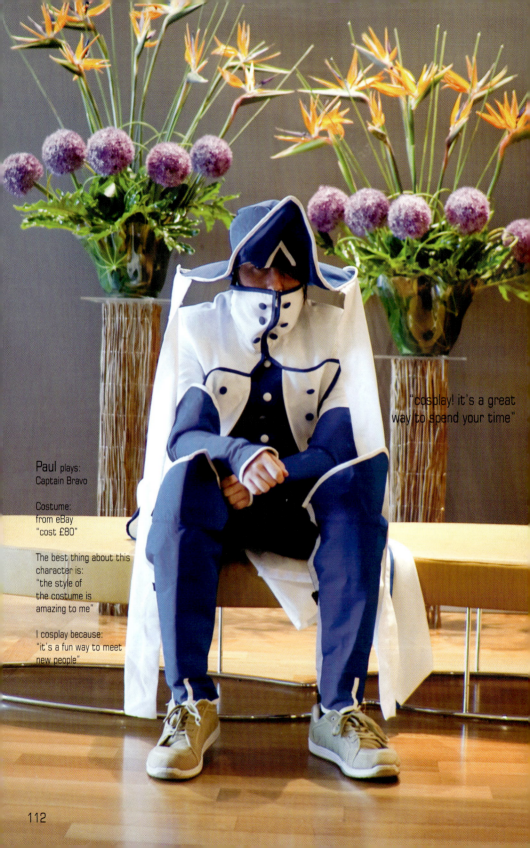

"cosplay! it's a great way to spend your time"

Paul plays:
Captain Bravo

Costume:
from eBay
"cost £80"

The best thing about this character is:
"the style of the costume is amazing to me"

I cosplay because:
"it's a fun way to meet new people"

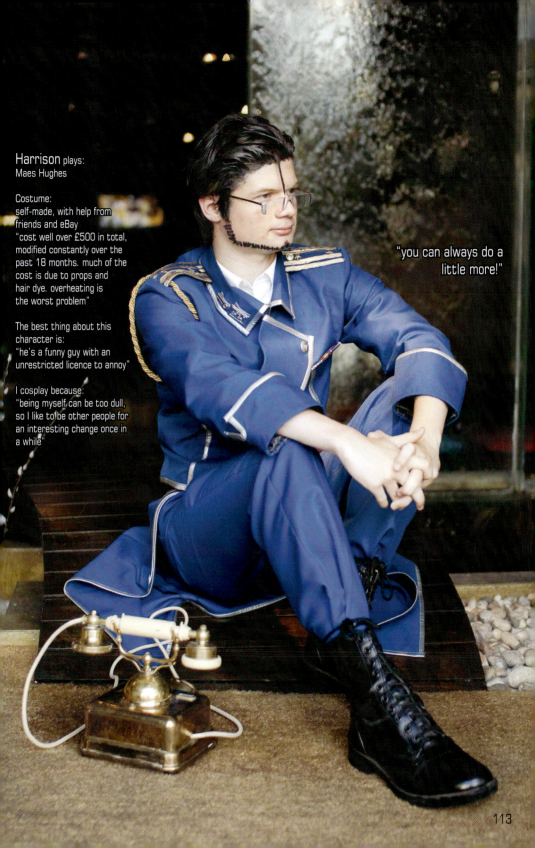

Harrison plays:
Maes Hughes

Costume:
self-made, with help from
friends and eBay
"cost well over £500 in total,
modified constantly over the
past 18 months. much of the
cost is due to props and
hair dye. overheating is
the worst problem"

The best thing about this
character is:
"he's a funny guy with an
unrestricted licence to annoy"

I cosplay because:
"being myself can be too dull,
so I like to be other people for
an interesting change once in
a while"

"you can always do a
little more!"

113

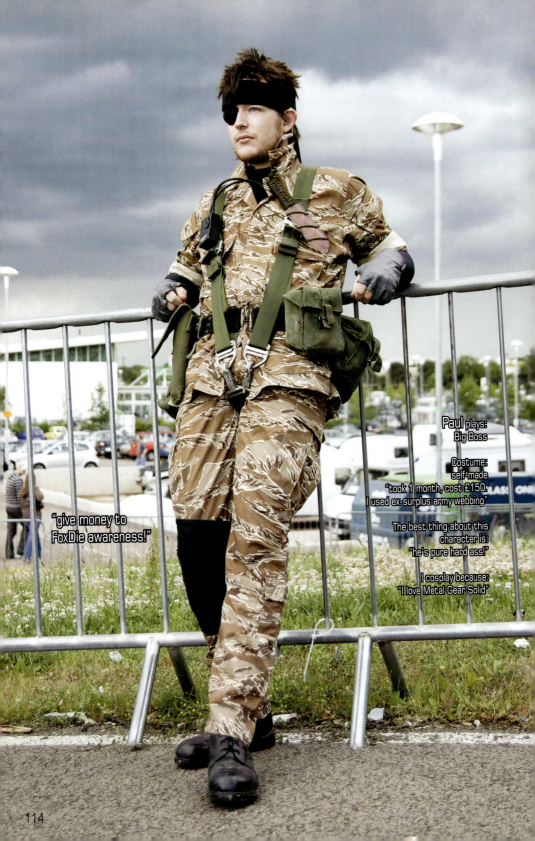

Paul plays:
Big Boss

Costume:
self-made
"took 1 month, cost £150.
I used ex-surplus army webbing"

The best thing about this
character is:
"he's pure hard ass!"

I cosplay because:
"I love Metal Gear Solid"

"give money to
FoxDie awareness!"

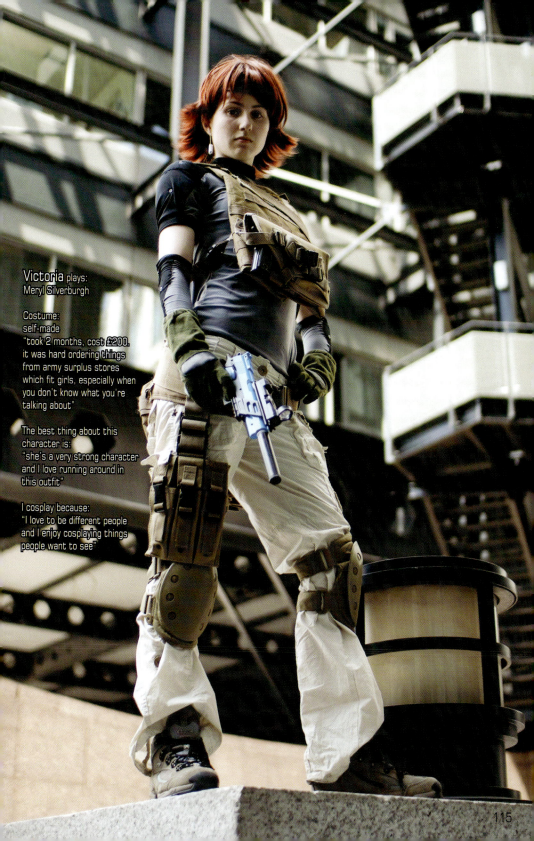

Victoria plays:
Meryl Silverburgh

Costume:
self-made
"took 2 months, cost £200.
it was hard ordering things
from army surplus stores
which fit girls, especially when
you don't know what you're
talking about"

The best thing about this
character is:
"she's a very strong character
and I love running around in
this outfit"

I cosplay because:
"I love to be different people
and I enjoy cosplaying things
people want to see"

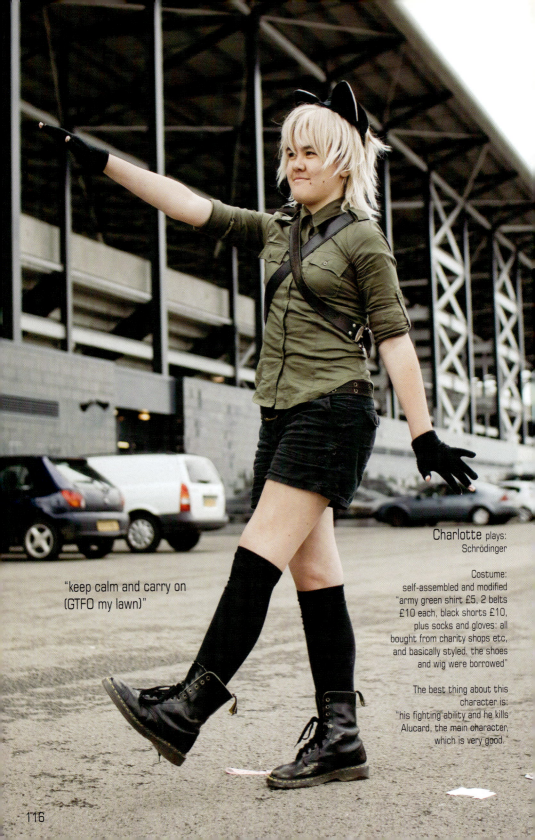

Charlotte plays:
Schrödinger

Costume:
self-assembled and modified
"army green shirt £5, 2 belts
£10 each, black shorts £10,
plus socks and gloves: all
bought from charity shops etc,
and basically styled. the shoes
and wig were borrowed"

The best thing about this
character is:
"his fighting ability and he kills
Alucard, the main character,
which is very good."

"keep calm and carry on
(GTFO my lawn)"

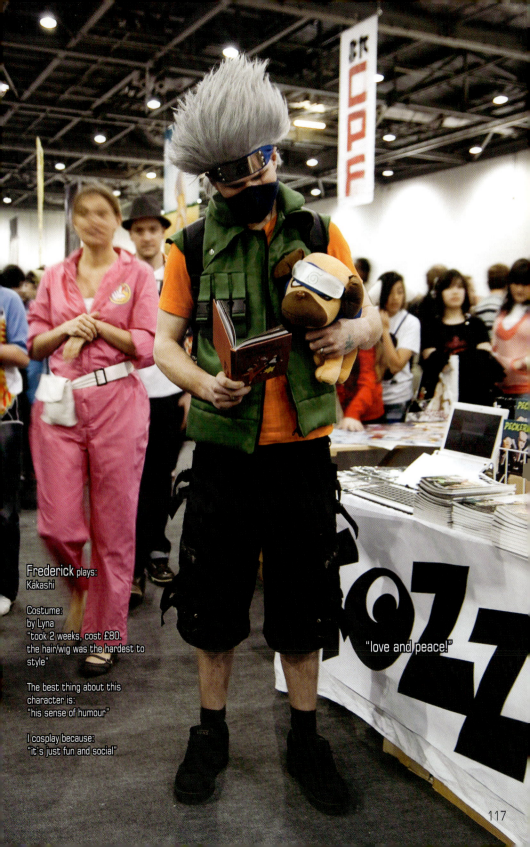

Frederick plays:
Kakashi

Costume:
by Lyna
"took 2 weeks, cost £80.
the hair/wig was the hardest to
style"

The best thing about this
character is:
"his sense of humour"

I cosplay because:
"it's just fun and social"

"love and peace!"

117

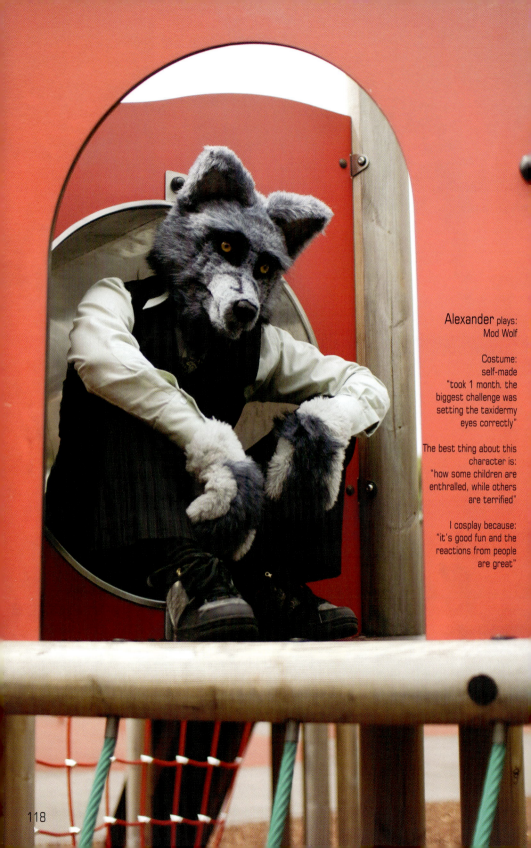

Alexander plays:
Mod Wolf

Costume:
self-made
"took 1 month. the
biggest challenge was
setting the taxidermy
eyes correctly"

The best thing about this
character is:
"how some children are
enthralled, while others
are terrified"

I cosplay because:
"it's good fun and the
reactions from people
are great"

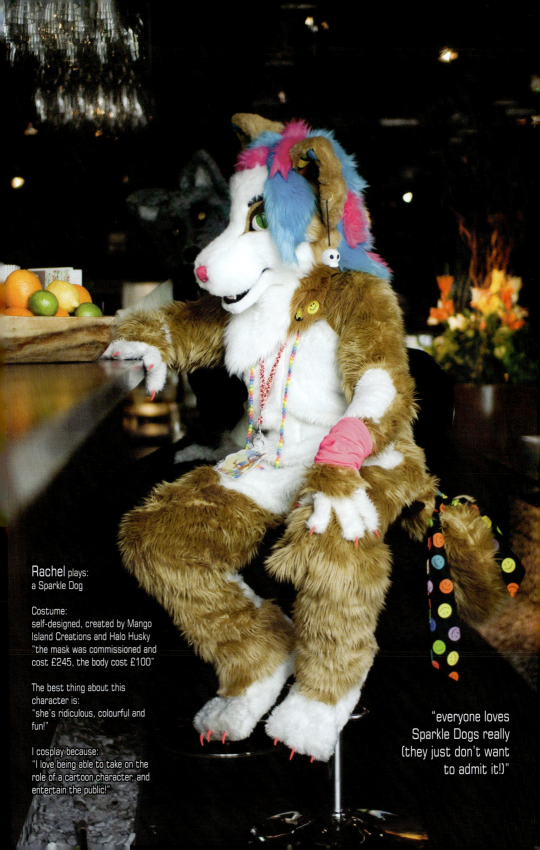

Rachel plays:
a Sparkle Dog

Costume:
self-designed, created by Mango
Island Creations and Halo Husky
"the mask was commissioned and
cost £245, the body cost £100"

The best thing about this
character is:
"she's ridiculous, colourful and
fun!"

I cosplay because:
"I love being able to take on the
role of a cartoon character, and
entertain the public!"

"everyone loves
Sparkle Dogs really
(they just don't want
to admit it!)"

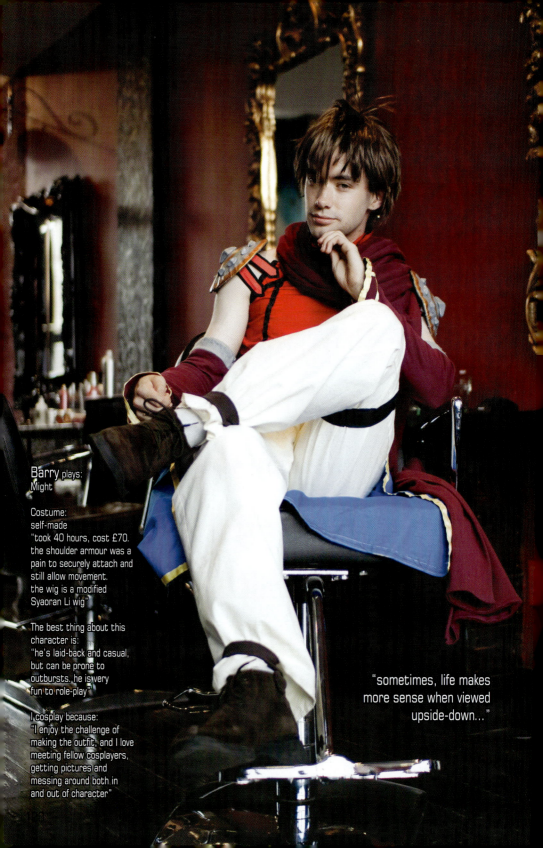

Barry plays:
Might

Costume:
self-made
"took 40 hours, cost £70.
the shoulder armour was a
pain to securely attach and
still allow movement.
the wig is a modified
Syaoran Li wig"

The best thing about this
character is:
"he's laid-back and casual,
but can be prone to
outbursts. he is very
fun to role-play"

I cosplay because:
"I enjoy the challenge of
making the outfit, and I love
meeting fellow cosplayers,
getting pictures and
messing around both in
and out of character"

"sometimes, life makes
more sense when viewed
upside-down..."

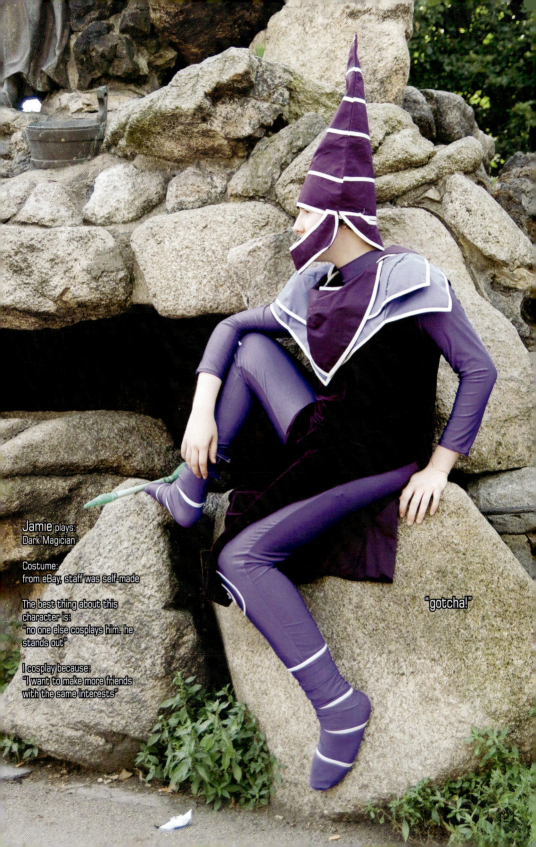

Jamie plays:
Dark Magician

Costume:
from eBay, staff was self-made

The best thing about this
character is:
"no one else cosplays him. he
stands out"

I cosplay because:
"I want to make more friends
with the same interests"

"gotcha!"

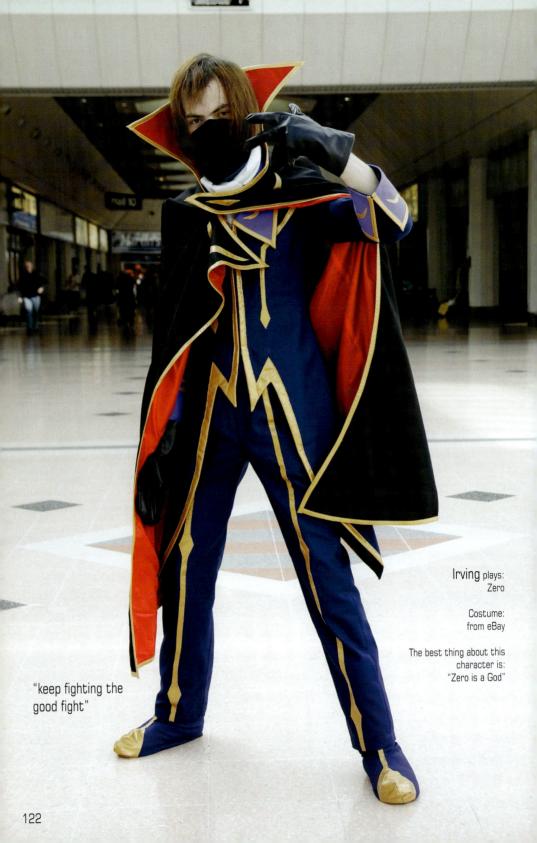

Irving plays:
Zero

Costume:
from eBay

The best thing about this
character is:
"Zero is a God"

"keep fighting the
good fight"

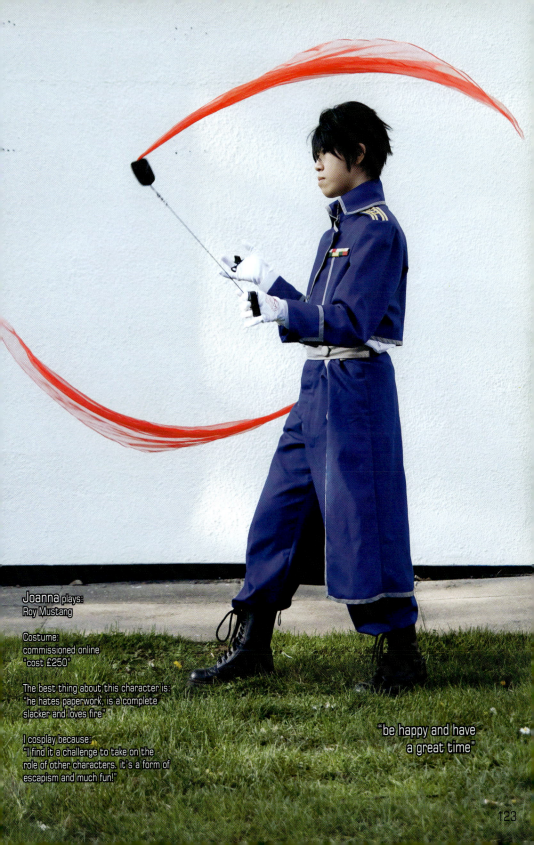

Joanna plays:
Roy Mustang

Costume:
commissioned online
"cost £250"

The best thing about this character is:
"he hates paperwork, is a complete
slacker and loves fire"

I cosplay because:
"I find it a challenge to take on the
role of other characters. it's a form of
escapism and much fun!"

"be happy and have
a great time"

123

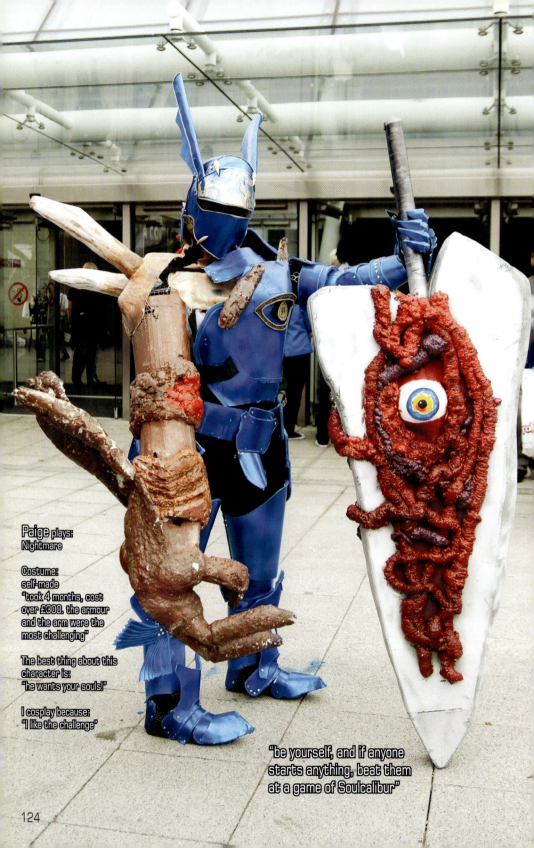

Paige plays:
Nightmare

Costume:
self-made
"took 4 months, cost
over £300. the armour
and the arm were the
most challenging"

The best thing about this
character is:
"he wants your souls!"

I cosplay because:
"I like the challenge"

"be yourself, and if anyone
starts anything, beat them
at a game of Soulcalibur"

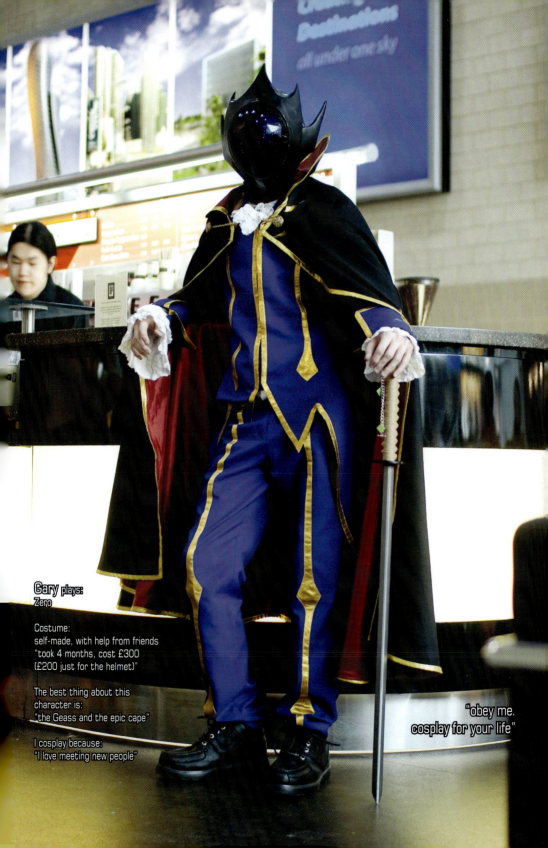

Gary plays:
Zero

Costume:
self-made, with help from friends
"took 4 months, cost £300
(£200 just for the helmet)"

The best thing about this
character is:
"the Geass and the epic cape"

I cosplay because:
"I love meeting new people"

"obey me.
cosplay for your life"

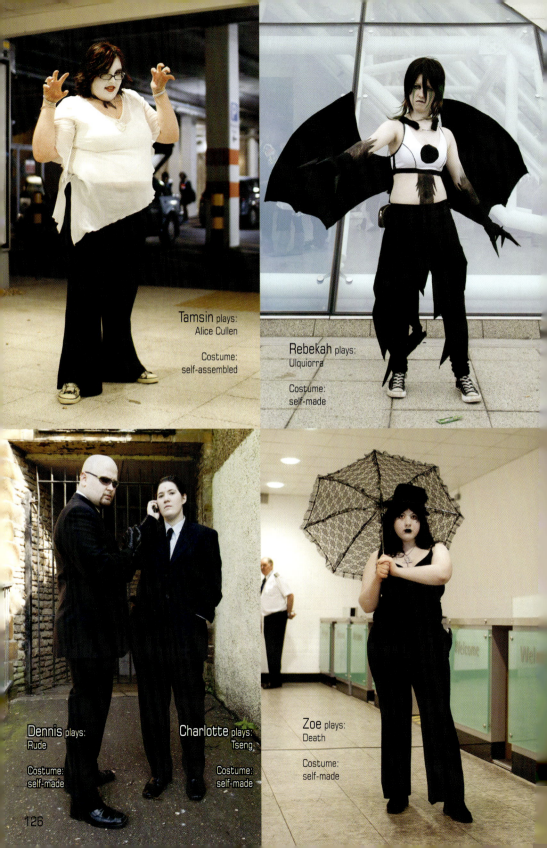

Tamsin plays:
Alice Cullen

Costume:
self-assembled

Rebekah plays:
Ulquiorra

Costume:
self-made

Dennis plays:
Rude

Costume:
self-made

Charlotte plays:
Tseng

Costume:
self-made

Zoe plays:
Death

Costume:
self-made

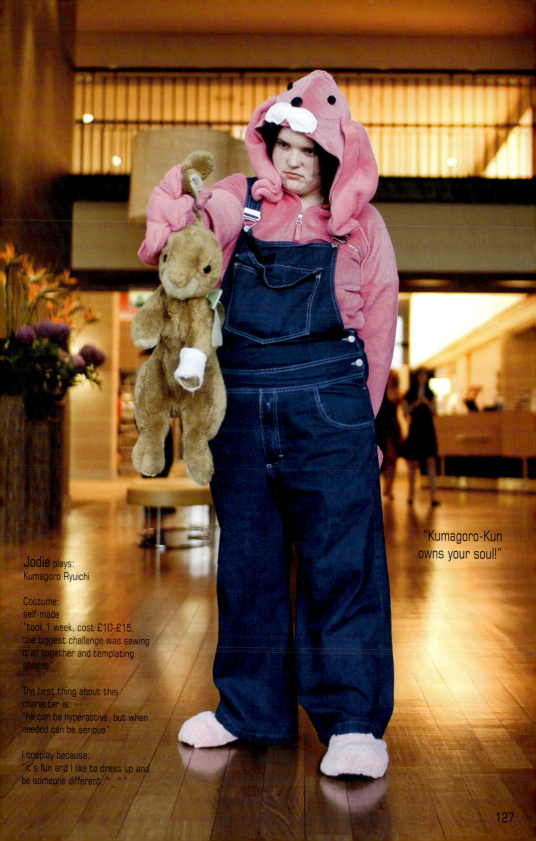

Jodie plays:
Kumagoro Ryuichi

Costume:
self-made
"took 1 week, cost £10-£15.
the biggest challenge was sewing
it all together and templating
shapes"

The best thing about this
character is:
"he can be hyperactive, but when
needed can be serious"

I cosplay because:
"it's fun and I like to dress up and
be someone different ^_^"

"Kumagoro-Kun
owns your soul!"

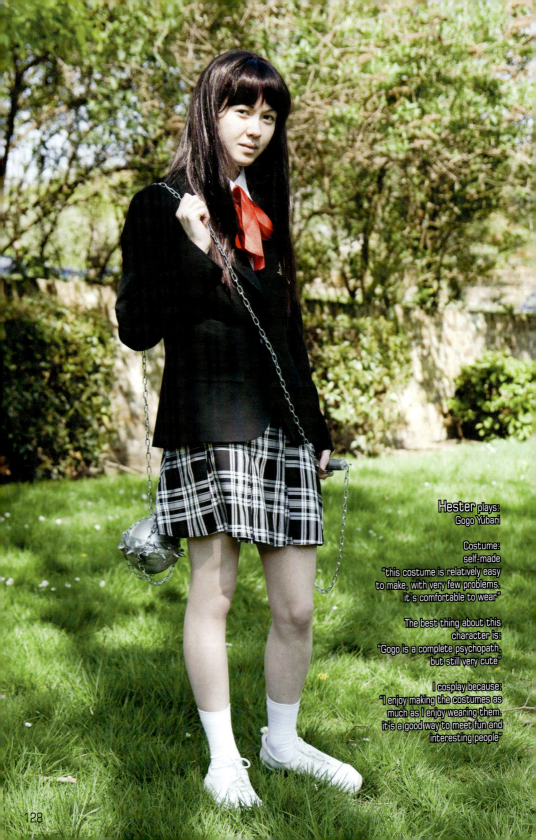

Hester plays:
Gogo Yubari

Costume:
self-made
"this costume is relatively easy
to make, with very few problems.
it's comfortable to wear"

The best thing about this
character is:
"Gogo is a complete psychopath,
but still very cute"

I cosplay because:
"I enjoy making the costumes as
much as I enjoy wearing them.
it's a good way to meet fun and
interesting people"

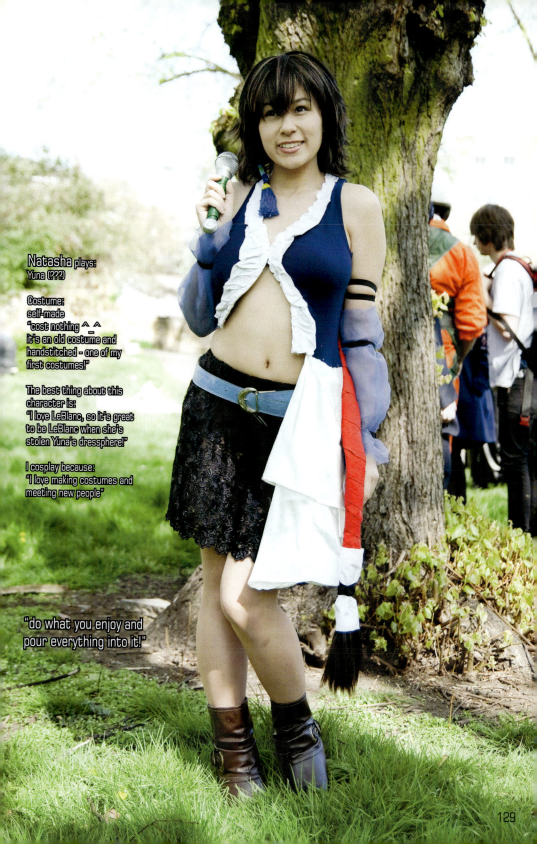

Natasha plays:
Yuna (???)

Costume:
self-made
"cost nothing ^_^
it's an old costume and
handstitched - one of my
first costumes!"

The best thing about this
character is:
"I love LeBlanc, so it's great
to be LeBlanc when she's
stolen Yuna's dressphere!"

I cosplay because:
"I love making costumes and
meeting new people"

"do what you enjoy and
pour everything into it!"

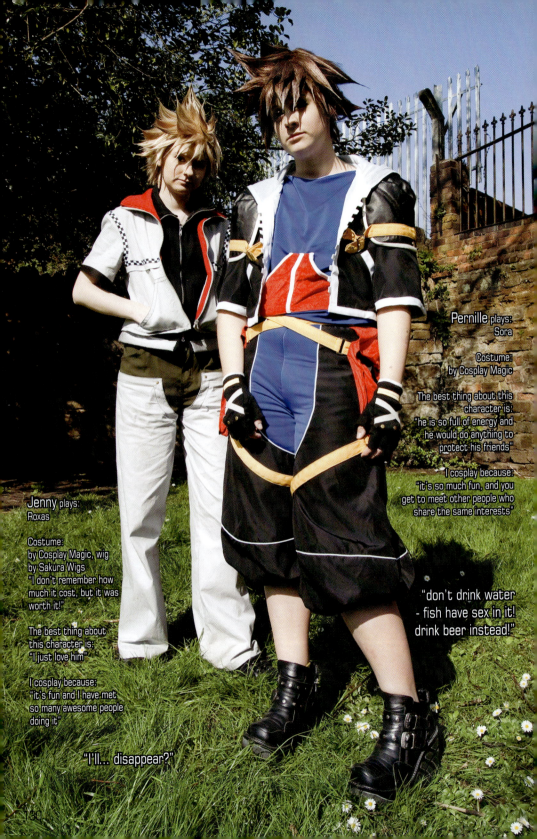

Pernille plays:
Sora

Costume:
by Cosplay Magic

The best thing about this character is:
"he is so full of energy and he would do anything to protect his friends"

I cosplay because:
"it's so much fun, and you get to meet other people who share the same interests"

Jenny plays:
Roxas

Costume:
by Cosplay Magic, wig by Sakura Wigs
"I don't remember how much it cost, but it was worth it!"

The best thing about this character is:
"I just love him"

I cosplay because:
"it's fun and I have met so many awesome people doing it"

"don't drink water
- fish have sex in it!
drink beer instead!"

"I'll... disappear?"

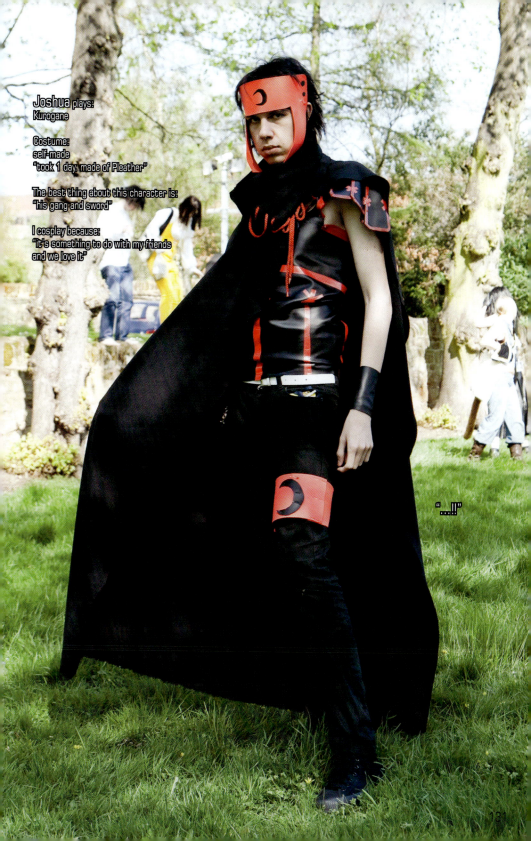

Joshua plays:
Kurogane

Costume:
self-made
"took 1 day, made of Pleather"

The best thing about this character is:
"his gang and sword"

I cosplay because:
"it's something to do with my friends
and we love it"

"⌐_⌐"

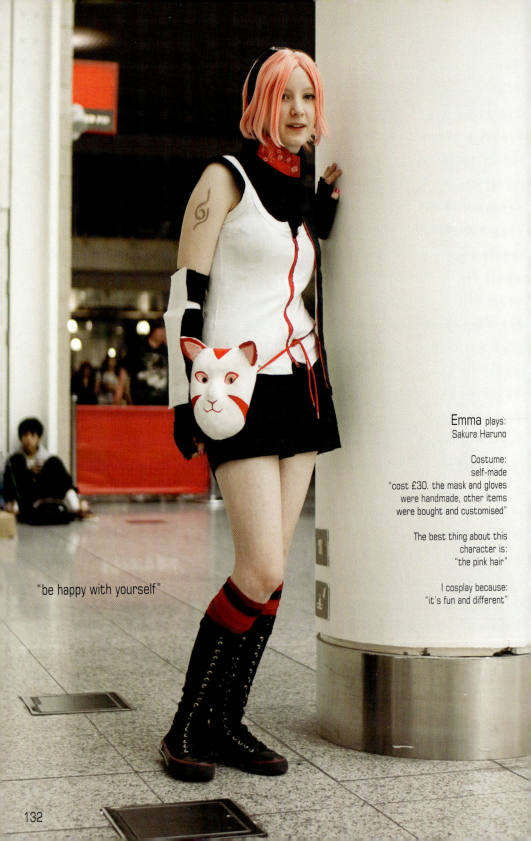

"be happy with yourself"

Emma plays:
Sakura Haruno

Costume:
self-made
"cost £30. the mask and gloves
were handmade, other items
were bought and customised"

The best thing about this
character is:
"the pink hair"

I cosplay because:
"it's fun and different"

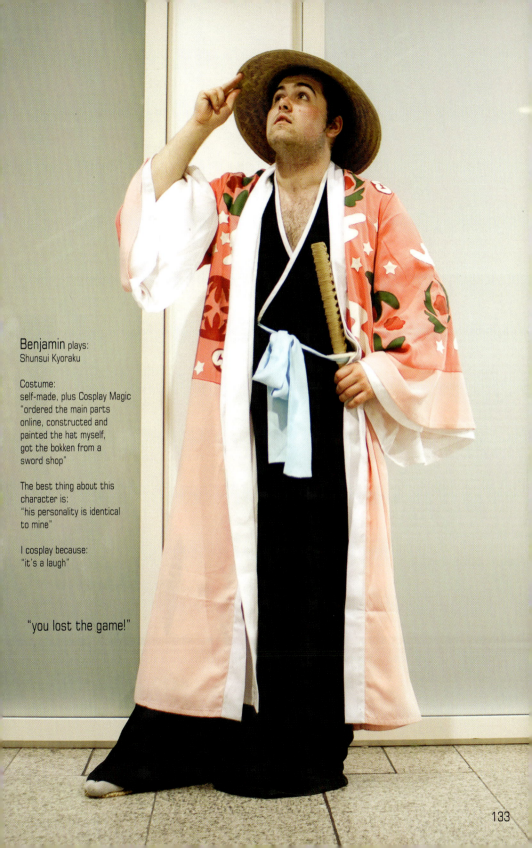

Benjamin plays:
Shunsui Kyoraku

Costume:
self-made, plus Cosplay Magic
"ordered the main parts
online, constructed and
painted the hat myself,
got the bokken from a
sword shop"

The best thing about this
character is:
"his personality is identical
to mine"

I cosplay because:
"it's a laugh"

"you lost the game!"

133

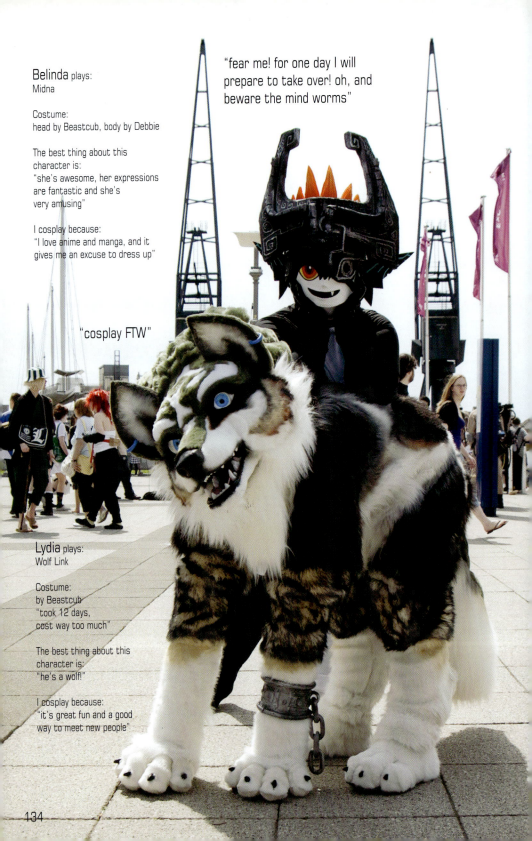

Belinda plays:
Midna

Costume:
head by Beastcub, body by Debbie

The best thing about this character is:
"she's awesome, her expressions are fantastic and she's very amusing"

I cosplay because:
"I love anime and manga, and it gives me an excuse to dress up"

"cosplay FTW"

"fear me! for one day I will prepare to take over! oh, and beware the mind worms"

Lydia plays:
Wolf Link

Costume:
by Beastcub
"took 12 days, cost way too much"

The best thing about this character is:
"he's a wolf!"

I cosplay because:
"it's great fun and a good way to meet new people"

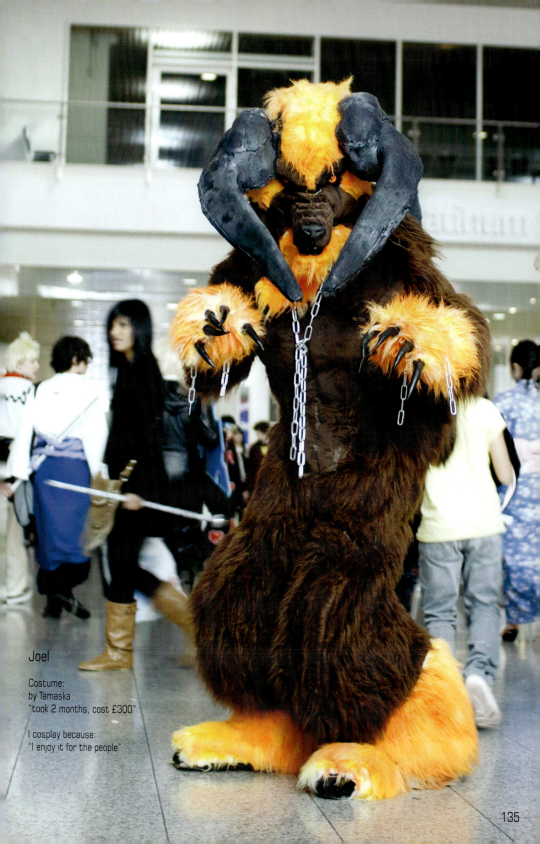

Joel

Costume:
by Tamaska
"took 2 months, cost £300"

I cosplay because:
"I enjoy it for the people"

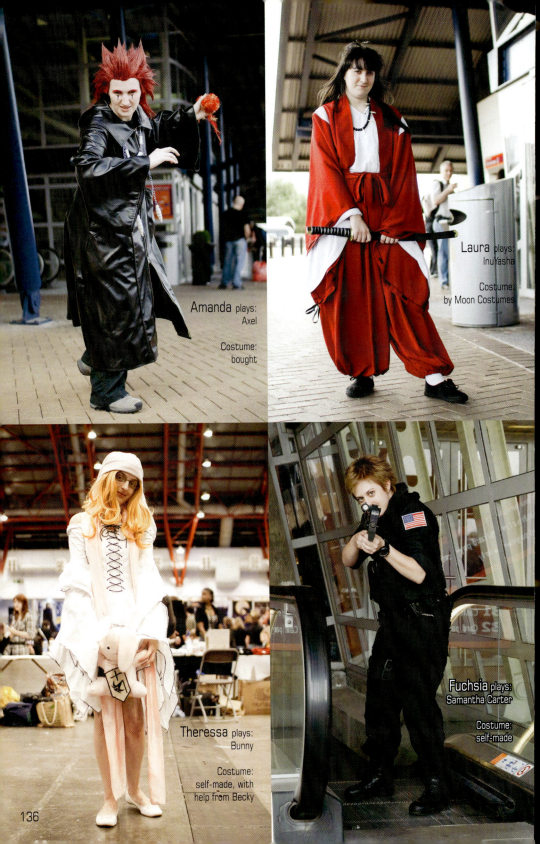

Amanda plays:
Axel

Costume:
bought

Laura plays:
InuYasha

Costume:
by Moon Costumes

Theressa plays:
Bunny

Costume:
self-made, with
help from Becky

Fuchsia plays:
Samantha Carter

Costume:
self-made

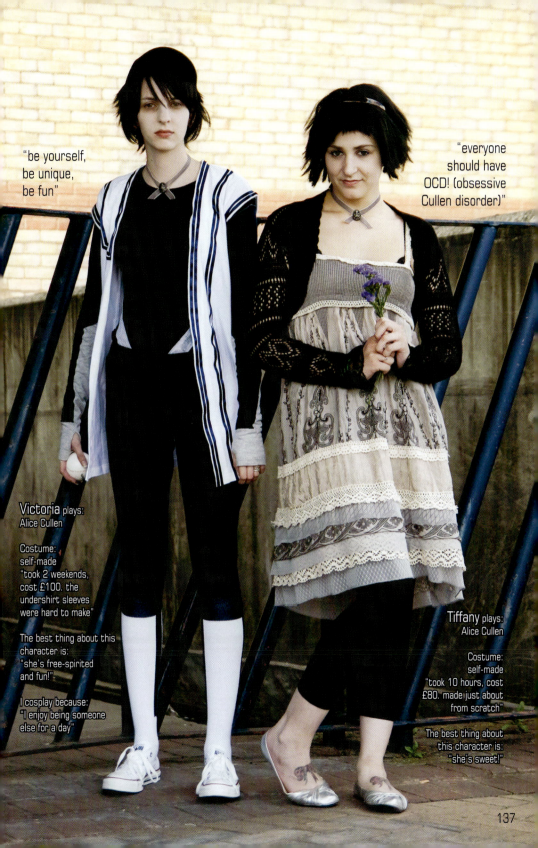

"be yourself,
be unique,
be fun"

"everyone
should have
OCD! (obsessive
Cullen disorder)"

Victoria plays:
Alice Cullen

Costume:
self-made
"took 2 weekends,
cost £100. the
undershirt sleeves
were hard to make"

The best thing about this
character is:
"she's free-spirited
and fun!"

I cosplay because:
"I enjoy being someone
else for a day"

Tiffany plays:
Alice Cullen

Costume:
self-made
"took 10 hours, cost
£80. made just about
from scratch"

The best thing about
this character is:
"she's sweet!"

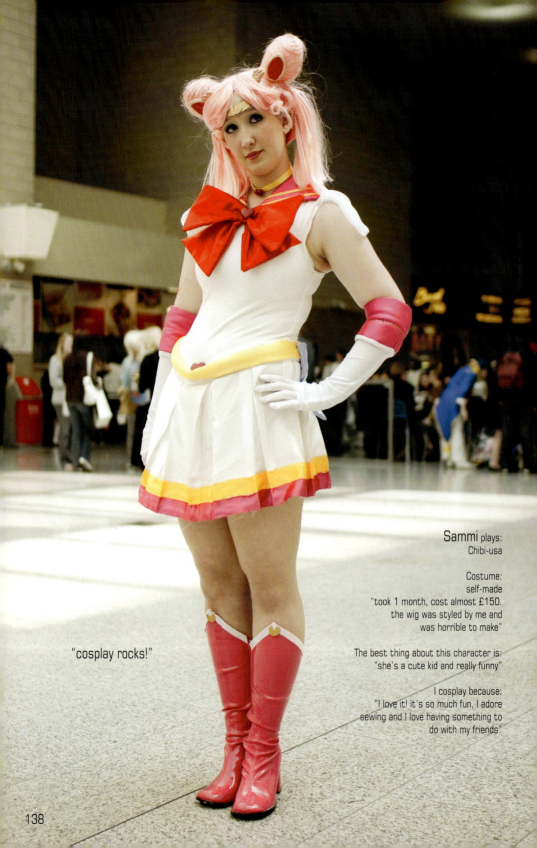

Sammi plays:
Chibi-usa

Costume:
self-made
"took 1 month, cost almost £150.
the wig was styled by me and
was horrible to make"

The best thing about this character is:
"she's a cute kid and really funny"

I cosplay because:
"I love it! it's so much fun, I adore
sewing and I love having something to
do with my friends"

"cosplay rocks!"

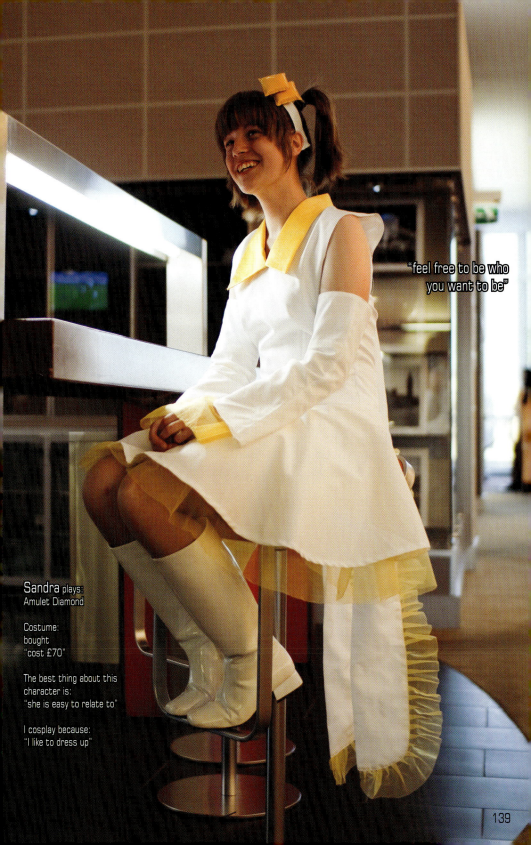

"feel free to be who
you want to be"

Sandra plays:
Amulet Diamond

Costume:
bought
"cost £70"

The best thing about this
character is:
"she is easy to relate to"

I cosplay because:
"I like to dress up"

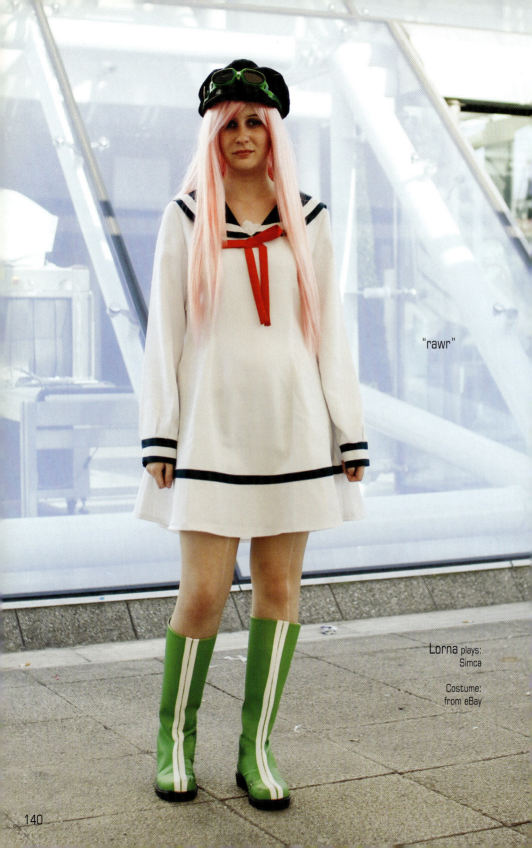

"rawr"

Lorna plays:
Simca

Costume:
from eBay

140

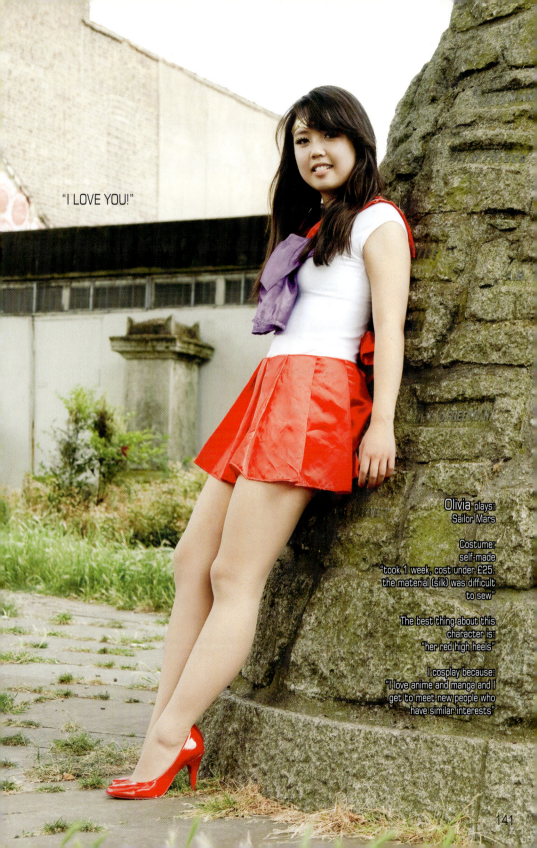

"I LOVE YOU!"

Olivia plays:
Sailor Mars

Costume:
self-made
"took 1 week, cost under £25.
the material (silk) was difficult
to sew"

The best thing about this
character is:
"her red high heels"

I cosplay because:
"I love anime and manga and I
get to meet new people who
have similar interests"

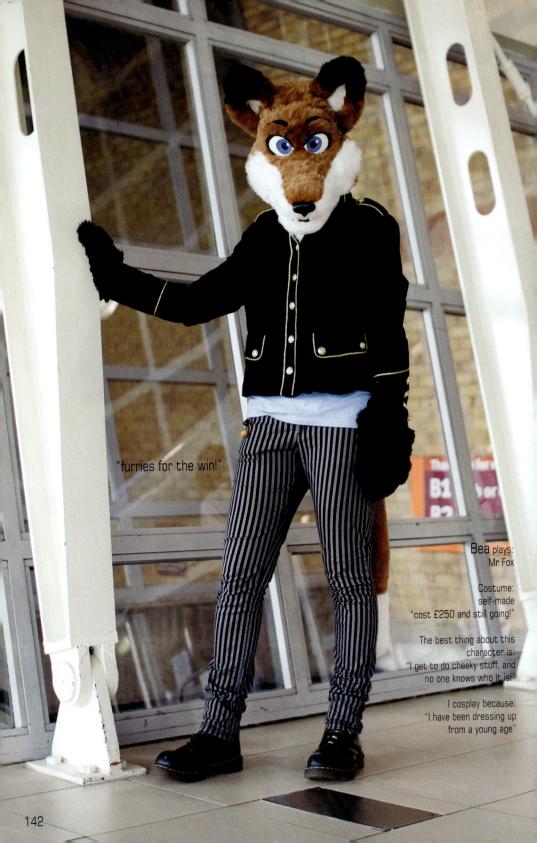

"furries for the win!"

Bea plays:
Mr Fox

Costume:
self-made
"cost £250 and still going!"

The best thing about this
character is:
"I get to do cheeky stuff, and
no one knows who it is!"

I cosplay because:
"I have been dressing up
from a young age"

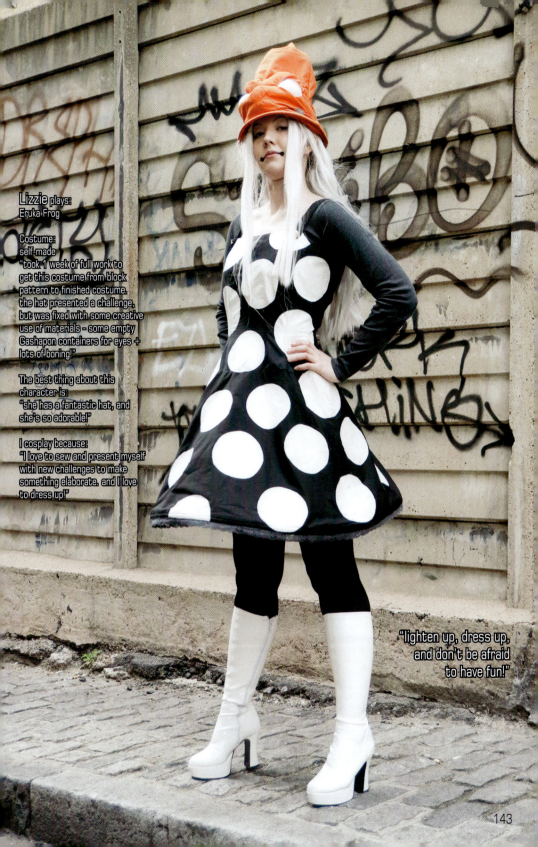

Lizzie plays:
Eruka Frog

Costume:
self-made
"took 1 week of full work to
get this costume from block
pattern to finished costume.
the hat presented a challenge,
but was fixed with some creative
use of materials - some empty
Gashapon containers for eyes +
lots of boning!"

The best thing about this
character is:
"she has a fantastic hat, and
she's so adorable!"

I cosplay because:
"I love to sew and present myself
with new challenges to make
something elaborate. and I love
to dress up!"

"lighten up, dress up,
and don't be afraid
to have fun!"

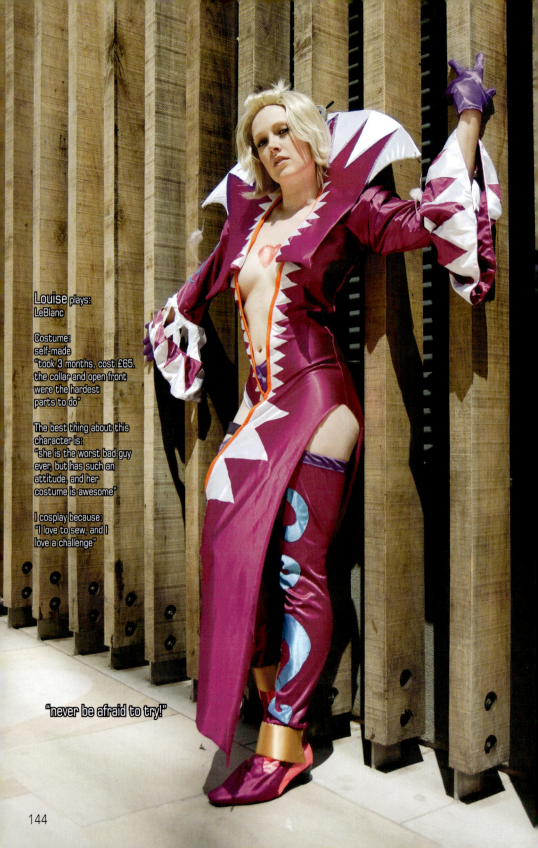

Louise plays:
LeBlanc

Costume:
self-made
"took 3 months, cost £65.
the collar and open front
were the hardest
parts to do"

The best thing about this
character is:
"she is the worst bad guy
ever, but has such an
attitude, and her
costume is awesome"

I cosplay because:
"I love to sew, and I
love a challenge"

"never be afraid to try!"

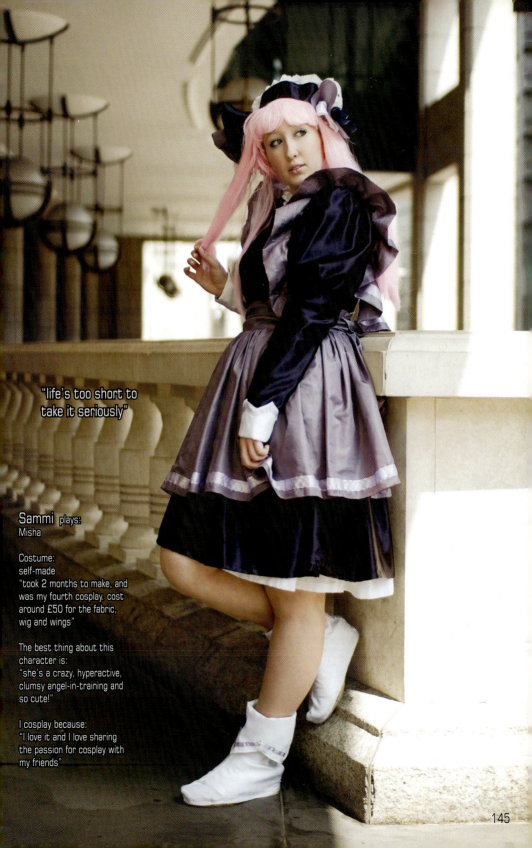

"life's too short to take it seriously"

Sammi plays:
Misha

Costume:
self-made
"took 2 months to make, and was my fourth cosplay. cost around £50 for the fabric, wig and wings"

The best thing about this character is:
"she's a crazy, hyperactive, clumsy angel-in-training and so cute!"

I cosplay because:
"I love it and I love sharing the passion for cosplay with my friends"

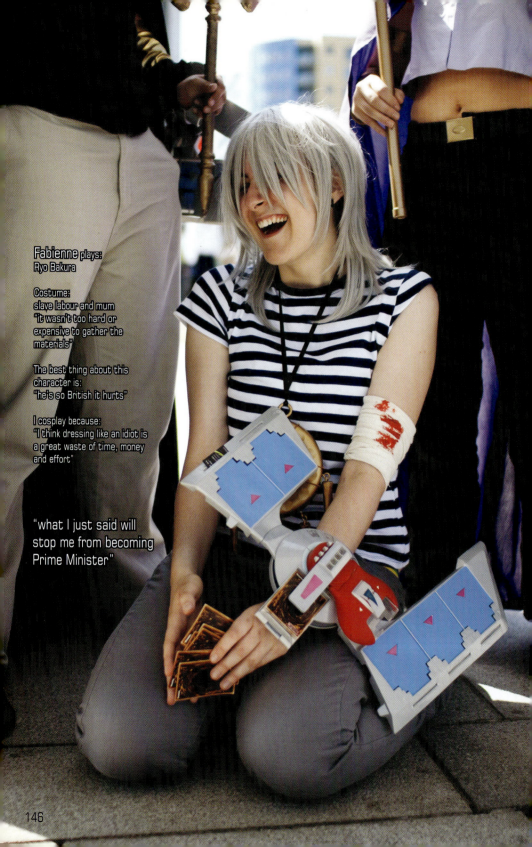

Fabienne plays:
Ryo Bakura

Costume:
slave labour and mum
"it wasn't too hard or
expensive to gather the
materials"

The best thing about this
character is:
"he's so British it hurts"

I cosplay because:
"I think dressing like an idiot is
a great waste of time, money
and effort"

"what I just said will
stop me from becoming
Prime Minister"

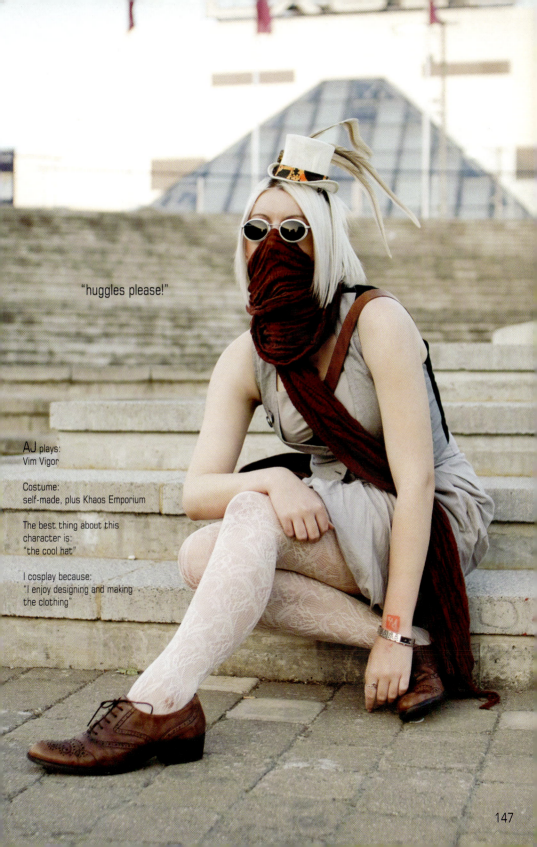

"huggles please!"

AJ plays:
Vim Vigor

Costume:
self-made, plus Khaos Emporium

The best thing about this
character is:
"the cool hat"

I cosplay because:
"I enjoy designing and making
the clothing"

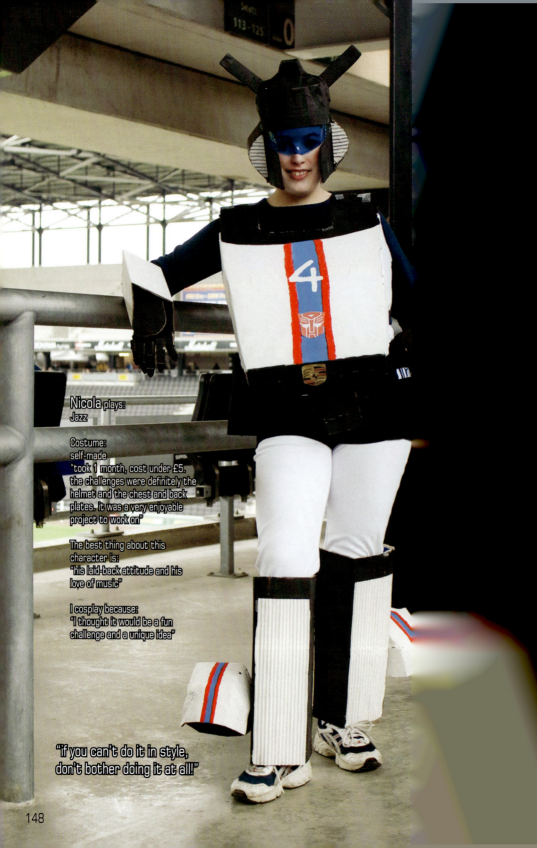

Nicola plays:
Jazz

Costume:
self-made
"took 1 month, cost under £5.
the challenges were definitely the
helmet and the chest and back
plates. It was a very enjoyable
project to work on"

The best thing about this
character is:
"his laid-back attitude and his
love of music"

I cosplay because:
"I thought it would be a fun
challenge and a unique idea"

"if you can't do it in style,
don't bother doing it at all!"

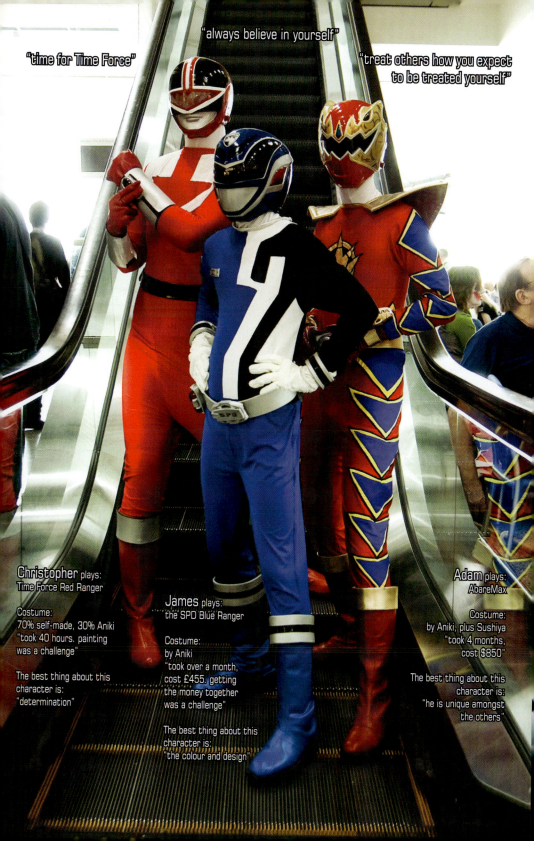

"time for Time Force"

"always believe in yourself"

"treat others how you expect
to be treated yourself"

Christopher plays:
Time Force Red Ranger

Costume:
70% self-made, 30% Aniki
"took 40 hours. painting
was a challenge"

The best thing about this
character is:
"determination"

James plays:
the SPD Blue Ranger

Costume:
by Aniki
"took over a month,
cost £455. getting
the money together
was a challenge"

The best thing about this
character is:
"the colour and design"

Adam plays:
AbareMax

Costume:
by Aniki, plus Sushiya
"took 4 months,
cost $850"

The best thing about this
character is:
"he is unique amongst
the others"

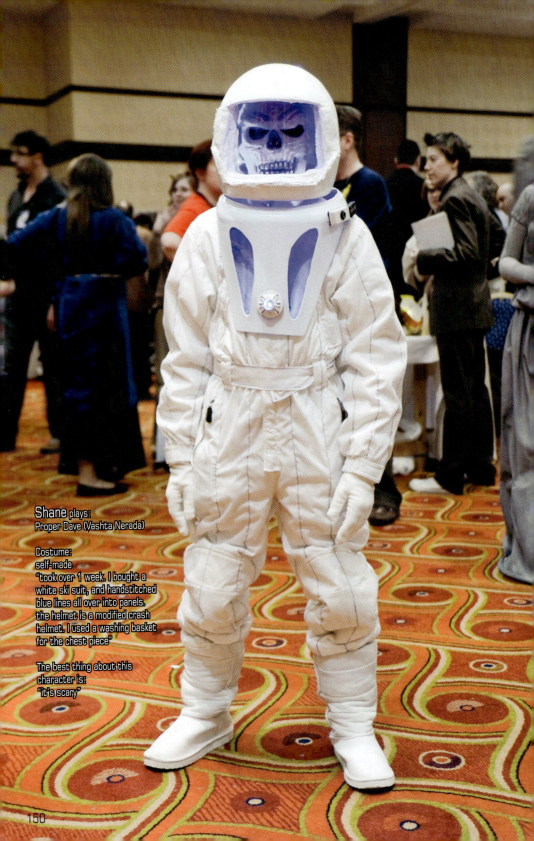

Shane plays:
Proper Dave (Vashta Nerada)

Costume:
self-made
"took over 1 week. I bought a
white ski suit, and handstitched
blue lines all over into panels.
the helmet is a modified crash
helmet. I used a washing basket
for the chest piece"

The best thing about this
character is:
"it's scary"

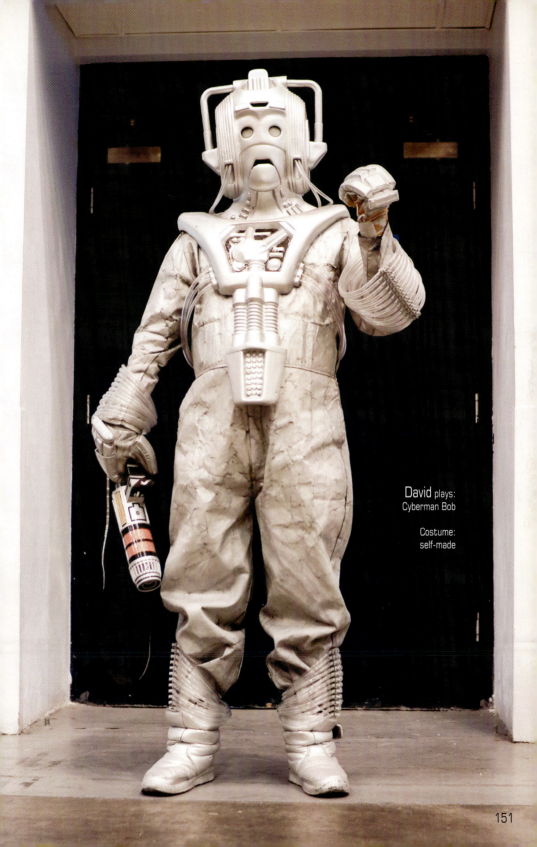

David plays:
Cyberman Bob

Costume:
self-made

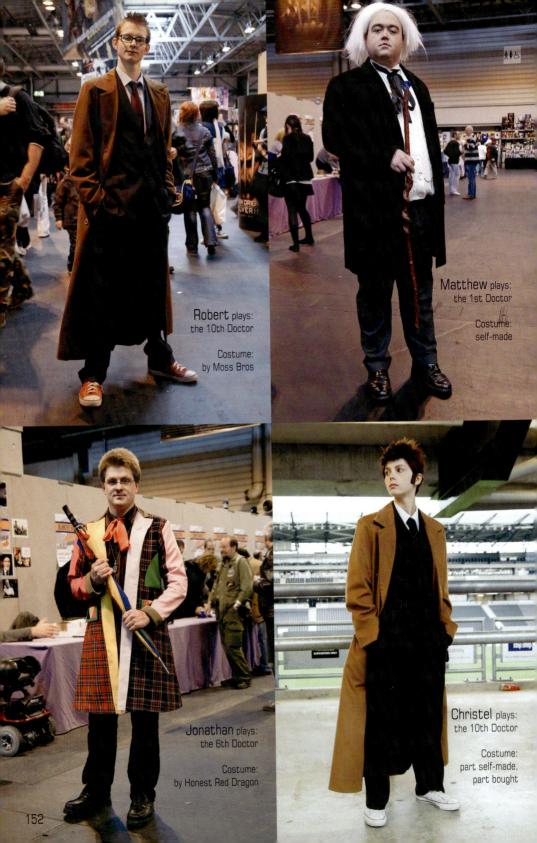

Robert plays:
the 10th Doctor

Costume:
by Moss Bros

Matthew plays:
the 1st Doctor

Costume:
self-made

Jonathan plays:
the 6th Doctor

Costume:
by Honest Red Dragon

Christel plays:
the 10th Doctor

Costume:
part self-made,
part bought

152

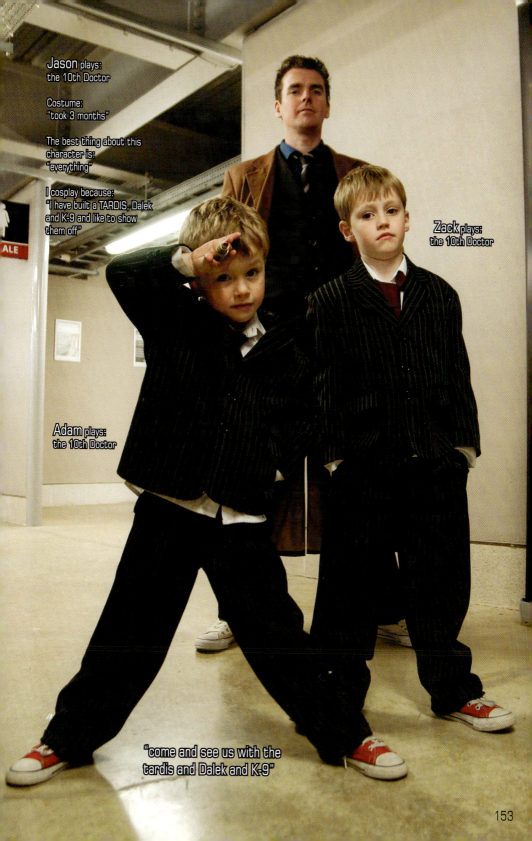

Jason plays:
the 10th Doctor

Costume:
"took 3 months"

The best thing about this character is:
"everything"

I cosplay because:
"I have built a TARDIS, Dalek and K-9 and like to show them off"

Zack plays:
the 10th Doctor

Adam plays:
the 10th Doctor

"come and see us with the tardis and Dalek and K-9"

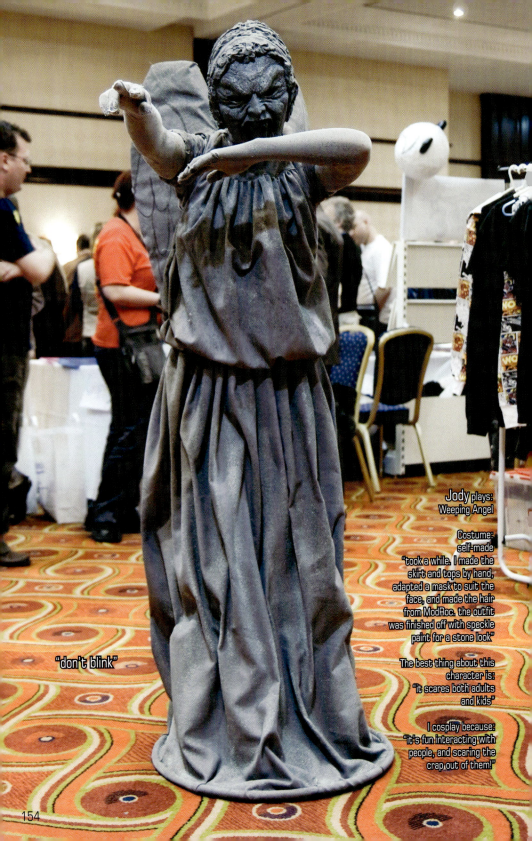

Jody plays:
Weeping Angel

Costume:
self-made
"took a while. I made the
skirt and tops by hand,
adapted a mask to suit the
face, and made the hair
from ModRoc. the outfit
was finished off with speckle
paint for a stone look"

The best thing about this
character is:
"it scares both adults
and kids"

I cosplay because:
"it's fun interacting with
people, and scaring the
crap out of them!"

"don't blink"

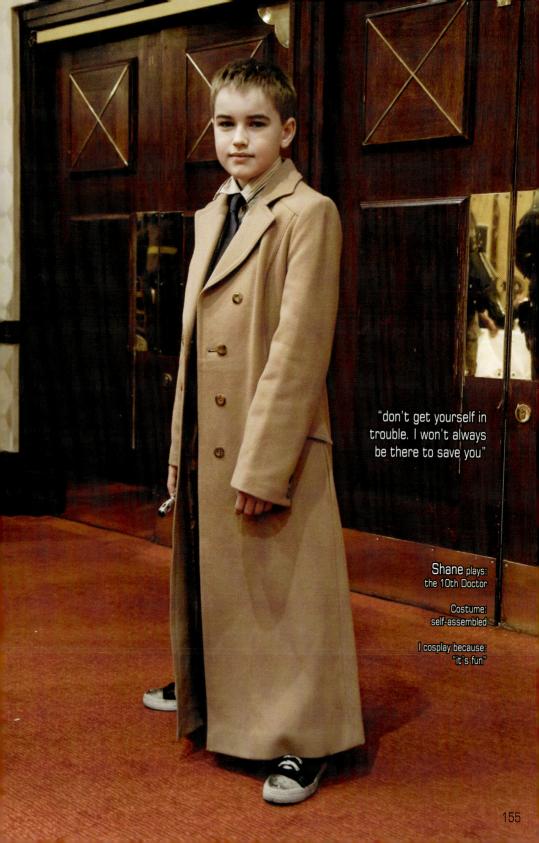

"don't get yourself in trouble. I won't always be there to save you"

Shane plays:
the 10th Doctor

Costume:
self-assembled

I cosplay because:
"it's fun"

155

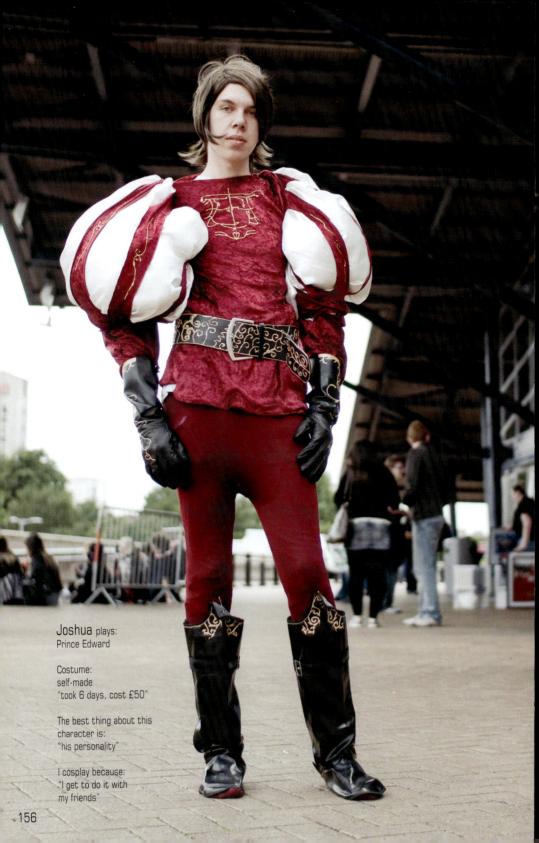

Joshua plays:
Prince Edward

Costume:
self-made
"took 6 days, cost £50"

The best thing about this
character is:
"his personality"

I cosplay because:
"I get to do it with
my friends"

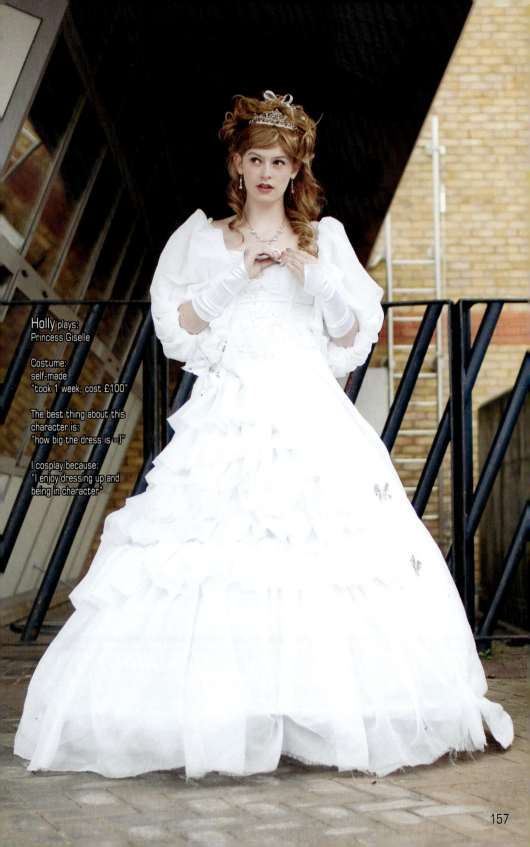

Holly plays:
Princess Giselle

Costume:
self-made
"took 1 week, cost £100"

The best thing about this
character is:
"how big the dress is =)"

I cosplay because:
"I enjoy dressing up and
being in character"

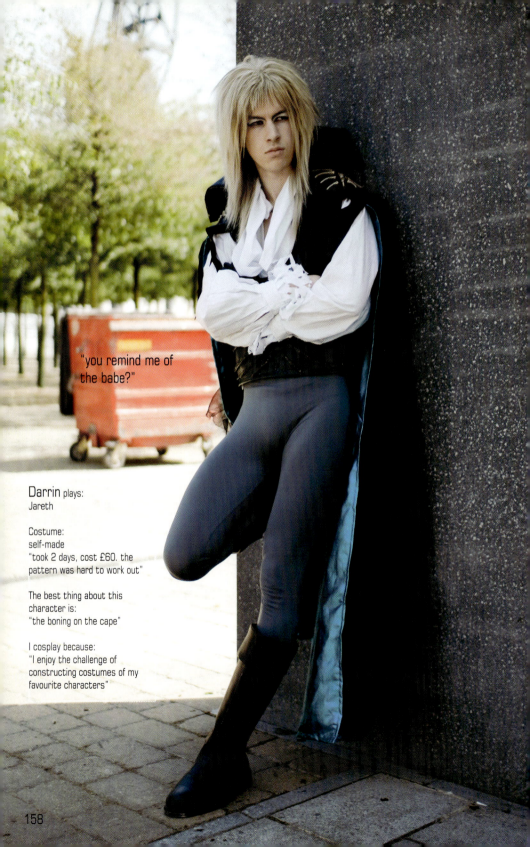

"you remind me of the babe?"

Darrin plays:
Jareth

Costume:
self-made
"took 2 days, cost £60. the pattern was hard to work out"

The best thing about this character is:
"the boning on the cape"

I cosplay because:
"I enjoy the challenge of constructing costumes of my favourite characters"

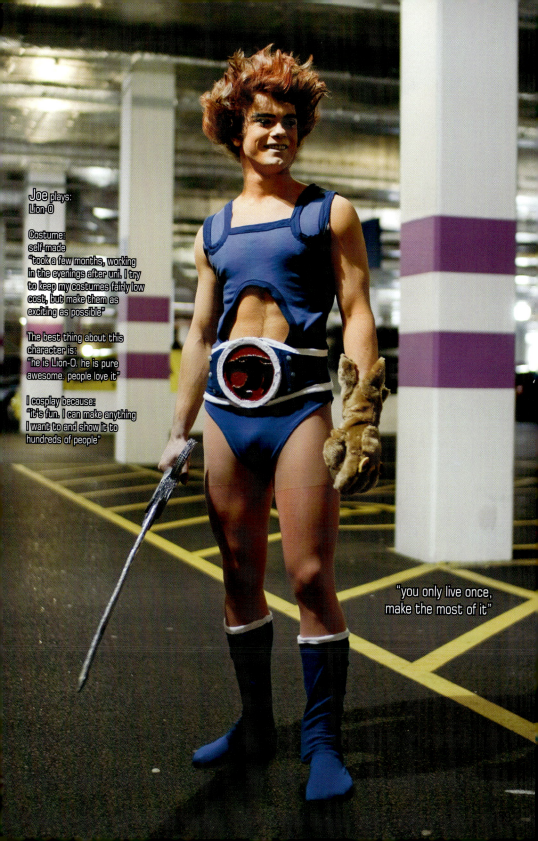

Joe plays:
Lion-O

Costume:
self-made
"took a few months, working in the evenings after uni. I try to keep my costumes fairly low cost, but make them as exciting as possible"

The best thing about this character is:
"he is Lion-O. he is pure awesome. people love it"

I cosplay because:
"it's fun. I can make anything I want to and show it to hundreds of people"

"you only live once, make the most of it"

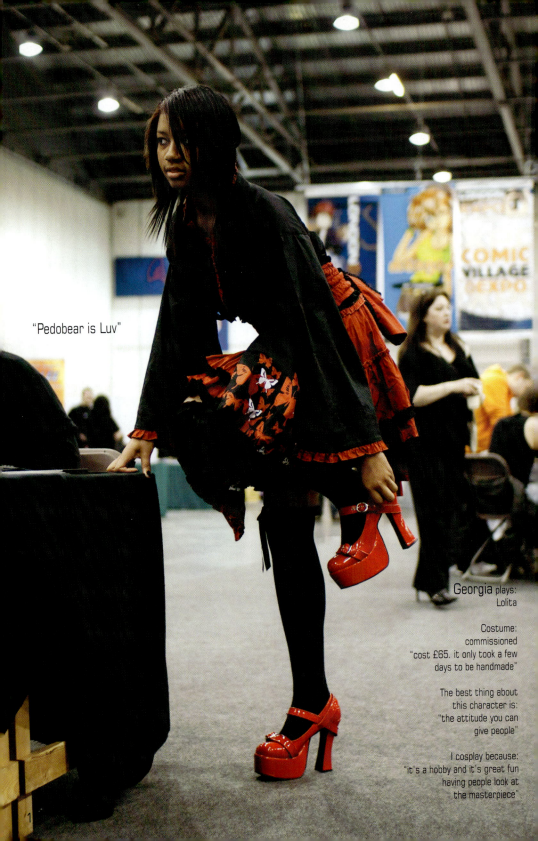

"Pedobear is Luv"

Georgia plays:
Lolita

Costume:
commissioned
"cost £65. it only took a few
days to be handmade"

The best thing about
this character is:
"the attitude you can
give people"

I cosplay because:
"it's a hobby and it's great fun
having people look at
the masterpiece"

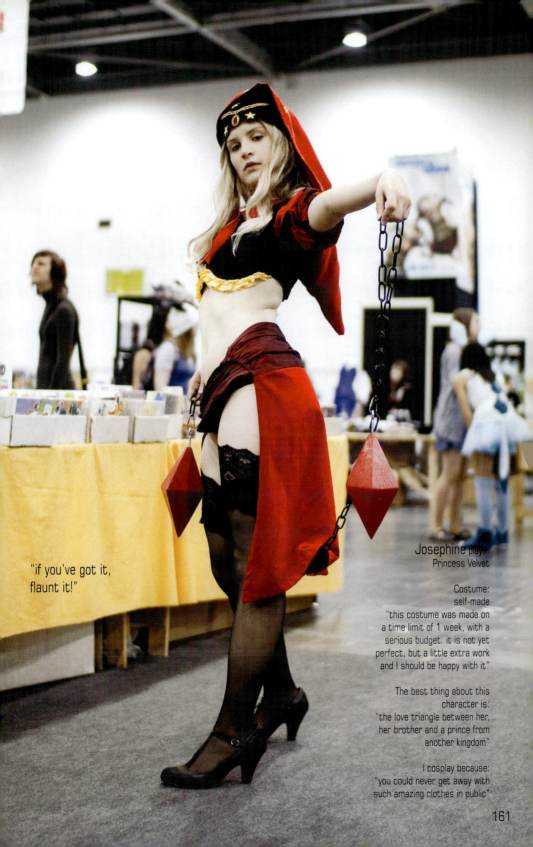

"if you've got it,
flaunt it!"

Josephine plays:
Princess Velvet

Costume:
self-made
"this costume was made on
a time limit of 1 week, with a
serious budget. it is not yet
perfect, but a little extra work
and I should be happy with it"

The best thing about this
character is:
"the love triangle between her,
her brother and a prince from
another kingdom"

I cosplay because:
"you could never get away with
such amazing clothes in public"

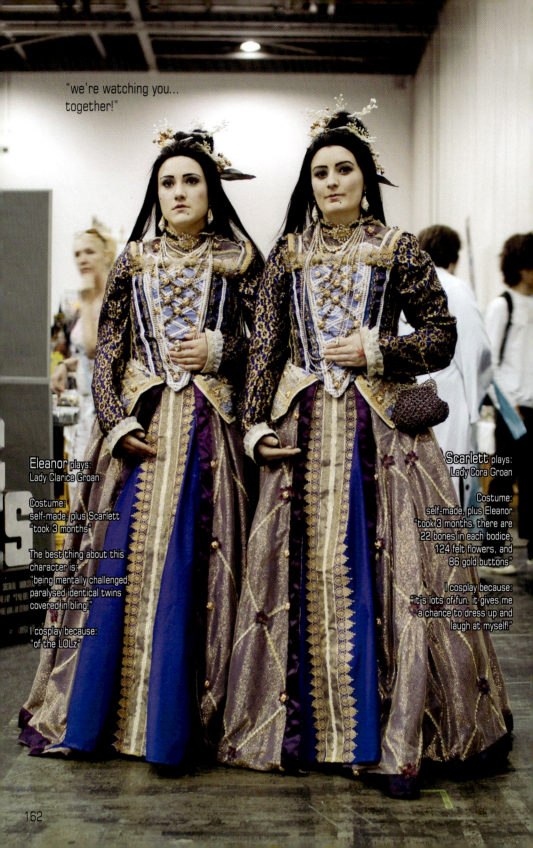

"we're watching you... together!"

Eleanor plays:
Lady Clarice Groan

Costume:
self-made, plus Scarlett
"took 3 months"

The best thing about this character is:
"being mentally challenged, paralysed identical twins covered in bling!"

I cosplay because:
"of the LOLz"

Scarlett plays:
Lady Cora Groan

Costume:
self-made, plus Eleanor
"took 3 months. there are 22 bones in each bodice, 124 felt flowers, and 86 gold buttons"

I cosplay because:
"it is lots of fun. it gives me a chance to dress up and laugh at myself!"

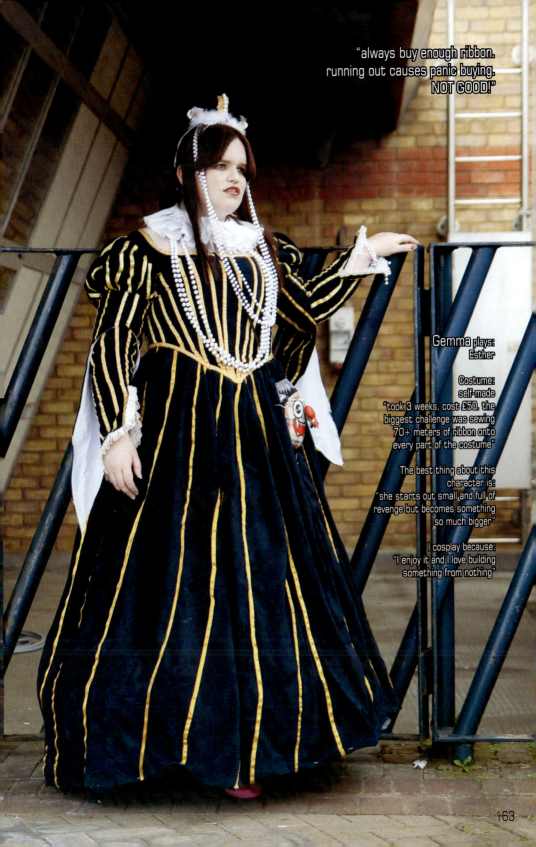

"always buy enough ribbon. running out causes panic buying. NOT GOOD!"

Gemma plays:
Esther

Costume:
self-made
"took 3 weeks, cost £50. the biggest challenge was sewing 70+ meters of ribbon onto every part of the costume"

The best thing about this character is:
"she starts out small and full of revenge but becomes something so much bigger"

I cosplay because:
"I enjoy it and I love building something from nothing"

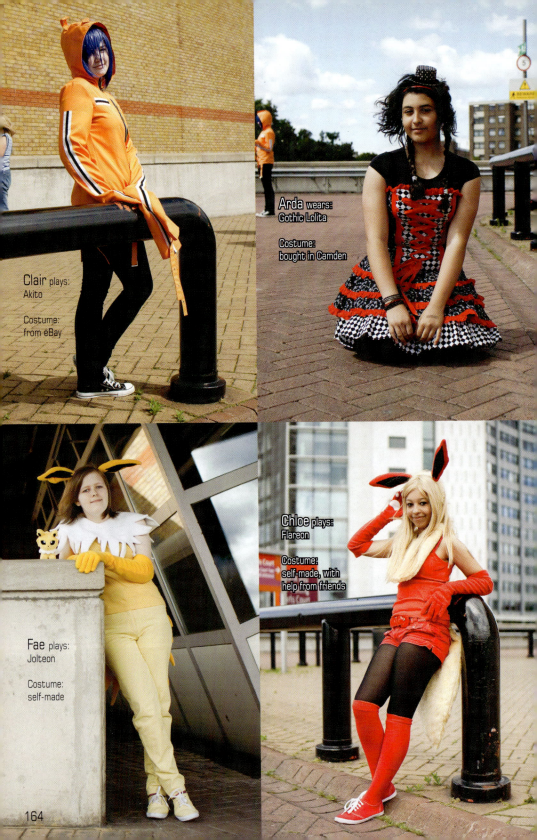

Clair plays:
Akito

Costume:
from eBay

Arda wears:
Gothic Lolita

Costume:
bought in Camden

Fae plays:
Jolteon

Costume:
self-made

Chloe plays:
Flareon

Costume:
self-made, with
help from friends

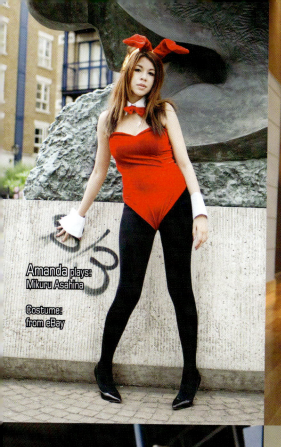

Amanda plays:
Mikuru Asahina

Costume:
from eBay

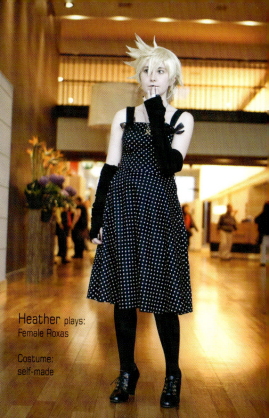

Heather plays:
Female Roxas

Costume:
self-made

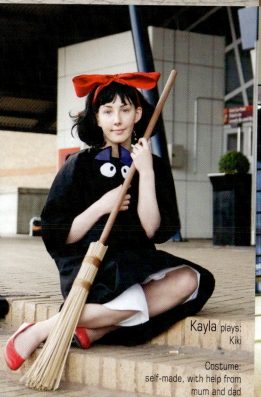

Kayla plays:
Kiki

Costume:
self-made, with help from
mum and dad

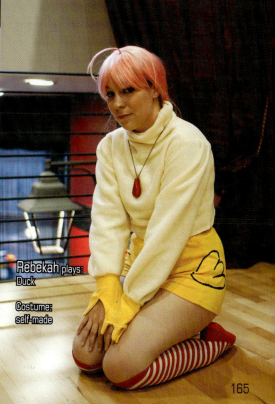

Rebekah plays:
Duck

Costume:
self-made

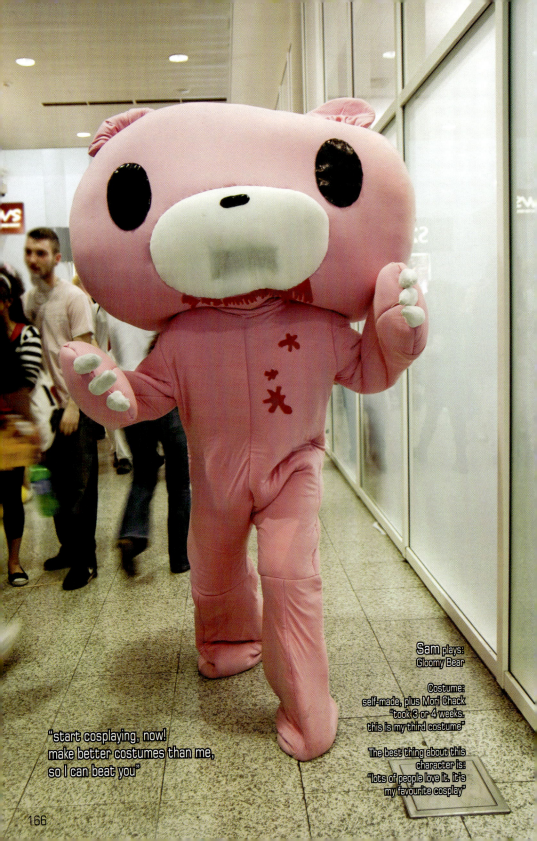

Sam plays:
Gloomy Bear

Costume:
self-made, plus Mori Chack
"took 3 or 4 weeks,
this is my third costume"

The best thing about this
character is:
"lots of people love it, it's
my favourite cosplay"

"start cosplaying, now!
make better costumes than me,
so I can beat you"

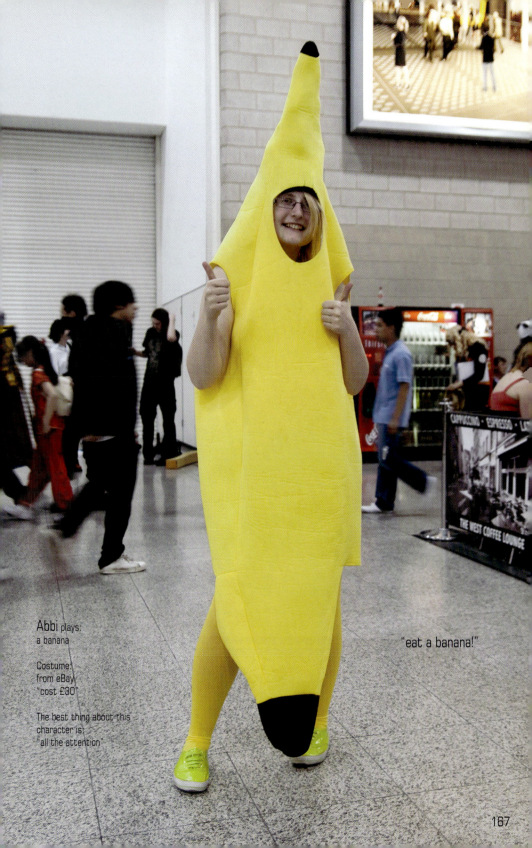

Abbi plays:
a banana

Costume:
from eBay
"cost £30"

The best thing about this
character is:
"all the attention"

"eat a banana!"

167

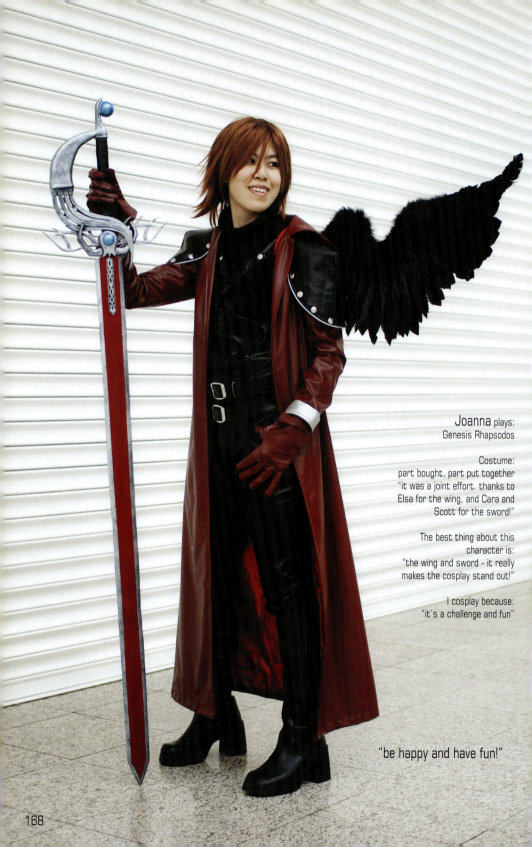

Joanna plays:
Genesis Rhapsodos

Costume:
part bought, part put together
"it was a joint effort. thanks to
Elsa for the wing, and Cara and
Scott for the sword!"

The best thing about this
character is:
"the wing and sword - it really
makes the cosplay stand out!"

I cosplay because:
"it's a challenge and fun"

"be happy and have fun!"

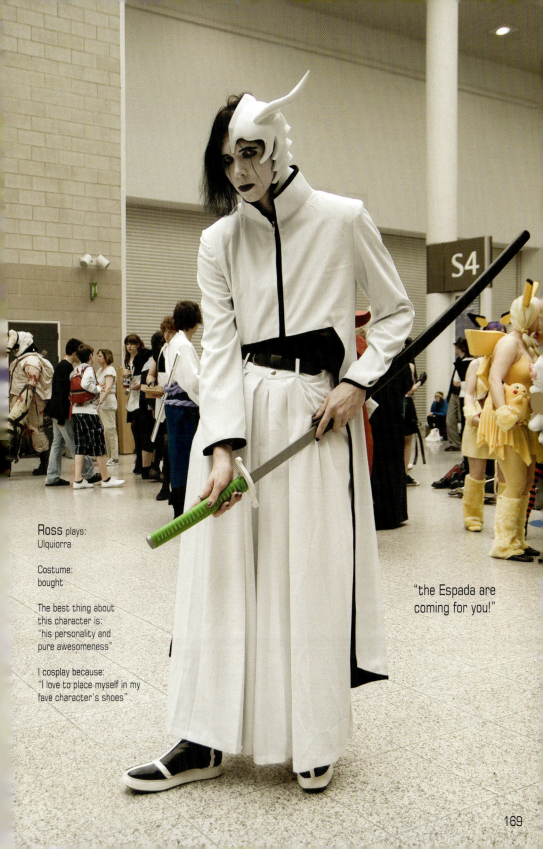

Ross plays:
Ulquiorra

Costume:
bought

The best thing about
this character is:
"his personality and
pure awesomeness"

I cosplay because:
"I love to place myself in my
fave character's shoes"

"the Espada are
coming for you!"

169

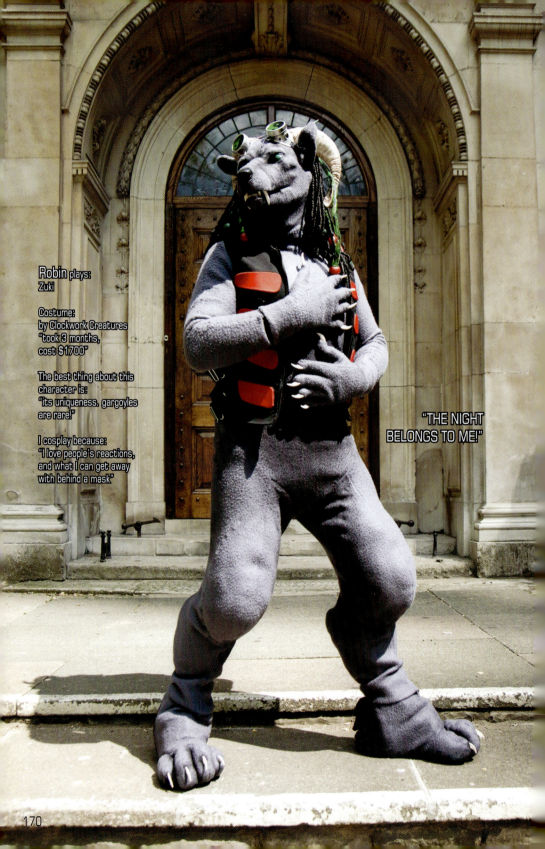

Robin plays:
Zuki

Costume:
by Clockwork Creatures
"took 3 months,
cost $1700"

The best thing about this
character is:
"its uniqueness. gargoyles
are rare!"

I cosplay because:
"I love people's reactions,
and what I can get away
with behind a mask"

"THE NIGHT
BELONGS TO ME!"

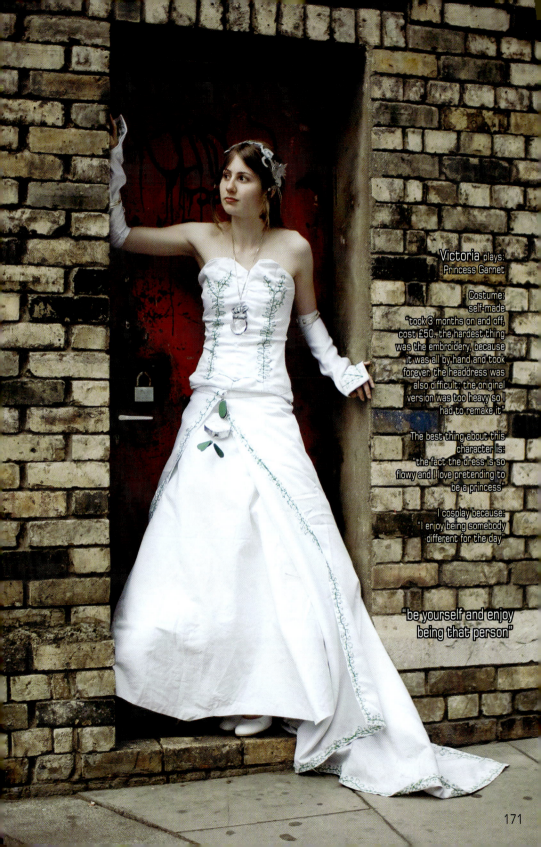

Victoria plays:
Princess Garnet

Costume:
self-made
"took 3 months on and off, cost £50. the hardest thing was the embroidery, because it was all by hand and took forever. the headdress was also difficult: the original version was too heavy so I had to remake it"

The best thing about this character is:
"the fact the dress is so flowy and I love pretending to be a princess"

I cosplay because:
"I enjoy being somebody different for the day"

"be yourself and enjoy being that person"

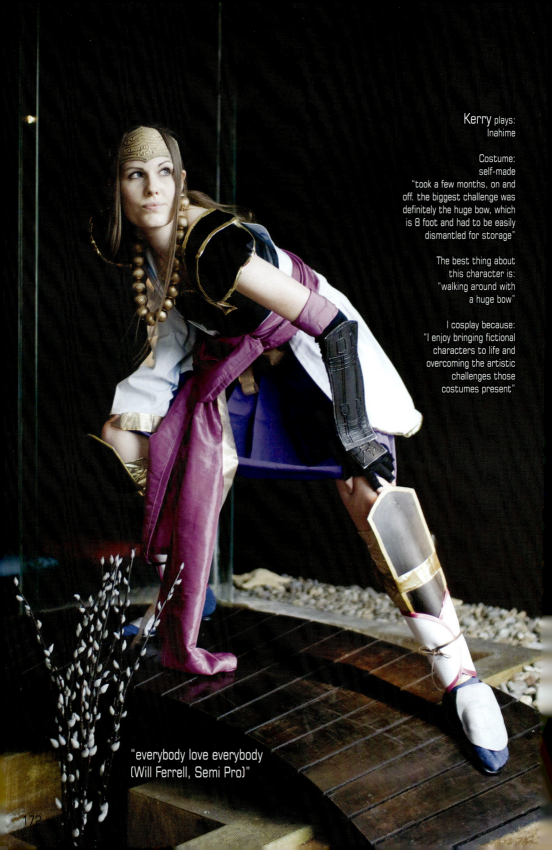

Kerry plays:
Inahime

Costume:
self-made
"took a few months, on and off. the biggest challenge was definitely the huge bow, which is 8 foot and had to be easily dismantled for storage"

The best thing about this character is: "walking around with a huge bow"

I cosplay because: "I enjoy bringing fictional characters to life and overcoming the artistic challenges those costumes present"

"everybody love everybody (Will Ferrell, Semi Pro)"

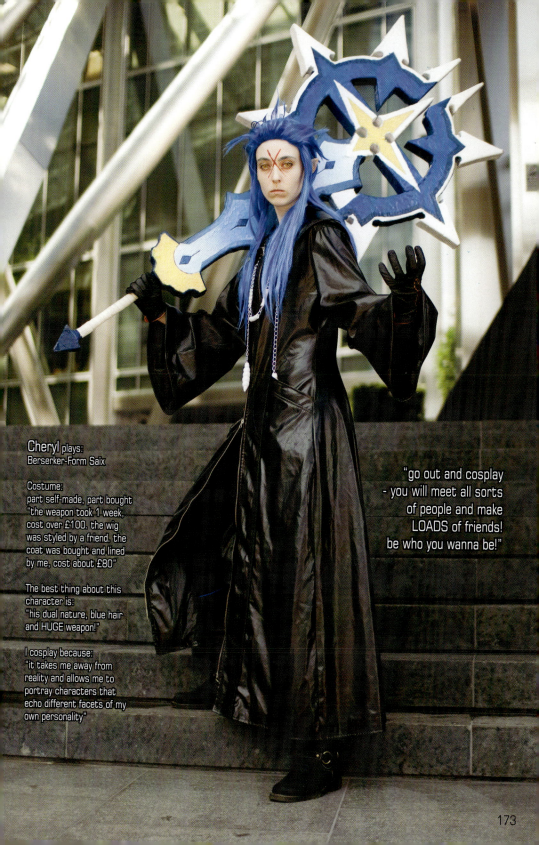

Cheryl plays:
Berserker-Form Saïx

Costume:
part self-made, part bought
"the weapon took 1 week,
cost over £100. the wig
was styled by a friend. the
coat was bought and lined
by me, cost about £80"

The best thing about this
character is:
"his dual nature, blue hair
and HUGE weapon!"

I cosplay because:
"it takes me away from
reality and allows me to
portray characters that
echo different facets of my
own personality"

"go out and cosplay
- you will meet all sorts
of people and make
LOADS of friends!
be who you wanna be!"

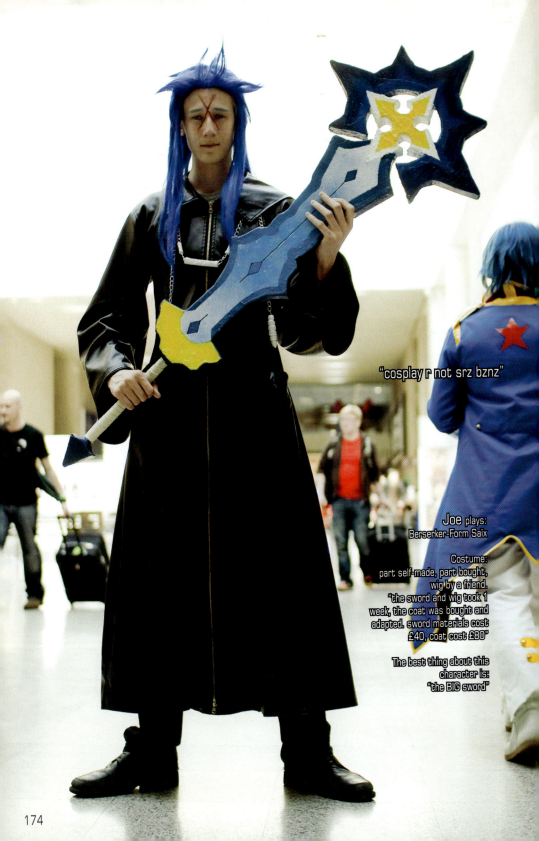

"cosplay r not srz bznz"

Joe plays:
Berserker-Form Saix

Costume:
part self-made, part bought,
wig by a friend.
"the sword and wig took 1
week, the coat was bought and
adapted. sword materials cost
£40, coat cost £80"

The best thing about this
character is:
"the BIG sword"

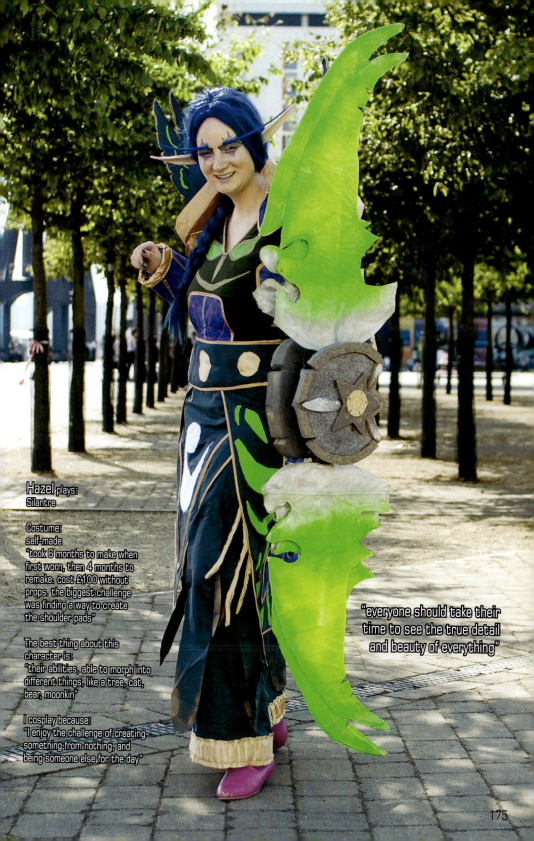

Hazel plays:
Silantre

Costume:
self-made
"took 6 months to make when
first worn, then 4 months to
remake. cost £100 without
props. the biggest challenge
was finding a way to create
the shoulder pads"

The best thing about this
character is:
"their abilities, able to morph into
different things, like a tree, cat,
bear, moonkin"

I cosplay because:
"I enjoy the challenge of creating
something from nothing, and
being someone else for the day"

"everyone should take their
time to see the true detail
and beauty of everything"

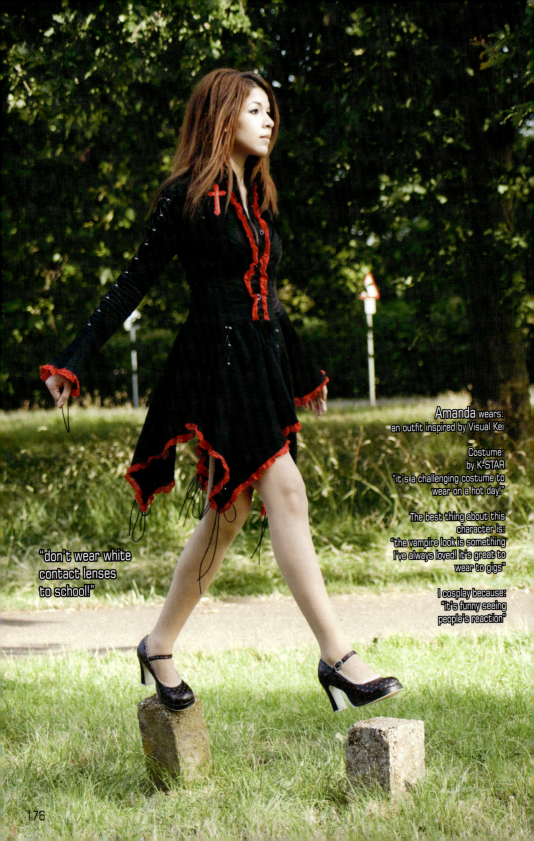

Amanda wears:
an outfit inspired by Visual Kei

Costume:
by K-STAR
"it's a challenging costume to
wear on a hot day!"

The best thing about this
character is:
"the vampire look is something
I've always loved! it's great to
wear to gigs"

I cosplay because:
"it's funny seeing
people's reaction"

"don't wear white
contact lenses
to school!"

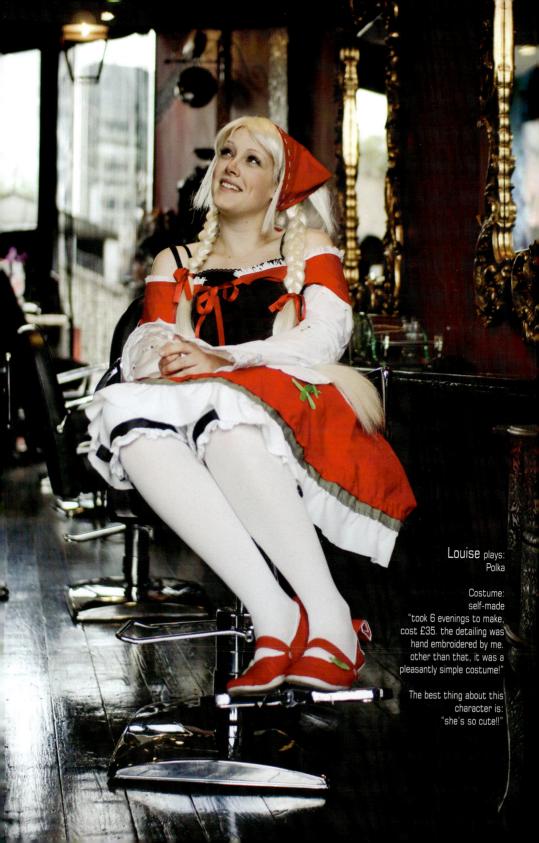

Louise plays:
Polka

Costume:
self-made
"took 6 evenings to make,
cost £35. the detailing was
hand embroidered by me.
other than that, it was a
pleasantly simple costume!"

The best thing about this
character is:
"she's so cute!!"

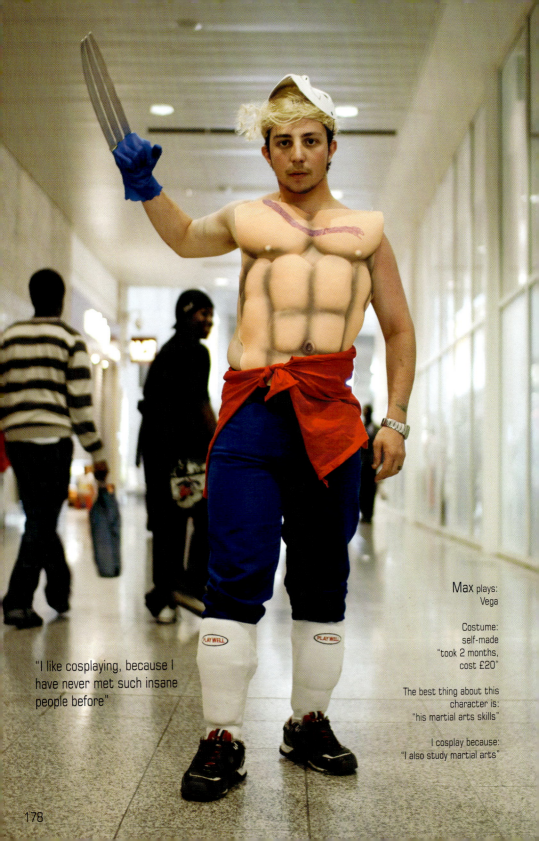

"I like cosplaying, because I
have never met such insane
people before"

Max plays:
Vega

Costume:
self-made
"took 2 months,
cost £20"

The best thing about this
character is:
"his martial arts skills"

I cosplay because:
"I also study martial arts"

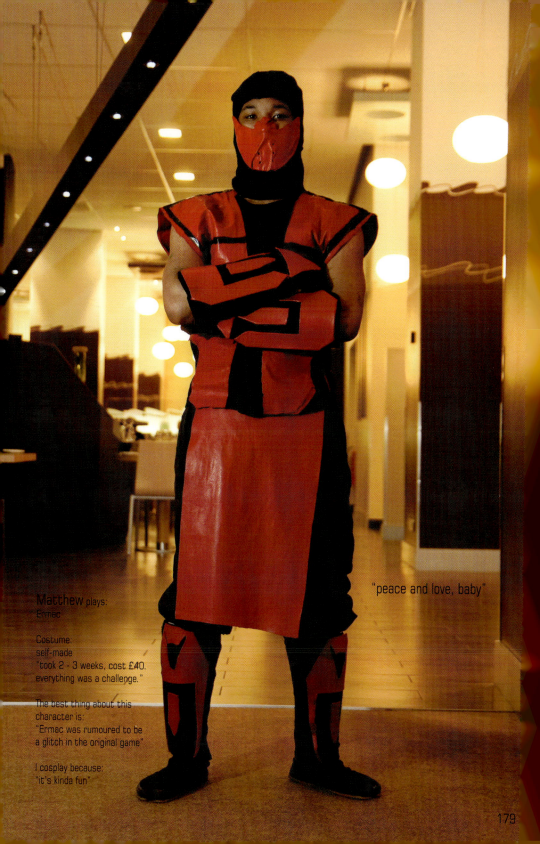

"peace and love, baby"

Matthew plays:
Ermac

Costume:
self-made
"took 2 - 3 weeks, cost £40.
everything was a challenge."

The best thing about this
character is:
"Ermac was rumoured to be
a glitch in the original game"

I cosplay because:
"it's kinda fun"

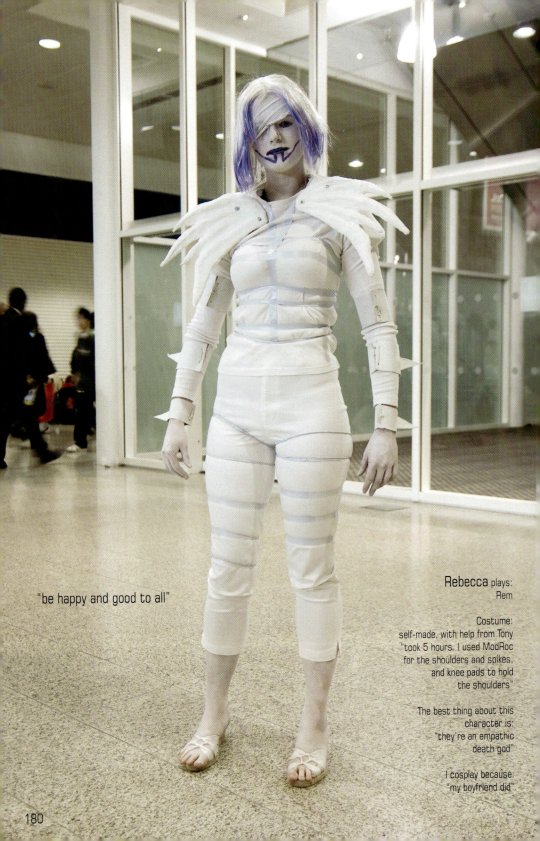

"be happy and good to all"

Rebecca plays:
Rem

Costume:
self-made, with help from Tony
"took 5 hours. I used ModRoc
for the shoulders and spikes,
and knee pads to hold
the shoulders"

The best thing about this
character is:
"they're an empathic
death god"

I cosplay because:
"my boyfriend did"

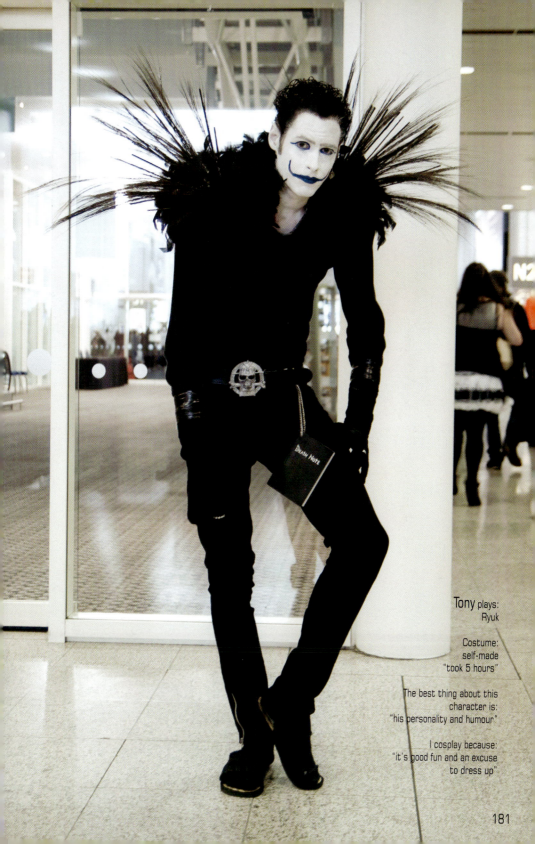

Tony plays:
Ryuk

Costume:
self-made
"took 5 hours"

The best thing about this
character is:
"his personality and humour"

I cosplay because:
"it's good fun and an excuse
to dress up"

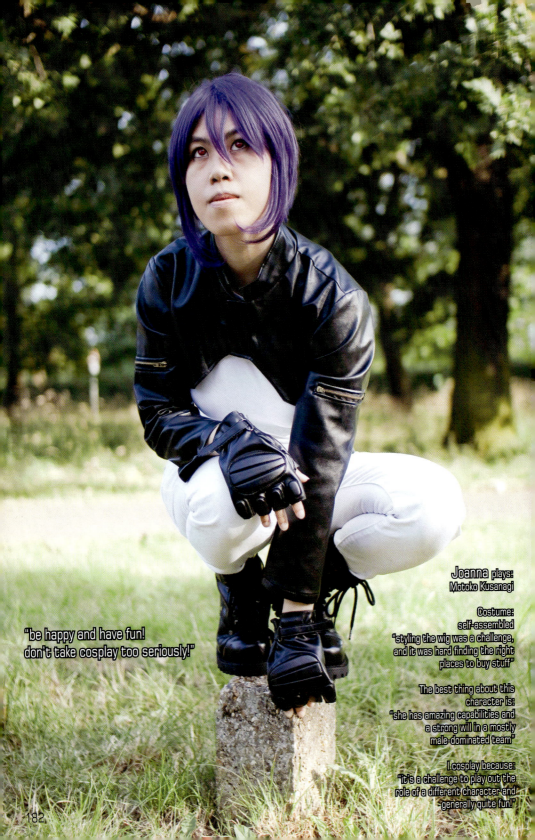

"be happy and have fun!
don't take cosplay too seriously!"

Joanna plays:
Motoko Kusanagi

Costume:
self-assembled
"styling the wig was a challenge,
and it was hard finding the right
places to buy stuff"

The best thing about this
character is:
"she has amazing capabilities and
a strong will in a mostly
male-dominated team"

I cosplay because:
"it's a challenge to play out the
role of a different character and
generally quite fun!"

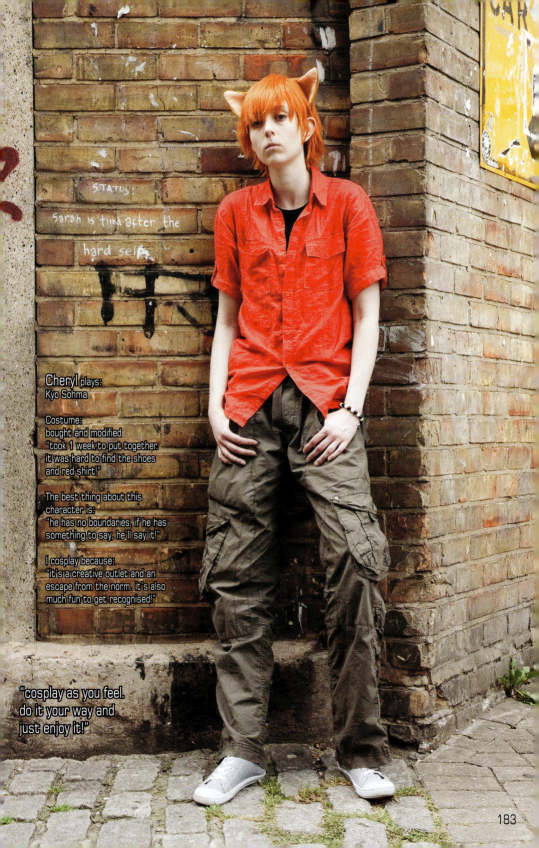

Cheryl plays:
Kyo Sohma

Costume:
bought and modified
"took 1 week to put together.
it was hard to find the shoes
and red shirt!"

The best thing about this
character is:
"he has no boundaries. if he has
something to say, he'll say it!"

I cosplay because:
"it's a creative outlet and an
escape from the norm. it's also
much fun to get recognised!"

"cosplay as you feel.
do it your way and
just enjoy it!"

183

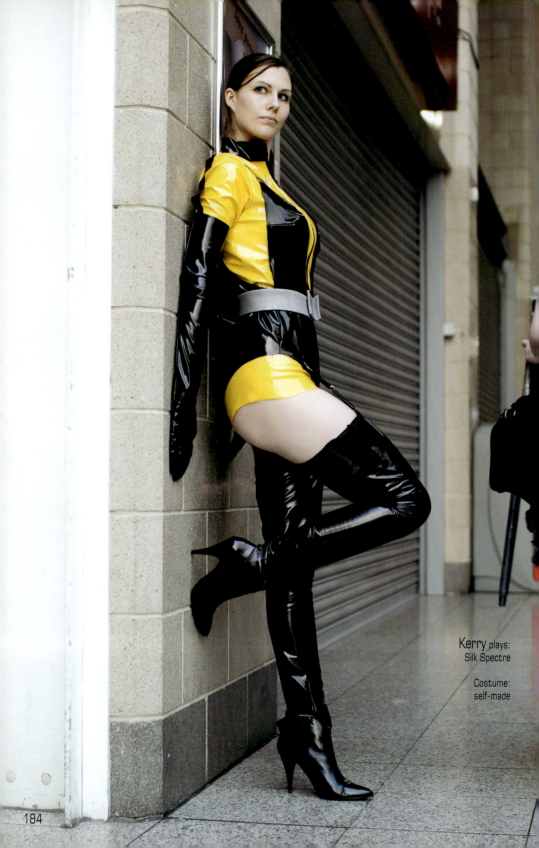

Kerry plays:
Silk Spectre

Costume:
self-made

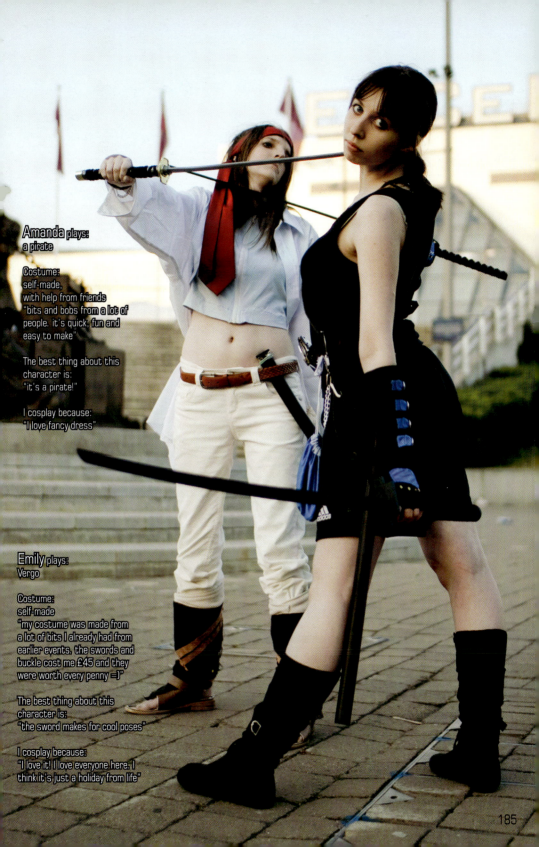

Amanda plays:
a pirate

Costume:
self-made,
with help from friends
"bits and bobs from a lot of
people. it's quick, fun and
easy to make"

The best thing about this
character is:
"it's a pirate!"

I cosplay because:
"I love fancy dress"

Emily plays:
Vergo

Costume:
self-made
"my costume was made from
a lot of bits I already had from
earlier events. the swords and
buckle cost me £45 and they
were worth every penny =}"

The best thing about this
character is:
"the sword makes for cool poses"

I cosplay because:
"I love it! I love everyone here. I
think it's just a holiday from life"

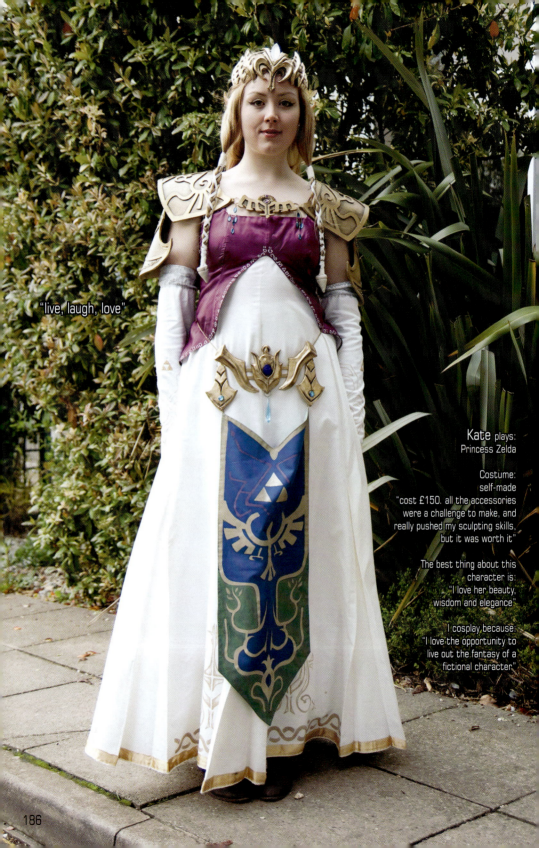

"live, laugh, love"

Kate plays:
Princess Zelda

Costume:
self-made
"cost £150. all the accessories
were a challenge to make, and
really pushed my sculpting skills,
but it was worth it"

The best thing about this
character is:
"I love her beauty,
wisdom and elegance"

I cosplay because:
"I love the opportunity to
live out the fantasy of a
fictional character"

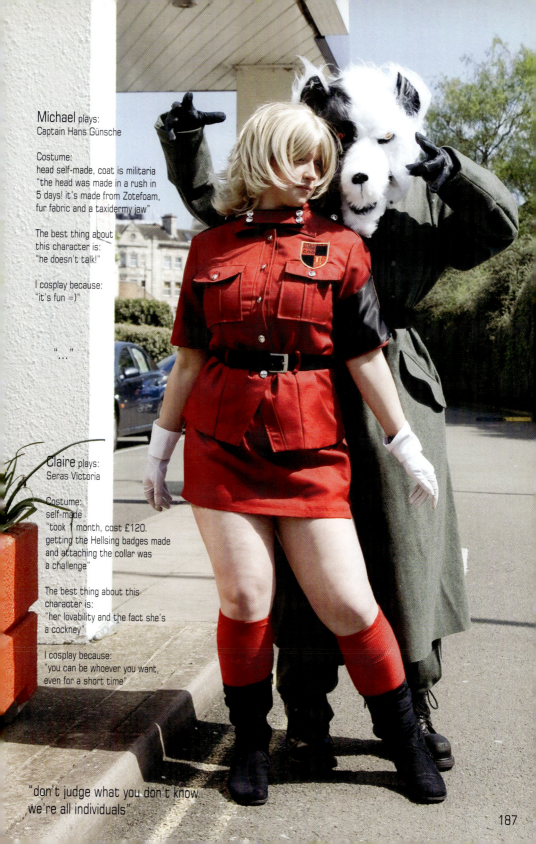

Michael plays:
Captain Hans Günsche

Costume:
head self-made, coat is militaria
"the head was made in a rush in
5 days! it's made from Zotefoam,
fur fabric and a taxidermy jaw"

The best thing about
this character is:
"he doesn't talk!"

I cosplay because:
"it's fun =)"

"..."

Claire plays:
Seras Victoria

Costume:
self-made
"took 1 month, cost £120.
getting the Hellsing badges made
and attaching the collar was
a challenge"

The best thing about this
character is:
"her lovability and the fact she's
a cockney"

I cosplay because:
"you can be whoever you want,
even for a short time"

"don't judge what you don't know.
we're all individuals"

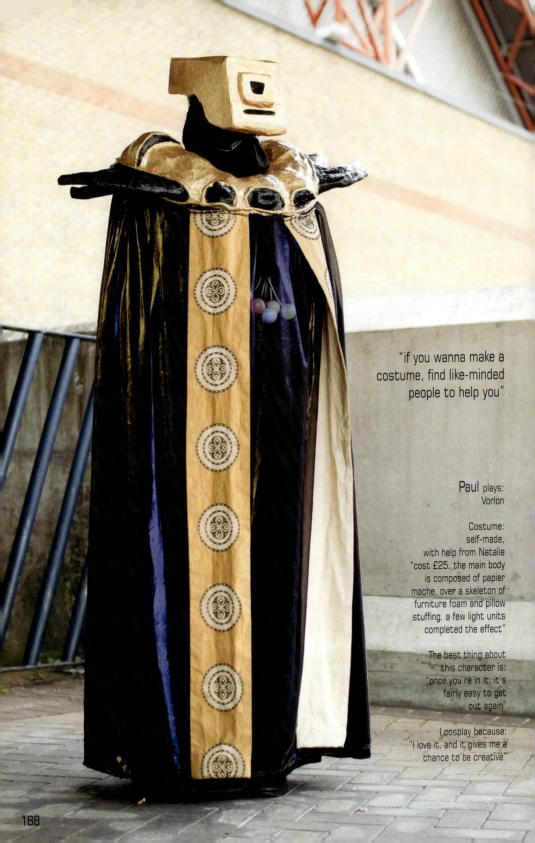

"if you wanna make a costume, find like-minded people to help you"

Paul plays:
Vorlon

Costume:
self-made,
with help from Natalie
"cost £25. the main body
is composed of papier
mache, over a skeleton of
furniture foam and pillow
stuffing. a few light units
completed the effect"

The best thing about
this character is:
"once you're in it, it's
fairly easy to get
out again"

I cosplay because:
"I love it, and it gives me a
chance to be creative"

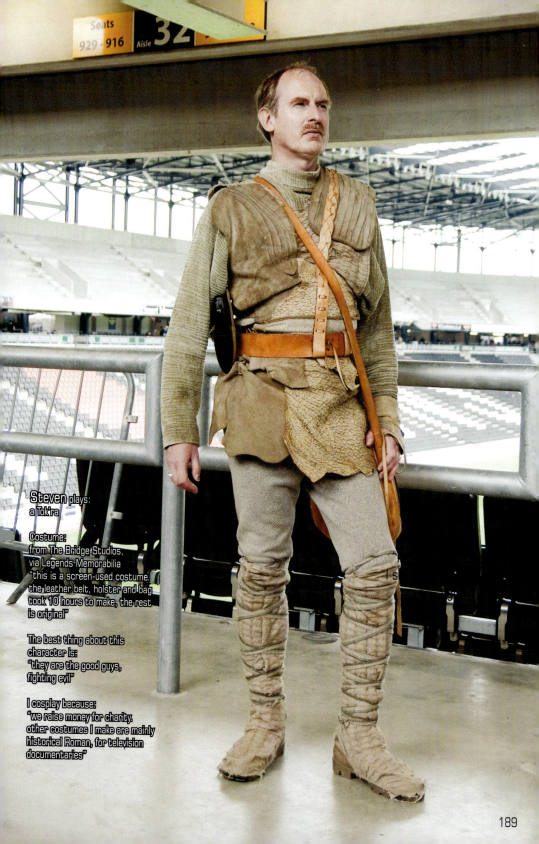

Steven plays:
a Tok'ra

Costume:
from The Bridge Studios,
via Legends Memorabilia
"this is a screen-used costume.
the leather belt, holster and bag
took 10 hours to make, the rest
is original"

The best thing about this
character is:
"they are the good guys,
fighting evil"

I cosplay because:
"we raise money for charity.
other costumes I make are mainly
historical Roman, for television
documentaries"

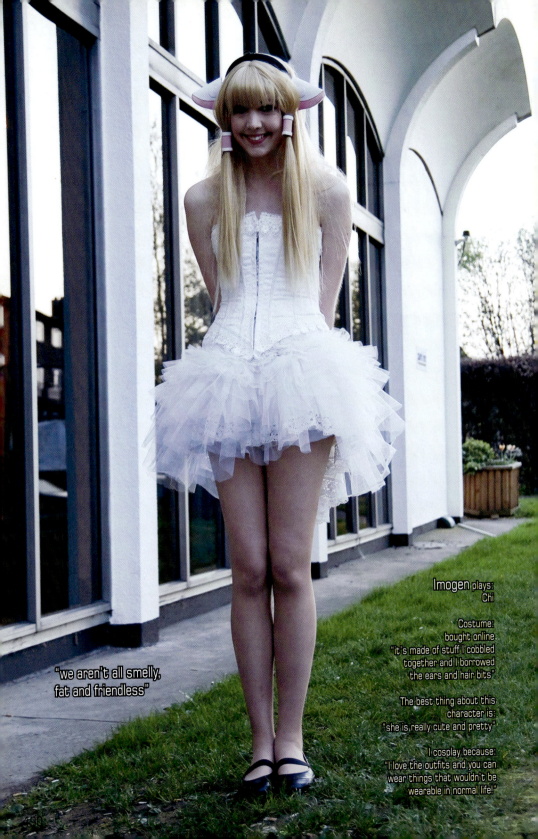

"we aren't all smelly, fat and friendless"

Imogen plays:
Chi

Costume:
bought online
_"it's made of stuff I cobbled
together and I borrowed
the ears and hair bits"_

The best thing about this
character is:
"she is really cute and pretty"

I cosplay because:
_"I love the outfits and you can
wear things that wouldn't be
wearable in normal life!"_

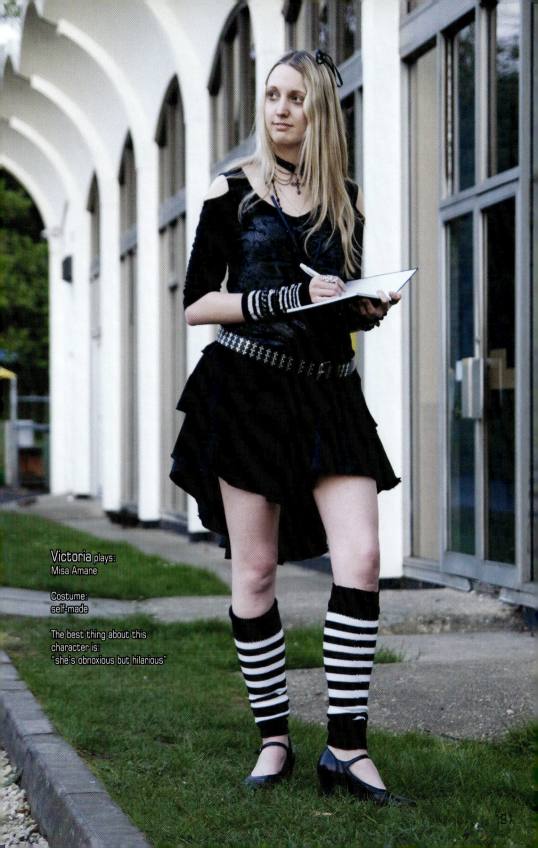

Victoria plays:
Misa Amane

Costume:
self-made

The best thing about this
character is:
"she's obnoxious but hilarious"

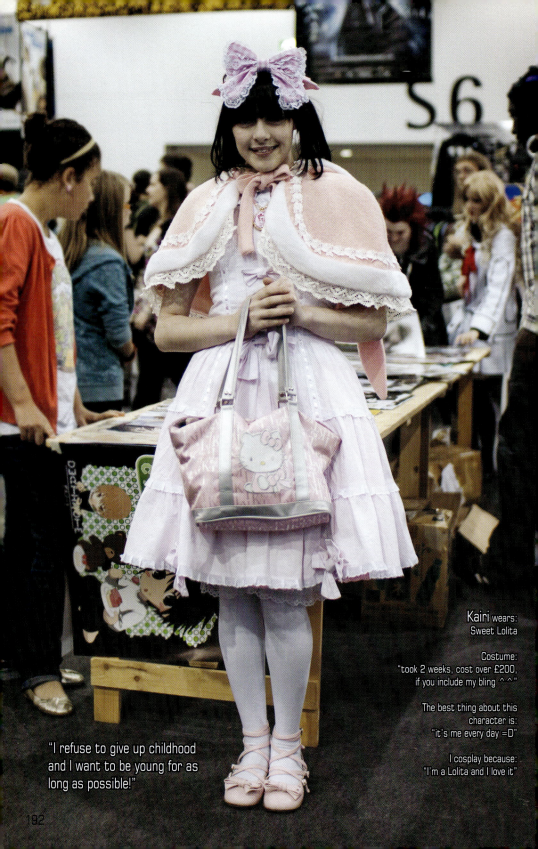

S.6

Kairi wears:
Sweet Lolita

Costume:
"took 2 weeks, cost over £200,
if you include my bling ^.^"

The best thing about this
character is:
"it's me every day =D"

I cosplay because:
"I'm a Lolita and I love it"

"I refuse to give up childhood
and I want to be young for as
long as possible!"

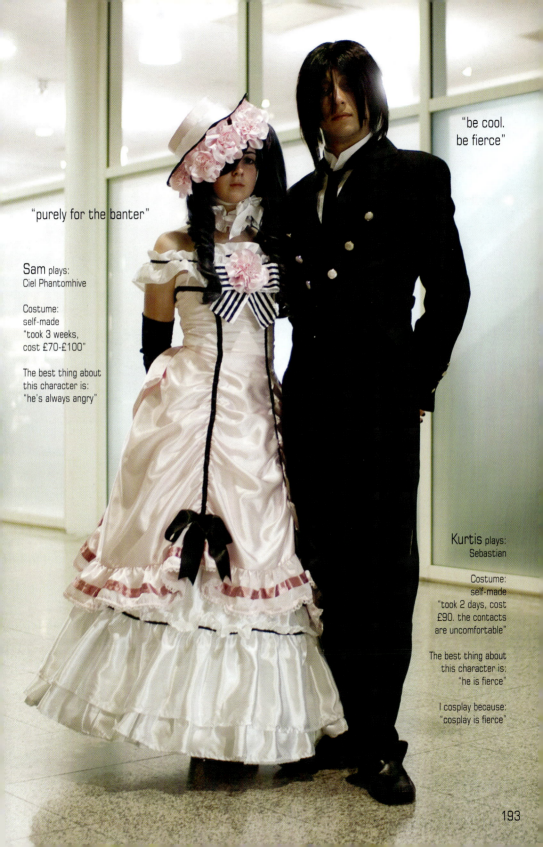

"be cool.
be fierce"

"purely for the banter"

Sam plays:
Ciel Phantomhive

Costume:
self-made
"took 3 weeks,
cost £70-£100"

The best thing about
this character is:
"he's always angry"

Kurtis plays:
Sebastian

Costume:
self-made
"took 2 days, cost
£90. the contacts
are uncomfortable"

The best thing about
this character is:
"he is fierce"

I cosplay because:
"cosplay is fierce"

193

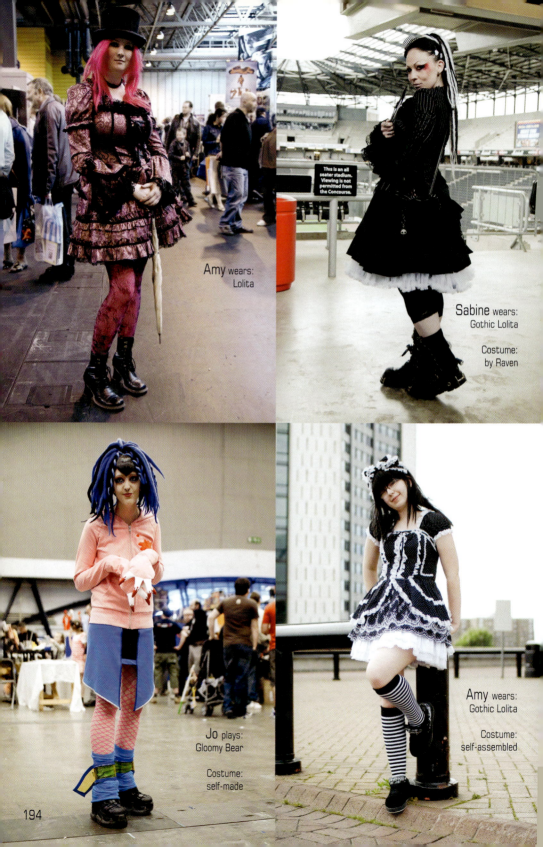

Amy wears:
Lolita

Sabine wears:
Gothic Lolita

Costume:
by Raven

Jo plays:
Gloomy Bear

Costume:
self-made

Amy wears:
Gothic Lolita

Costume:
self-assembled

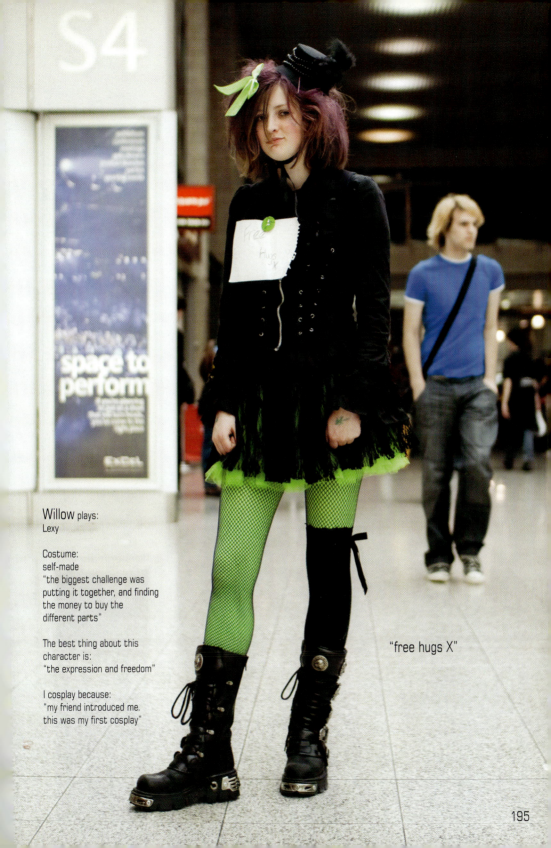

S4

space to perform

Willow plays:
Lexy

Costume:
self-made
"the biggest challenge was
putting it together, and finding
the money to buy the
different parts"

The best thing about this
character is:
"the expression and freedom"

I cosplay because:
"my friend introduced me.
this was my first cosplay"

"free hugs X"

195

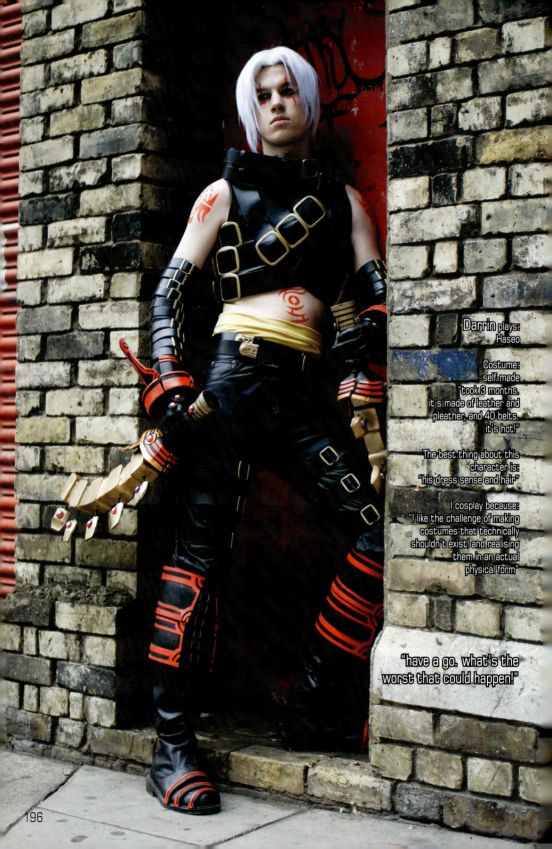

Darrin plays:
Haseo

Costume:
self-made
"took 3 months.
it's made of leather and
pleather, and 40 belts.
it's hot!"

The best thing about this
character is:
"his dress sense and hair"

I cosplay because:
"I like the challenge of making
costumes that technically
shouldn't exist! and realising
them in an actual
physical form"

"have a go. what's the
worst that could happen!"

196

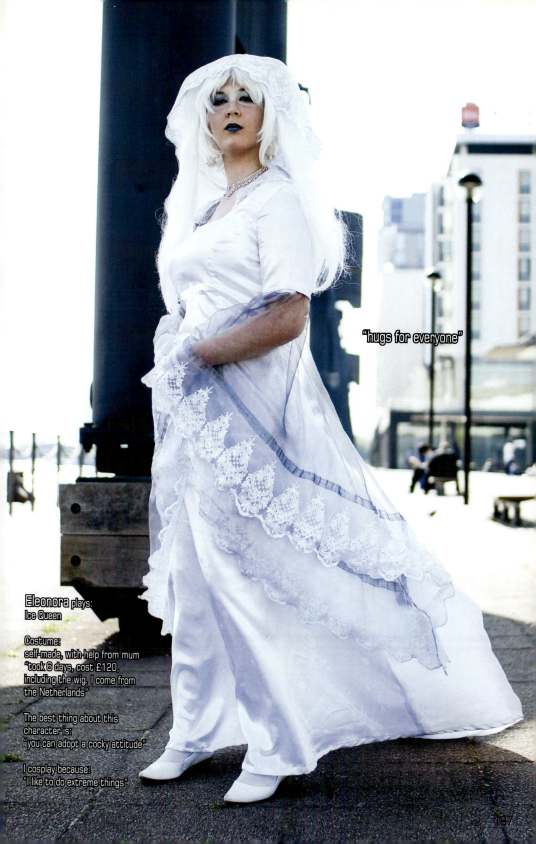

"hugs for everyone"

Eleonora plays:
Ice Queen

Costume:
self-made, with help from mum
"took 6 days, cost £120,
including the wig. I come from
the Netherlands"

The best thing about this
character is:
"you can adopt a cocky attitude"

I cosplay because:
"I like to do extreme things"

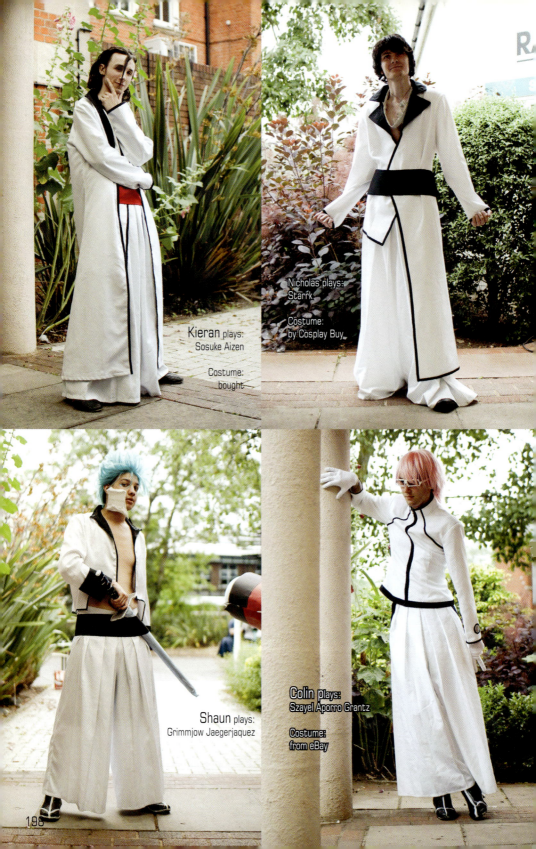

Kieran plays:
Sosuke Aizen

Costume:
bought

Nicholas plays:
Starrk

Costume:
by Cosplay Buy

Shaun plays:
Grimmjow Jaegerjaquez

Colin plays:
Szayel Aporro Grantz

Costume:
from eBay

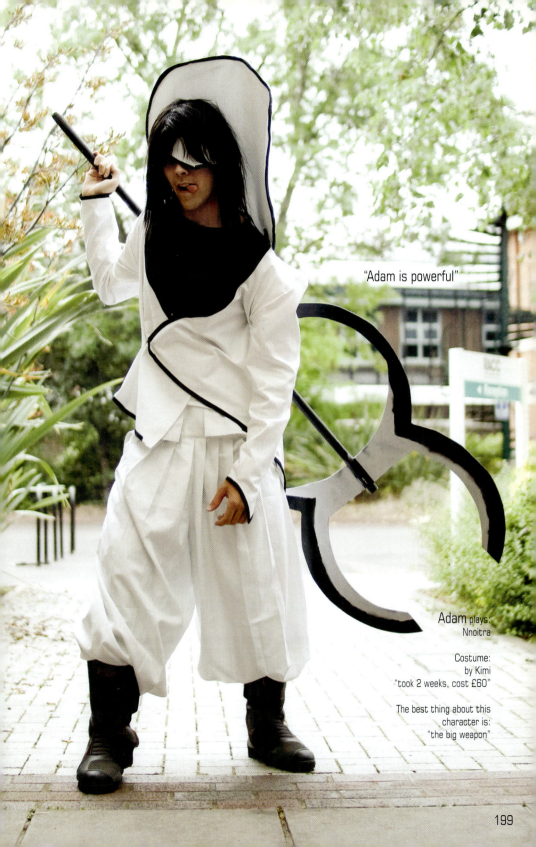

"Adam is powerful"

Adam plays:
Nnoitra

Costume:
by Kimi
"took 2 weeks, cost £60"

The best thing about this
character is:
"the big weapon"

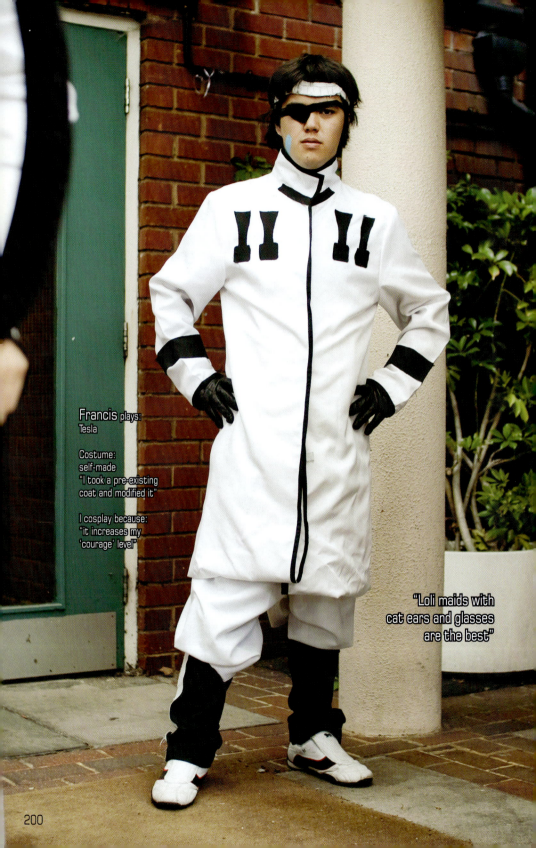

Francis plays:
Tesla

Costume:
self-made
"I took a pre-existing
coat and modified it"

I cosplay because:
"it increases my
'courage' level"

"Loli maids with
cat ears and glasses
are the best"

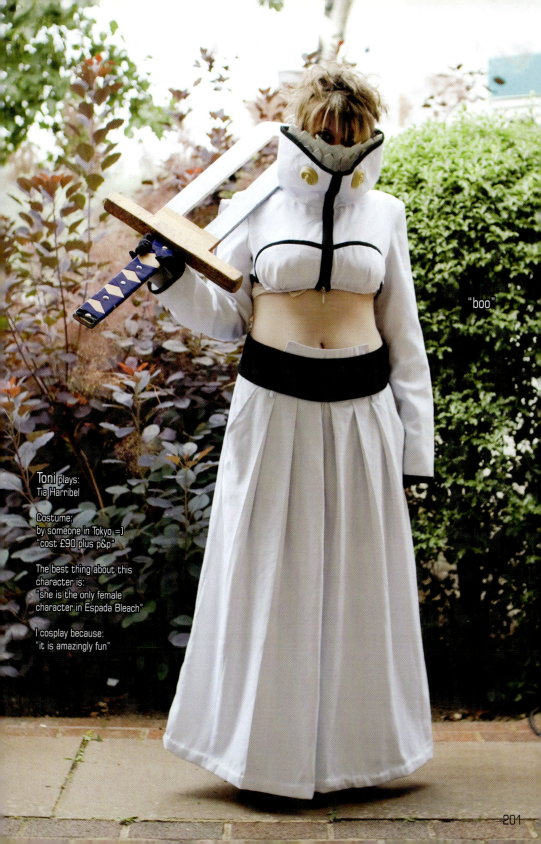

"boo"

Toni plays:
Tia Harribel

Costume:
by someone in Tokyo =)
"cost £90 plus p&p"

The best thing about this
character is:
"she is the only female
character in Espada Bleach"

I cosplay because:
"it is amazingly fun"

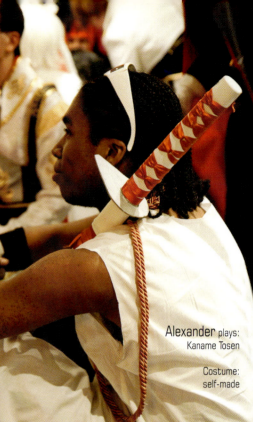

Rebecca plays:
Itachi Uchiha

Costume:
self-made,
with help from
QQ Cosplay

Alexander plays:
Kaname Tosen

Costume:
self-made

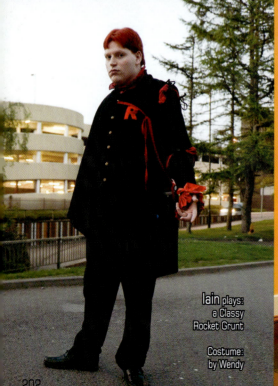

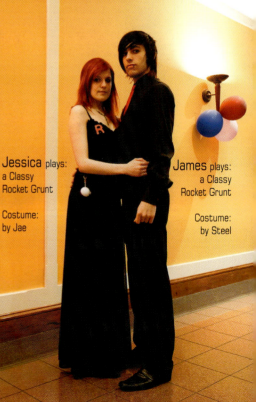

Jessica plays:
a Classy
Rocket Grunt

Costume:
by Jae

James plays:
a Classy
Rocket Grunt

Costume:
by Steel

Iain plays:
a Classy
Rocket Grunt

Costume:
by Wendy

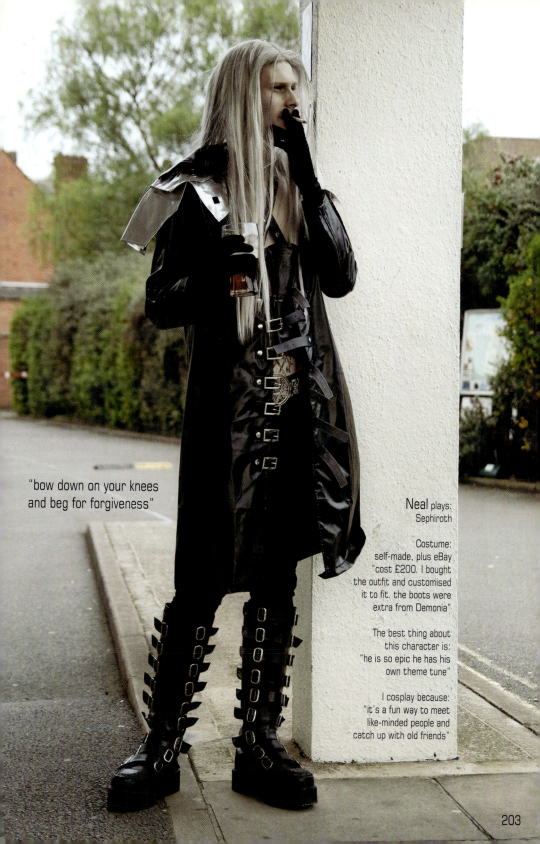

"bow down on your knees
and beg for forgiveness"

Neal plays:
Sephiroth

Costume:
self-made, plus eBay
"cost £200. I bought
the outfit and customised
it to fit. the boots were
extra from Demonia"

The best thing about
this character is:
"he is so epic he has his
own theme tune"

I cosplay because:
"it's a fun way to meet
like-minded people and
catch up with old friends"

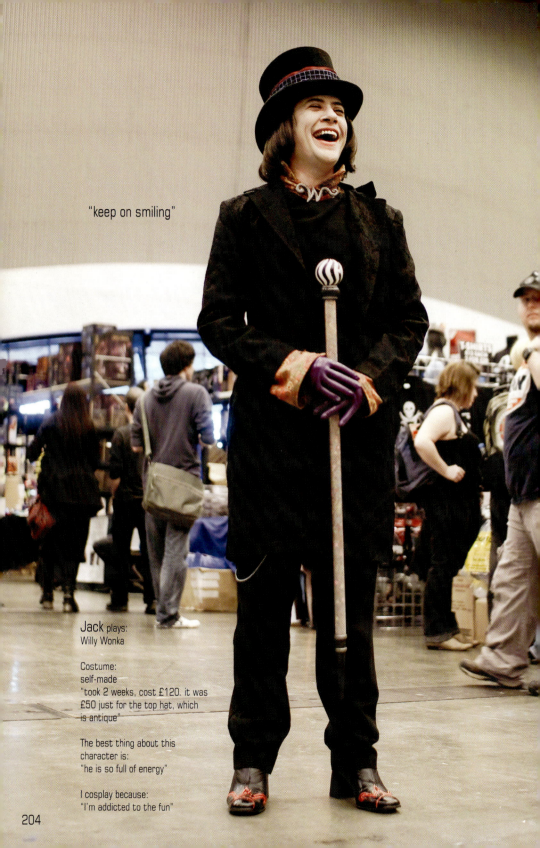

"keep on smiling"

Jack plays:
Willy Wonka

Costume:
self-made
"took 2 weeks, cost £120. it was
£50 just for the top hat, which
is antique"

The best thing about this
character is:
"he is so full of energy"

I cosplay because:
"I'm addicted to the fun"

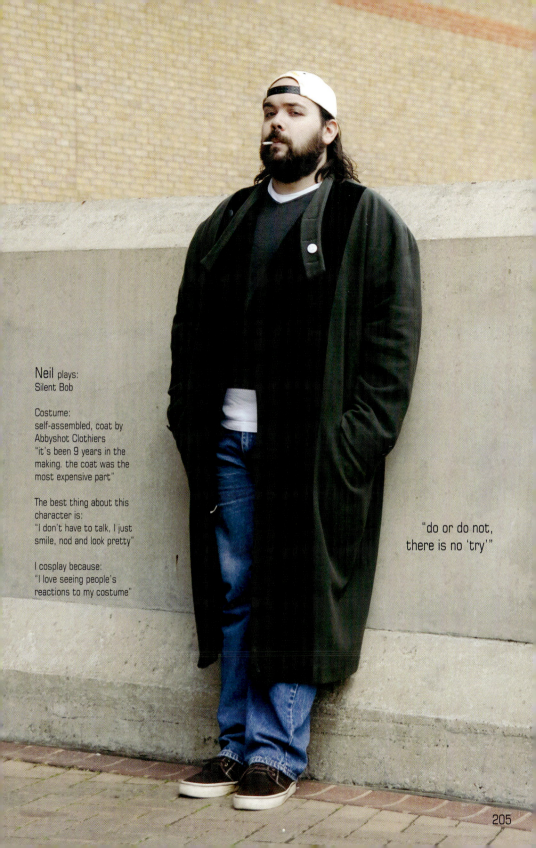

Neil plays:
Silent Bob

Costume:
self-assembled, coat by
Abbyshot Clothiers
"it's been 9 years in the
making. the coat was the
most expensive part"

The best thing about this
character is:
"I don't have to talk, I just
smile, nod and look pretty"

I cosplay because:
"I love seeing people's
reactions to my costume"

"do or do not,
there is no 'try'"

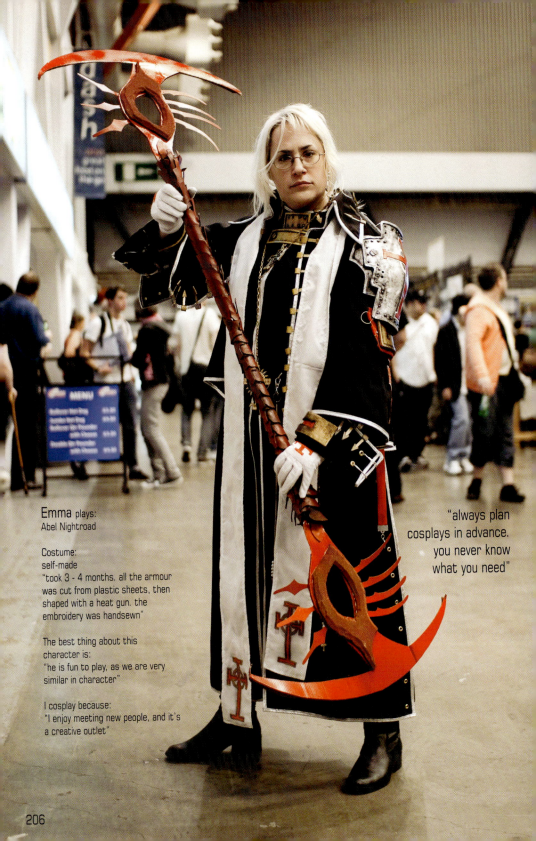

Emma plays:
Abel Nightroad

Costume:
self-made
"took 3 - 4 months. all the armour
was cut from plastic sheets, then
shaped with a heat gun. the
embroidery was handsewn"

The best thing about this
character is:
"he is fun to play, as we are very
similar in character"

I cosplay because:
"I enjoy meeting new people, and it's
a creative outlet"

"always plan
cosplays in advance.
you never know
what you need"

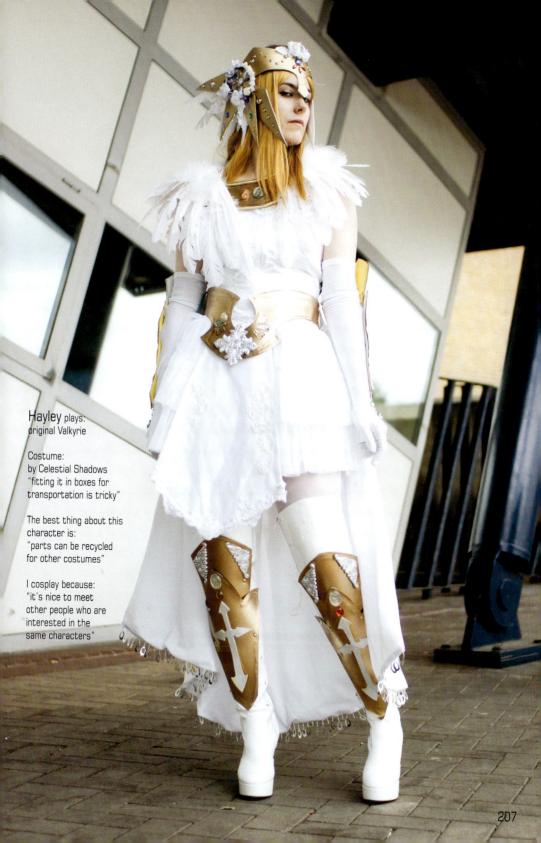

Hayley plays:
original Valkyrie

Costume:
by Celestial Shadows
"fitting it in boxes for
transportation is tricky"

The best thing about this
character is:
"parts can be recycled
for other costumes"

I cosplay because:
"it's nice to meet
other people who are
interested in the
same characters"

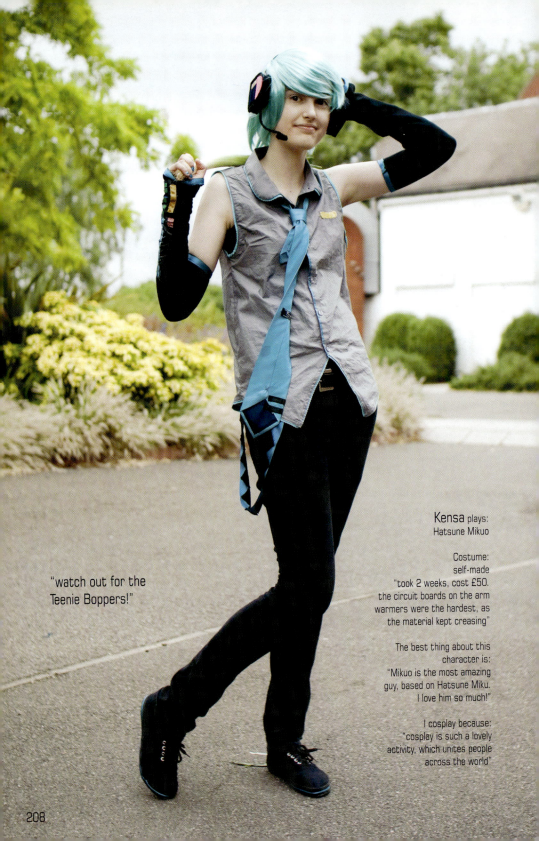

"watch out for the
Teenie Boppers!"

Kensa plays:
Hatsune Mikuo

Costume:
self-made
"took 2 weeks, cost £50.
the circuit boards on the arm
warmers were the hardest, as
the material kept creasing"

The best thing about this
character is:
"Mikuo is the most amazing
guy, based on Hatsune Miku.
I love him so much!"

I cosplay because:
"cosplay is such a lovely
activity, which unites people
across the world"

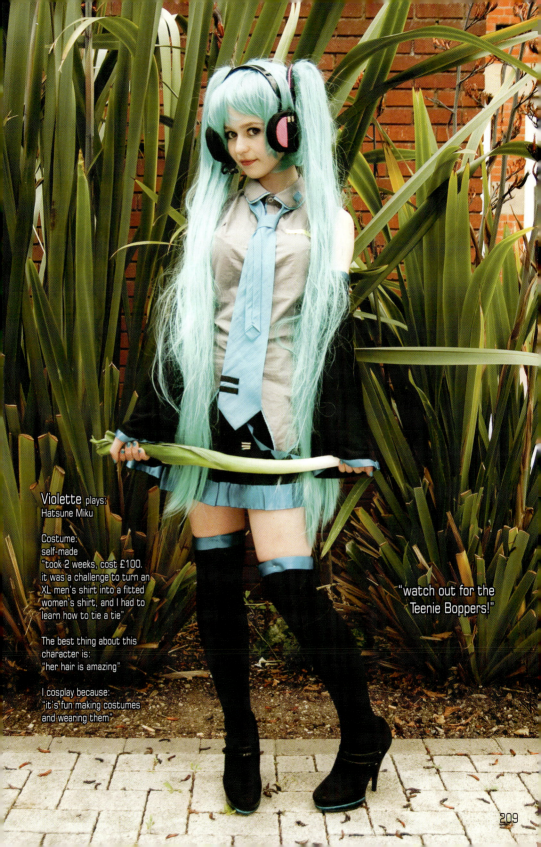

Violette plays:
Hatsune Miku

Costume:
self-made
"took 2 weeks, cost £100.
it was a challenge to turn an
XL men's shirt into a fitted
women's shirt, and I had to
learn how to tie a tie"

The best thing about this
character is:
"her hair is amazing"

I cosplay because:
"it's fun making costumes
and wearing them"

"watch out for the
Teenie Boppers!"

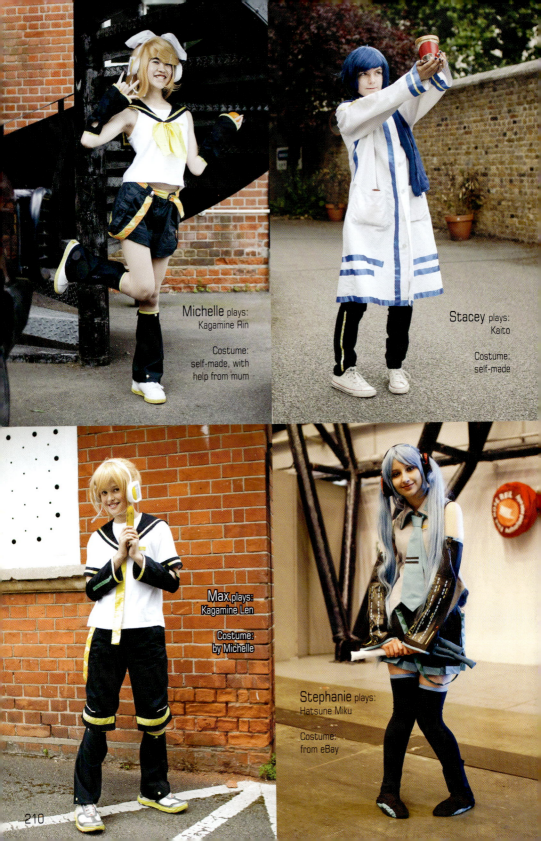

Michelle plays:
Kagamine Rin

Costume:
self-made, with
help from mum

Stacey plays:
Kaito

Costume:
self-made

Max plays:
Kagamine Len

Costume:
by Michelle

Stephanie plays:
Hatsune Miku

Costume:
from eBay

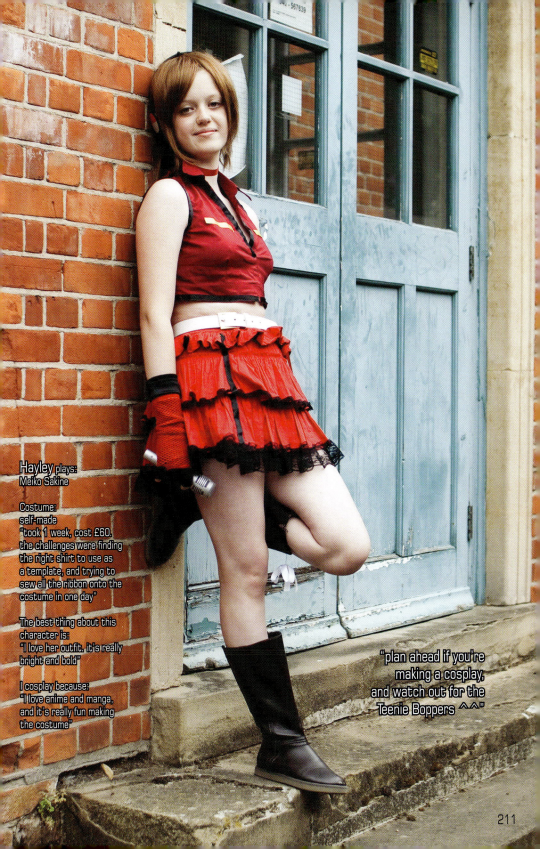

Hayley plays:
Meiko Sakine

Costume:
self-made
"took 1 week, cost £60.
the challenges were finding
the right shirt to use as
a template, and trying to
sew all the ribbon onto the
costume in one day"

The best thing about this
character is:
"I love her outfit, it's really
bright and bold"

I cosplay because:
"I love anime and manga,
and it's really fun making
the costume"

"plan ahead if you're
making a cosplay,
and watch out for the
Teenie Boppers ^^"

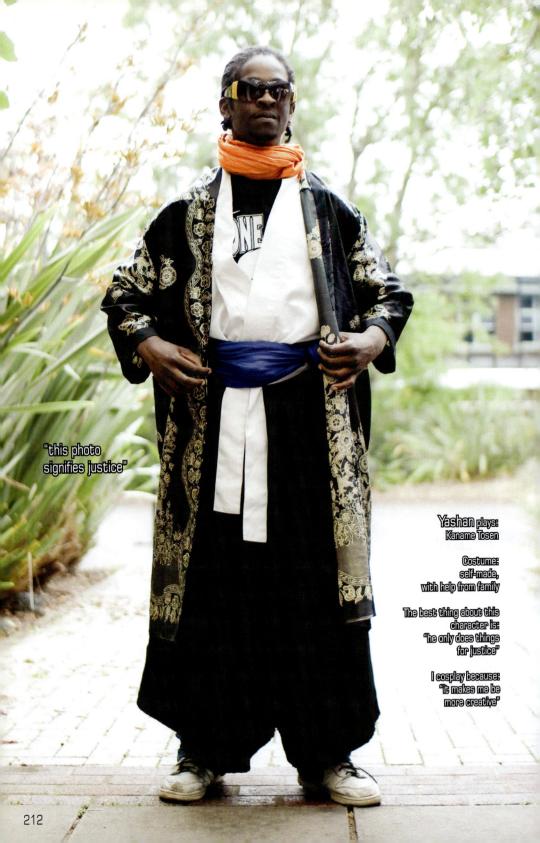

"this photo
signifies justice"

Yashan plays:
Kaname Tōsen

Costume:
self-made,
with help from family

The best thing about this
character is:
"he only does things
for justice"

I cosplay because:
"it makes me be
more creative"

212

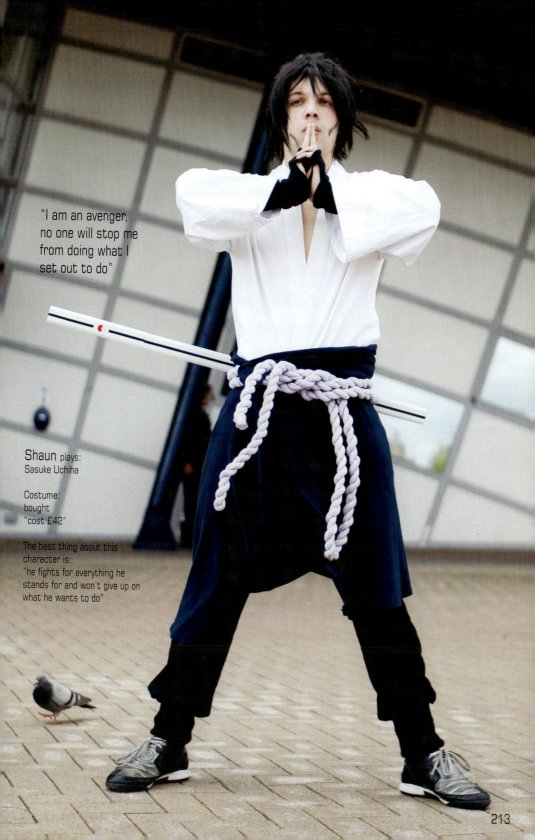

"I am an avenger, no one will stop me from doing what I set out to do"

Shaun plays:
Sasuke Uchiha

Costume:
bought
"cost £42"

The best thing about this character is:
"he fights for everything he stands for and won't give up on what he wants to do"

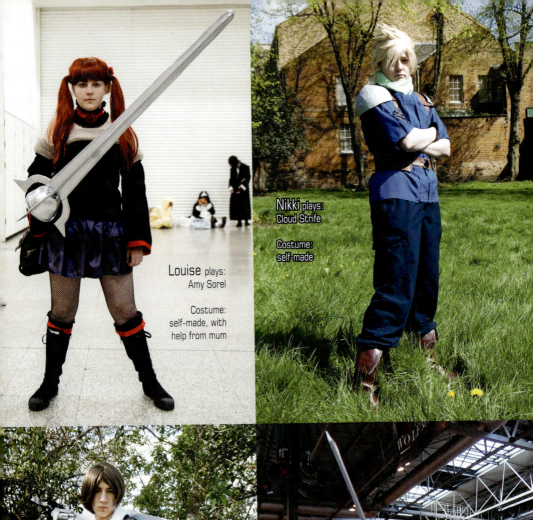

Louise plays:
Amy Sorel

Costume:
self-made, with
help from mum

Nikki plays:
Cloud Strife

Costume:
self-made

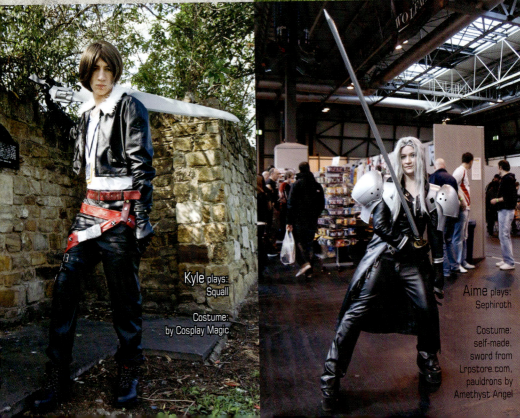

Kyle plays:
Squall

Costume:
by Cosplay Magic

Aime plays:
Sephiroth

Costume:
self-made,
sword from
Lrpstore.com,
pauldrons by
Amethyst Angel

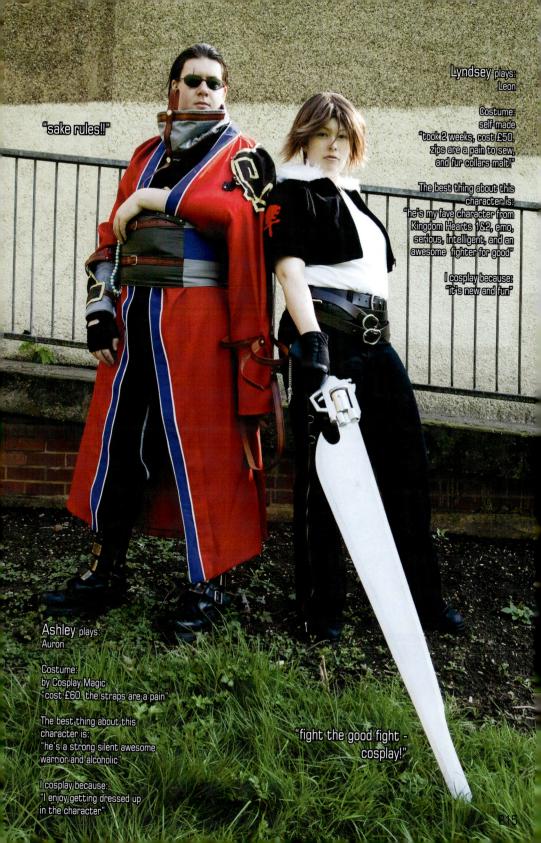

"sake rules!!"

Lyndsey plays:
Leon

Costume:
self-made
"took 2 weeks, cost £50,
zips are a pain to sew,
and fur collars malt!"

The best thing about this
character is:
"he's my fave character from
Kingdom Hearts 1&2, emo,
serious, intelligent, and an
awesome fighter for good"

I cosplay because:
"it's new and fun"

Ashley plays:
Auron

Costume:
by Cosplay Magic
"cost £60. the straps are a pain"

The best thing about this
character is:
"he's a strong silent awesome
warrior and alcoholic"

I cosplay because:
"I enjoy getting dressed up
in the character"

"fight the good fight -
cosplay!"

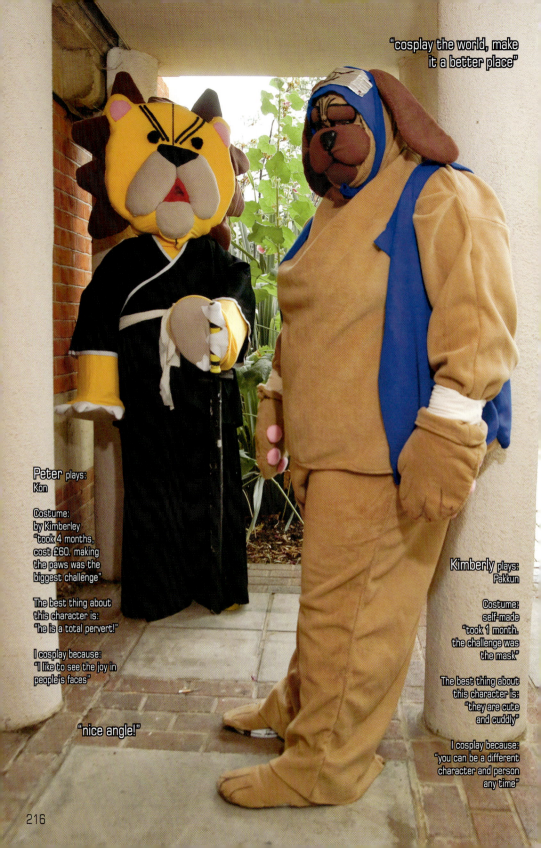

"cosplay the world, make it a better place"

Peter plays:
Kon

Costume:
by Kimberley
"took 4 months, cost £60. making the paws was the biggest challenge"

The best thing about this character is:
"he is a total pervert!"

I cosplay because:
"I like to see the joy in people's faces"

"nice angle!"

Kimberly plays:
Pakkun

Costume:
self-made
"took 1 month. the challenge was the mask"

The best thing about this character is:
"they are cute and cuddly"

I cosplay because:
"you can be a different character and person any time"

216

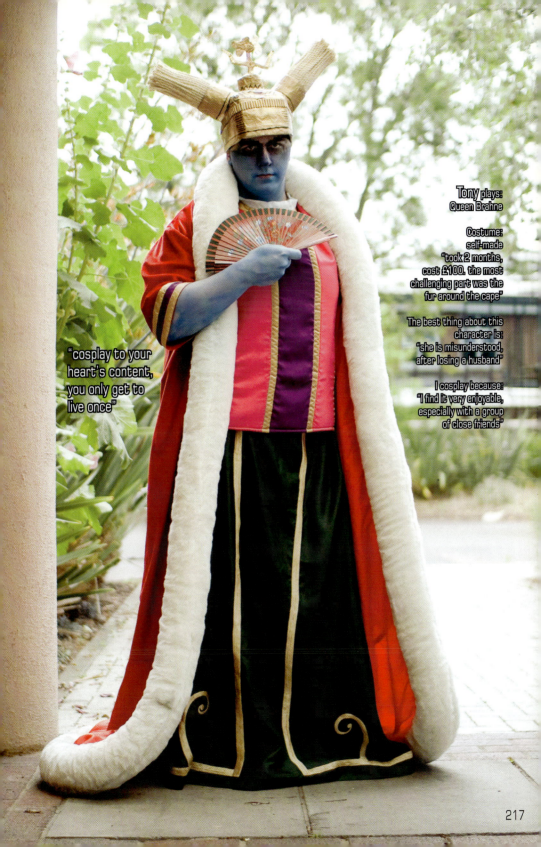

Tony plays:
Queen Brahne

Costume:
self-made
"took 2 months,
cost £100. the most
challenging part was the
fur around the cape"

The best thing about this
character is:
"she is misunderstood,
after losing a husband"

I cosplay because:
"I find it very enjoyable,
especially with a group
of close friends"

"cosplay to your
heart's content,
you only get to
live once"

217

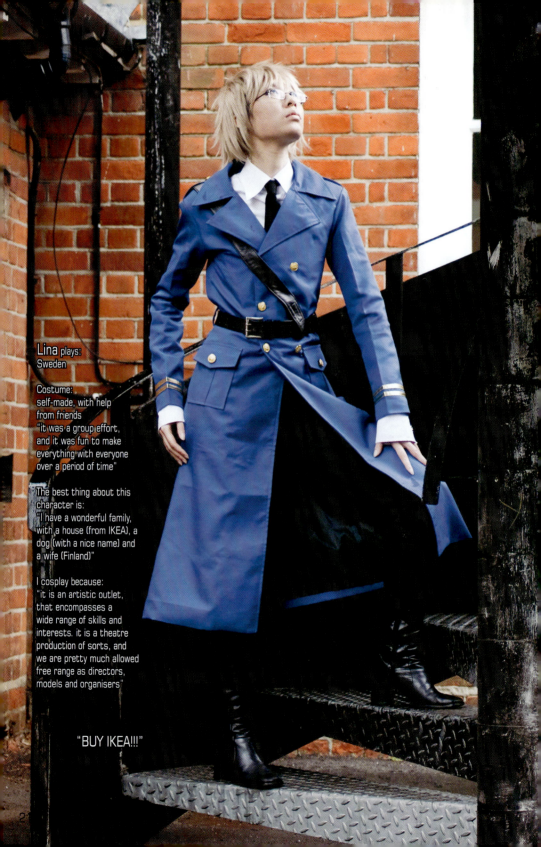

Lina plays:
Sweden

Costume:
self-made, with help
from friends
"it was a group effort,
and it was fun to make
everything with everyone
over a period of time"

The best thing about this
character is:
"I have a wonderful family,
with a house (from IKEA), a
dog (with a nice name) and
a wife (Finland)"

I cosplay because:
"it is an artistic outlet,
that encompasses a
wide range of skills and
interests. it is a theatre
production of sorts, and
we are pretty much allowed
free range as directors,
models and organisers"

"BUY IKEA!!!"

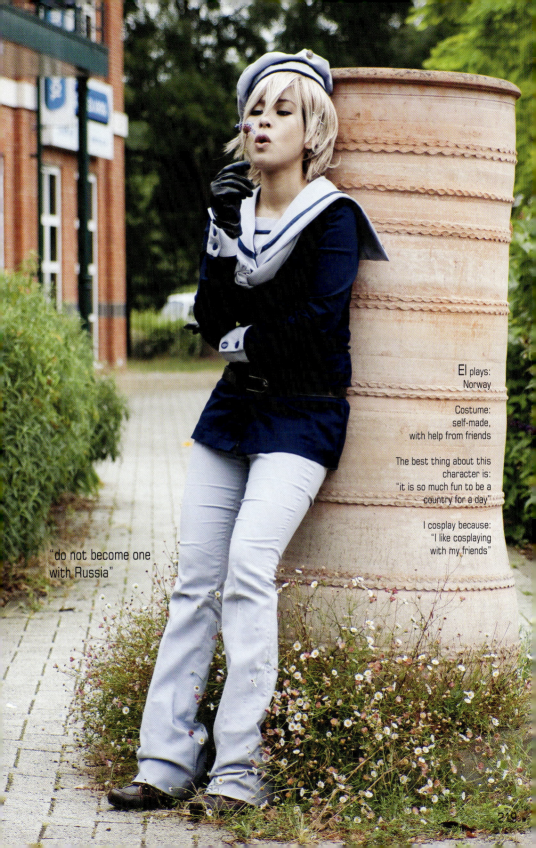

El plays:
Norway

Costume:
self-made,
with help from friends

The best thing about this
character is:
"it is so much fun to be a
country for a day"

I cosplay because:
"I like cosplaying
with my friends"

"do not become one
with Russia"

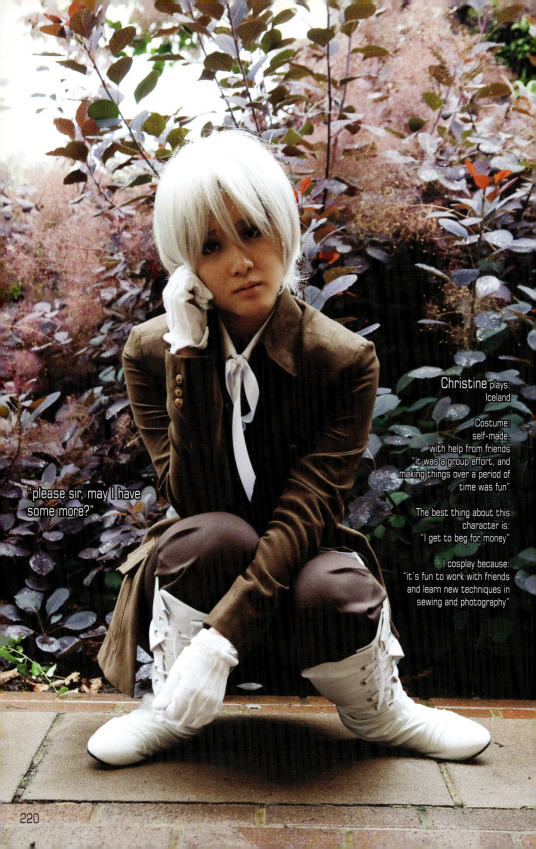

"please sir, may I have some more?"

Christine plays:
Iceland

Costume:
self-made;
with help from friends
"it was a group effort, and
making things over a period of
time was fun"

The best thing about this
character is:
"I get to beg for money"

I cosplay because:
"it's fun to work with friends
and learn new techniques in
sewing and photography"

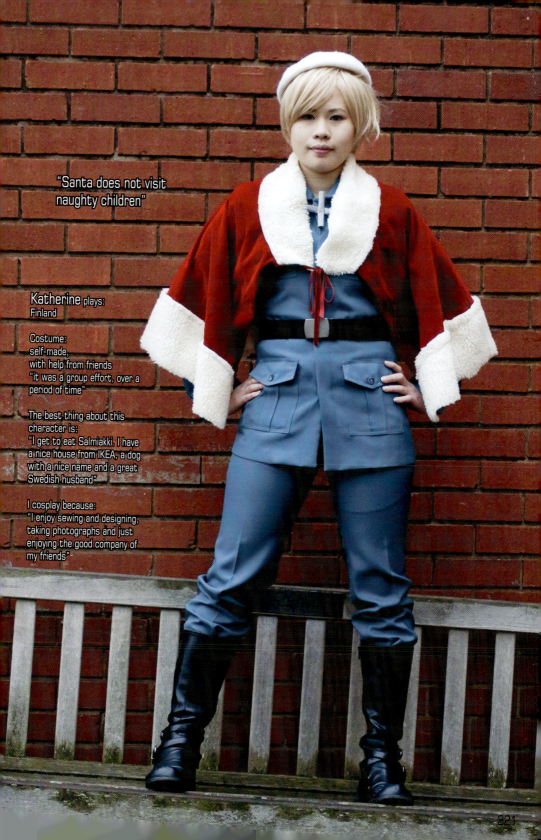

"Santa does not visit naughty children"

Katherine plays:
Finland

Costume:
self-made,
with help from friends
"it was a group effort, over a period of time"

The best thing about this character is:
"I get to eat Salmiakki. I have a nice house from IKEA, a dog with a nice name and a great Swedish husband"

I cosplay because:
"I enjoy sewing and designing, taking photographs and just enjoying the good company of my friends"

Elizabeth plays:
Dejiko

Costume:
self-made
"the dress took 2 weeks, and
was based on another pattern
which I adjusted. the bells are
papier mache and took 1 week.
the boots and gloves are my own
design and took a day each"

The best thing about
this character is:
"she is a hyper cute mega fun
super amazing cat girl"

I cosplay because:
"I love to dress up and have
everyone look at me"

"don't buy your costume
- it's cheating"

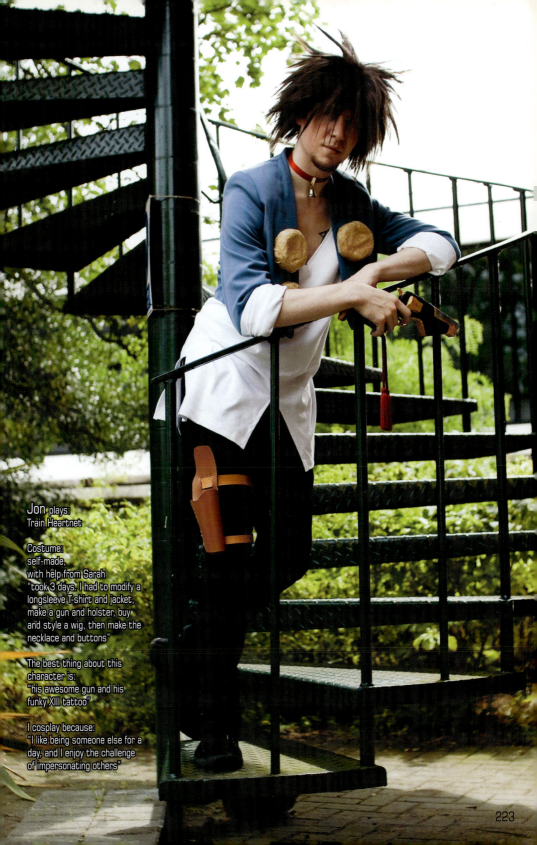

Jon plays:
Train Heartnet

Costume:
self-made,
with help from Sarah
"took 3 days. I had to modify a
longsleeve T-shirt and jacket,
make a gun and holster, buy
and style a wig, then make the
necklace and buttons"

The best thing about this
character is:
"his awesome gun and his
funky XIII tattoo"

I cosplay because:
"I like being someone else for a
day, and I enjoy the challenge
of impersonating others"

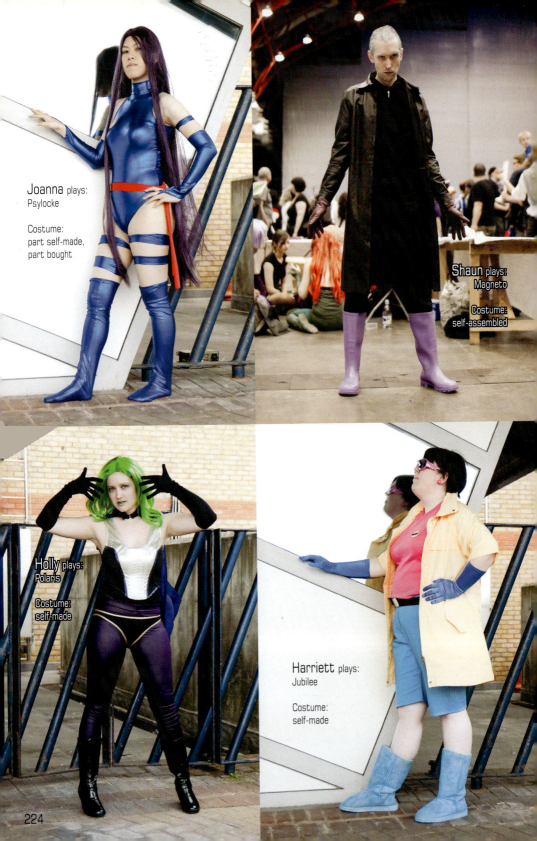

Joanna plays:
Psylocke

Costume:
part self-made,
part bought

Shaun plays:
Magneto

Costume:
self-assembled

Holly plays:
Polaris

Costume:
self-made

Harriett plays:
Jubilee

Costume:
self-made

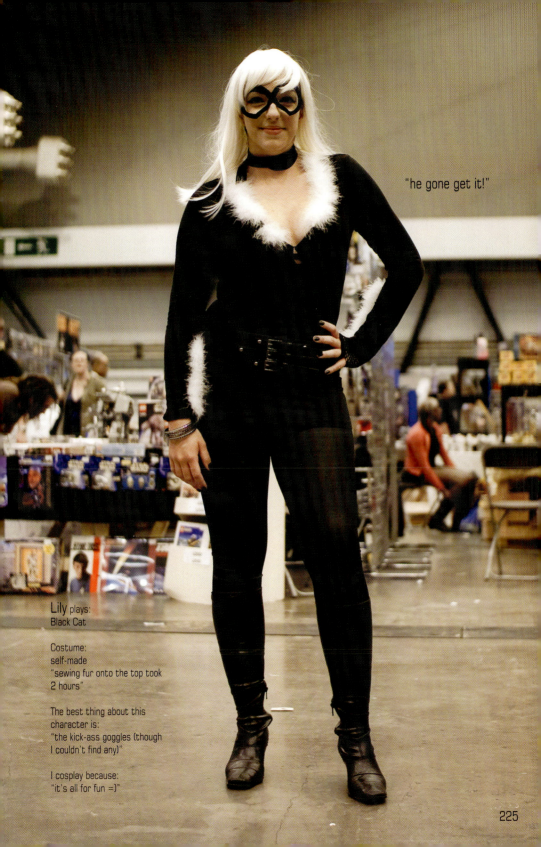

"he gone get it!"

Lily plays:
Black Cat

Costume:
self-made
"sewing fur onto the top took
2 hours"

The best thing about this
character is:
"the kick-ass goggles (though
I couldn't find any)"

I cosplay because:
"it's all for fun =)"

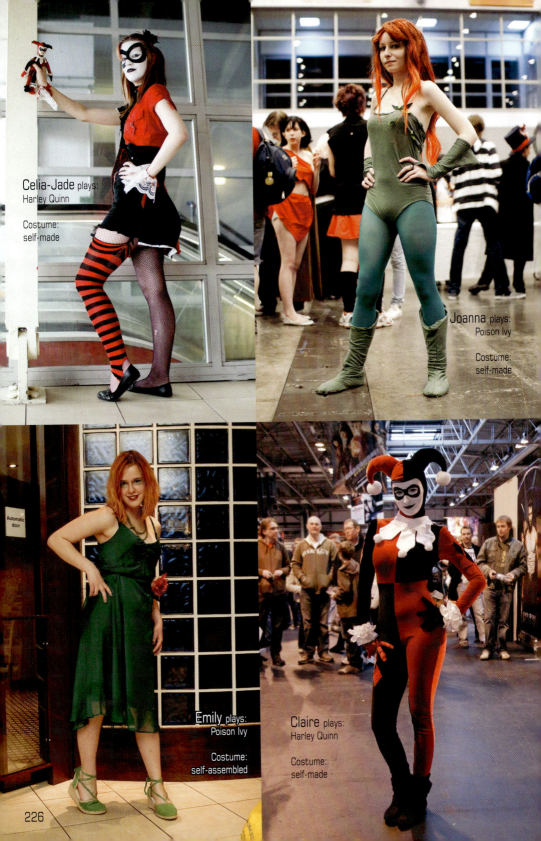

Celia-Jade plays:
Harley Quinn

Costume:
self-made

Joanna plays:
Poison Ivy

Costume:
self-made

Emily plays:
Poison Ivy

Costume:
self-assembled

Claire plays:
Harley Quinn

Costume:
self-made

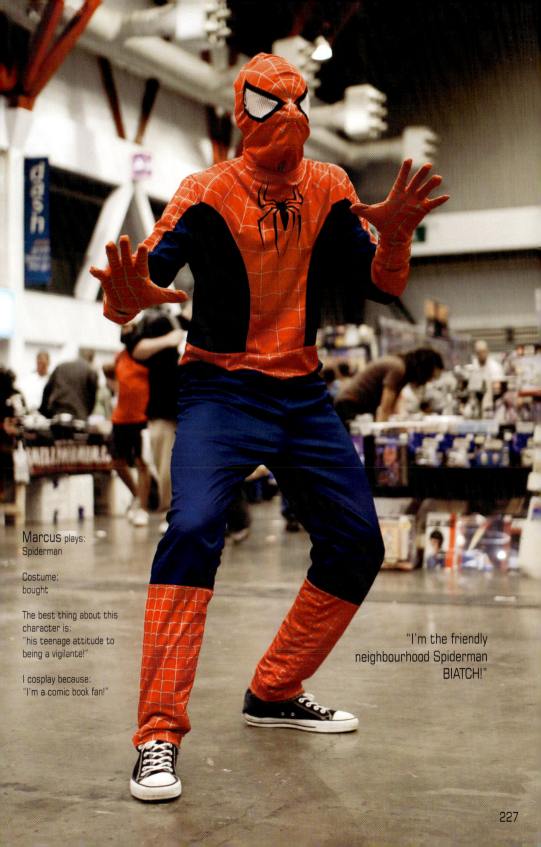

Marcus plays:
Spiderman

Costume:
bought

The best thing about this
character is:
"his teenage attitude to
being a vigilante!"

I cosplay because:
"I'm a comic book fan!"

"I'm the friendly
neighbourhood Spiderman
BIATCH!"

227

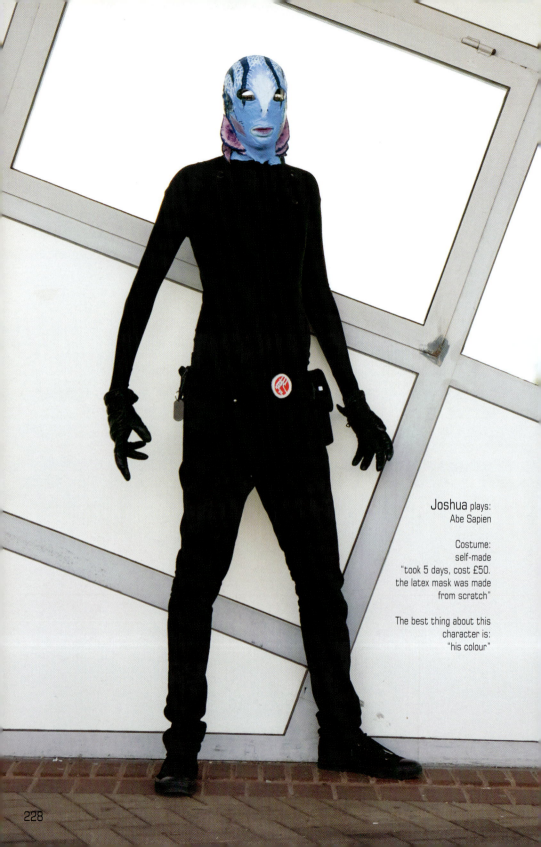

Joshua plays:
Abe Sapien

Costume:
self-made
"took 5 days, cost £50.
the latex mask was made
from scratch"

The best thing about this
character is:
"his colour"

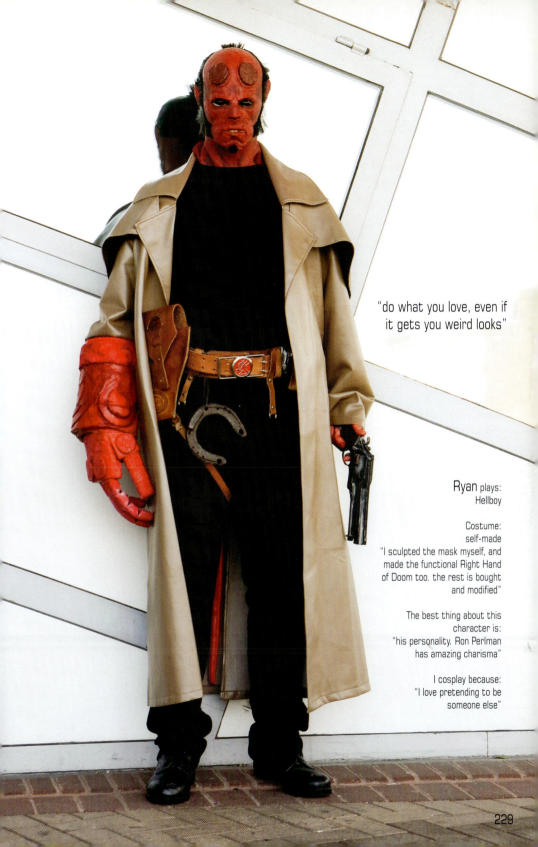

"do what you love, even if it gets you weird looks"

Ryan plays:
Hellboy

Costume:
self-made
"I sculpted the mask myself, and made the functional Right Hand of Doom too. the rest is bought and modified"

The best thing about this character is:
"his personality. Ron Perlman has amazing charisma"

I cosplay because:
"I love pretending to be someone else"

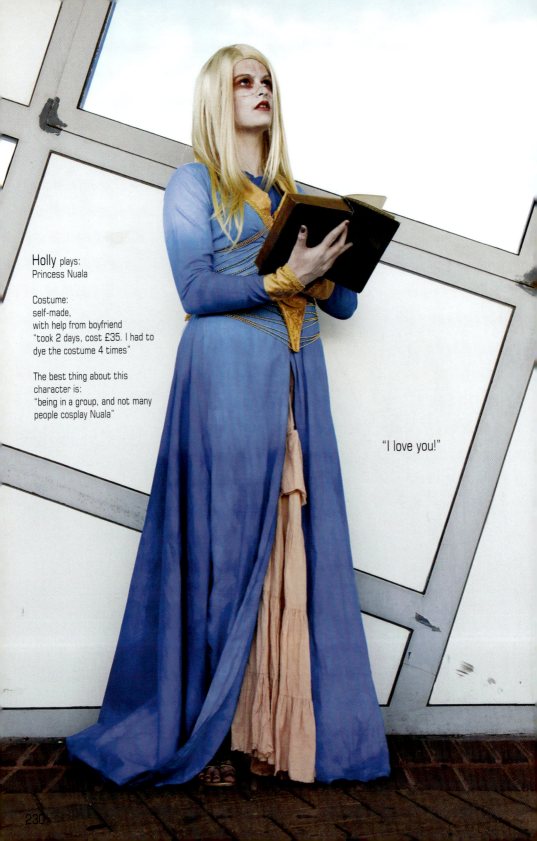

Holly plays:
Princess Nuala

Costume:
self-made,
with help from boyfriend
"took 2 days, cost £35. I had to
dye the costume 4 times"

The best thing about this
character is:
"being in a group, and not many
people cosplay Nuala"

"I love you!"

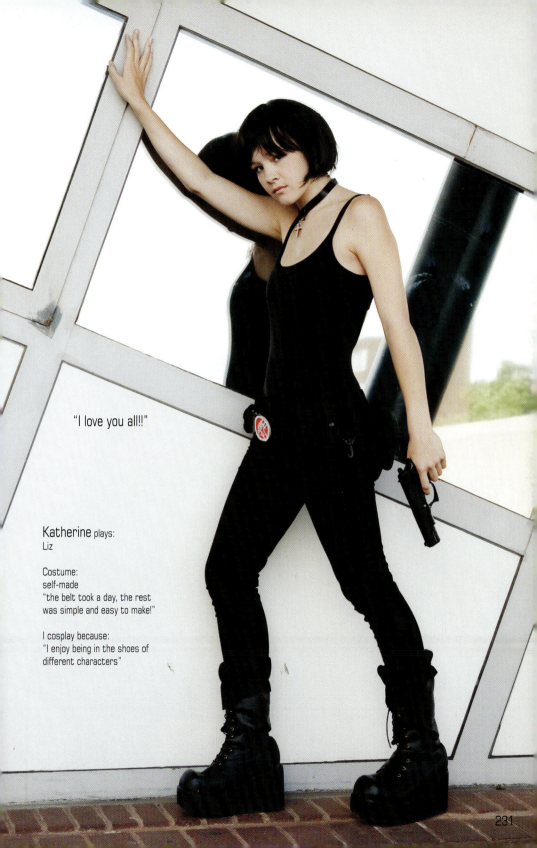

"I love you all!!"

Katherine plays:
Liz

Costume:
self-made
"the belt took a day, the rest
was simple and easy to make!"

I cosplay because:
"I enjoy being in the shoes of
different characters"

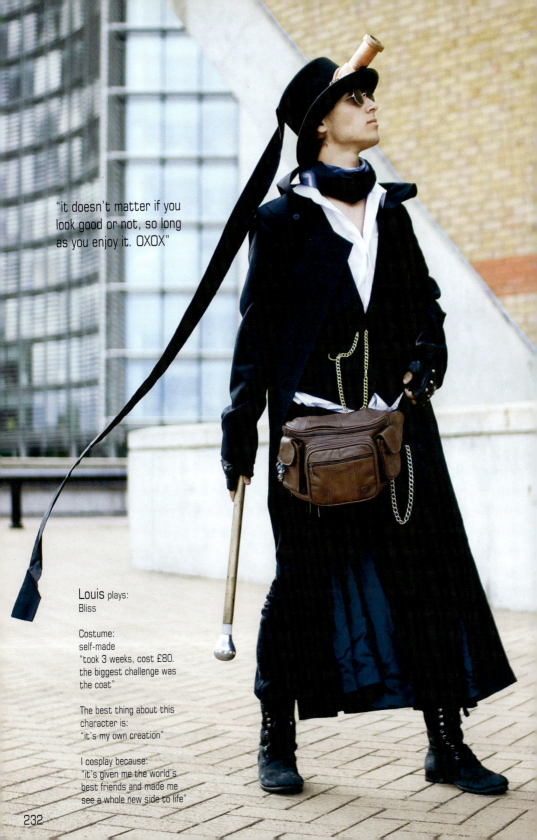

"it doesn't matter if you look good or not, so long as you enjoy it. OXOX"

Louis plays:
Bliss

Costume:
self-made
"took 3 weeks, cost £80.
the biggest challenge was
the coat"

The best thing about this
character is:
"it's my own creation"

I cosplay because:
"it's given me the world's
best friends and made me
see a whole new side to life"

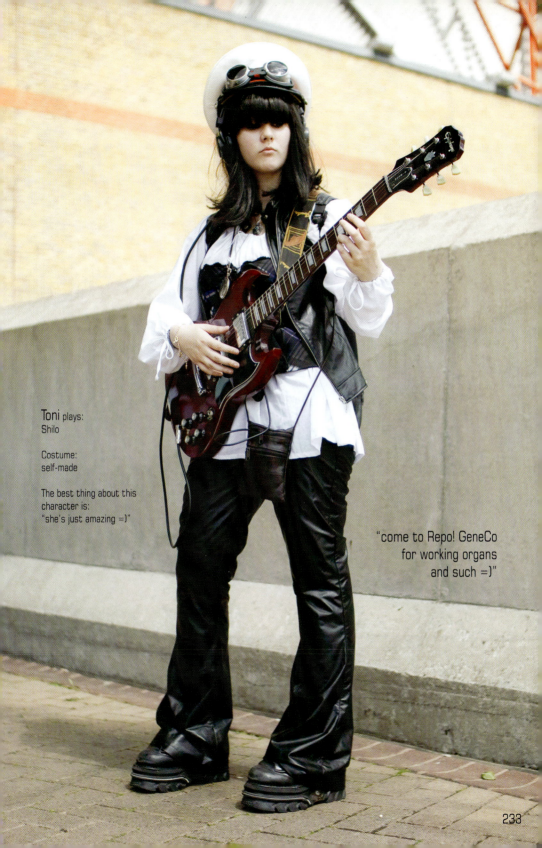

Toni plays:
Shilo

Costume:
self-made

The best thing about this
character is:
"she's just amazing =)"

"come to Repo! GeneCo
for working organs
and such =)"

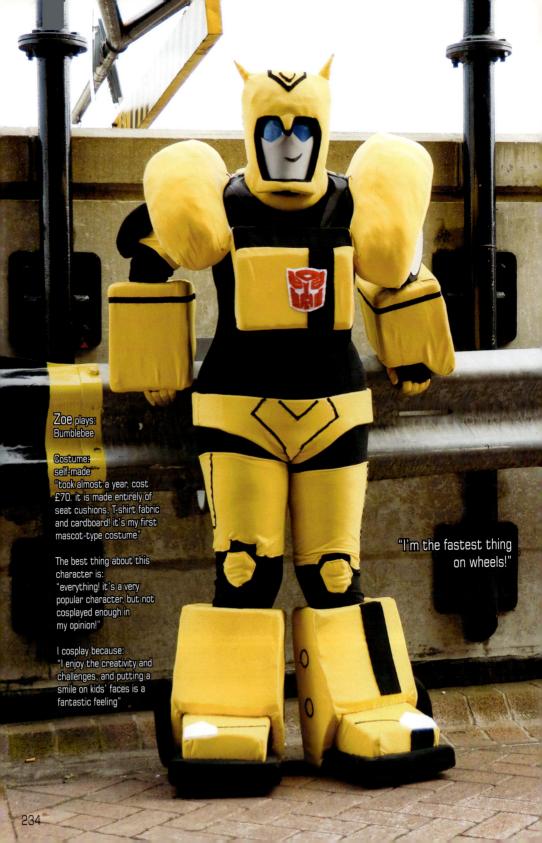

Zoe plays:
Bumblebee

Costume:
self-made
"took almost a year, cost
£70. it is made entirely of
seat cushions, T-shirt fabric
and cardboard! it's my first
mascot-type costume"

The best thing about this
character is:
"everything! it's a very
popular character, but not
cosplayed enough in
my opinion!"

I cosplay because:
"I enjoy the creativity and
challenges, and putting a
smile on kids' faces is a
fantastic feeling"

"I'm the fastest thing
on wheels!"

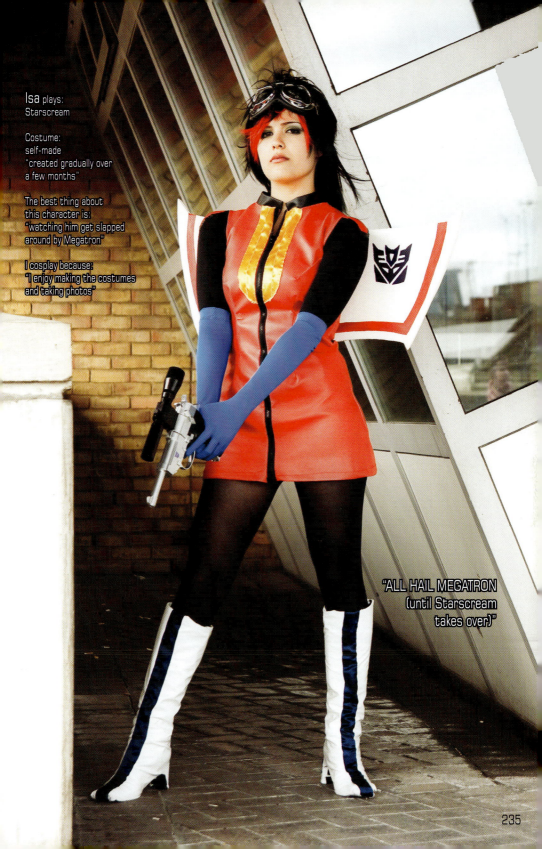

Isa plays:
Starscream

Costume:
self-made
"created gradually over
a few months"

The best thing about
this character is:
"watching him get slapped
around by Megatron"

I cosplay because:
"I enjoy making the costumes
and taking photos"

"ALL HAIL MEGATRON
(until Starscream
takes over)"

235

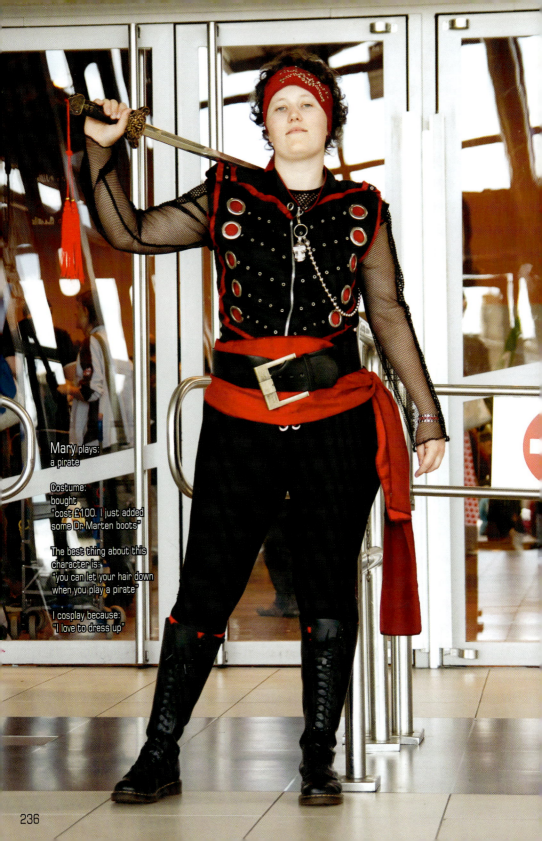

Mary plays:
a pirate

Costume:
bought
"cost £100. I just added
some Dr Marten boots"

The best thing about this
character is:
"you can let your hair down
when you play a pirate"

I cosplay because:
"I love to dress up"

236

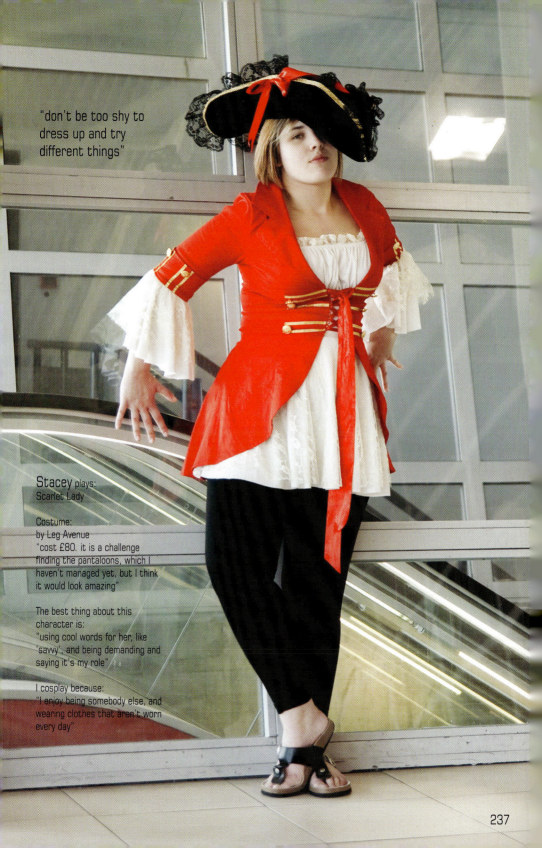

"don't be too shy to dress up and try different things"

Stacey plays:
Scarlet Lady

Costume:
by Leg Avenue
"cost £80. it is a challenge finding the pantaloons, which I haven't managed yet, but I think it would look amazing"

The best thing about this character is:
"using cool words for her, like 'savvy', and being demanding and saying it's my role"

I cosplay because:
"I enjoy being somebody else, and wearing clothes that aren't worn every day"

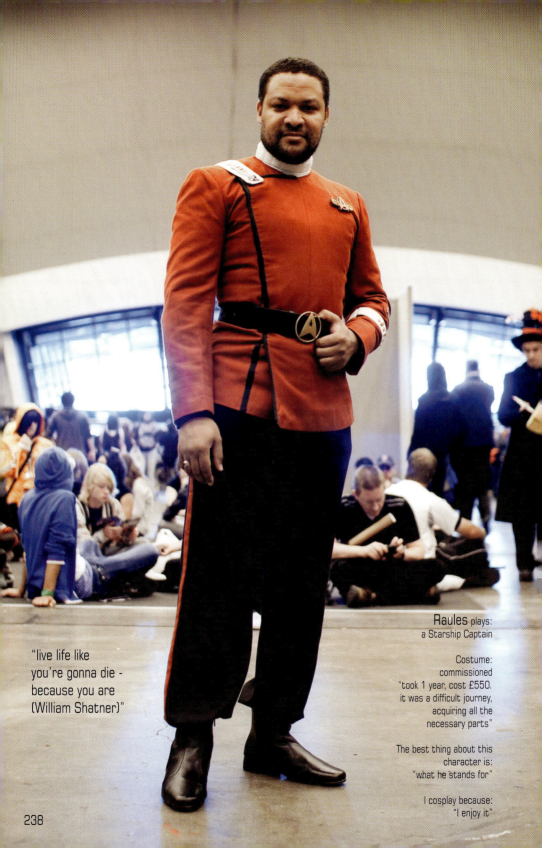

"live life like
you're gonna die -
because you are
(William Shatner)"

Raules plays:
a Starship Captain

Costume:
commissioned
"took 1 year, cost £550.
it was a difficult journey,
acquiring all the
necessary parts"

The best thing about this
character is:
"what he stands for"

I cosplay because:
"I enjoy it"

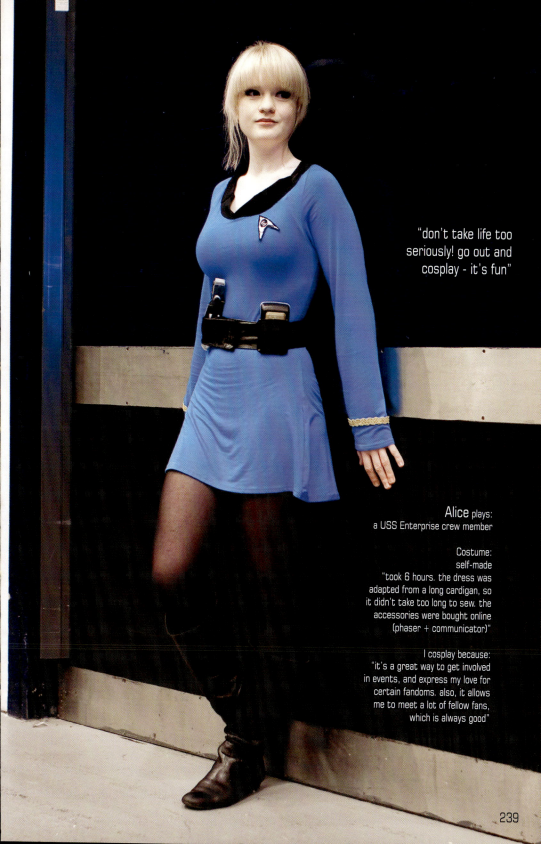

"don't take life too seriously! go out and cosplay - it's fun"

Alice plays:
a USS Enterprise crew member

Costume:
self-made
"took 6 hours. the dress was adapted from a long cardigan, so it didn't take too long to sew. the accessories were bought online (phaser + communicator)"

I cosplay because:
"it's a great way to get involved in events, and express my love for certain fandoms. also, it allows me to meet a lot of fellow fans, which is always good"

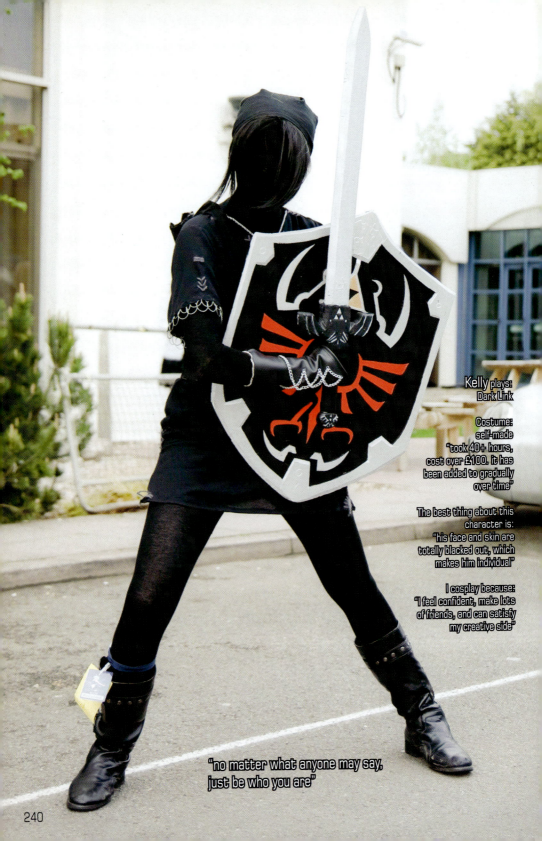

Kelly plays:
Dark Link

Costume:
self-made
"took 40+ hours,
cost over £100. it has
been added to gradually
over time"

The best thing about this
character is:
"his face and skin are
totally blacked out, which
makes him individual"

I cosplay because:
"I feel confident, make lots
of friends, and can satisfy
my creative side"

"no matter what anyone may say,
just be who you are"

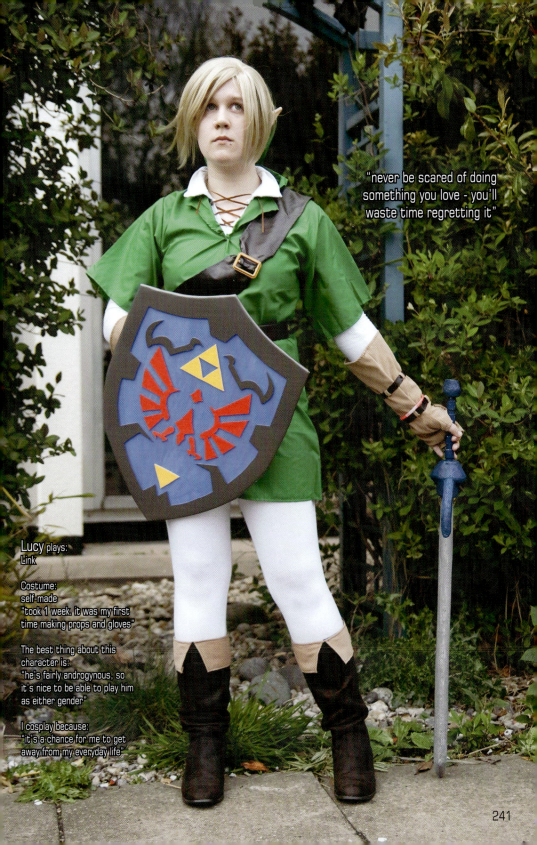

"never be scared of doing something you love - you'll waste time regretting it"

Lucy plays:
Link

Costume:
self-made
"took 1 week. it was my first time making props and gloves"

The best thing about this character is:
"he's fairly androgynous, so it's nice to be able to play him as either gender"

I cosplay because:
"it's a chance for me to get away from my everyday life"

241

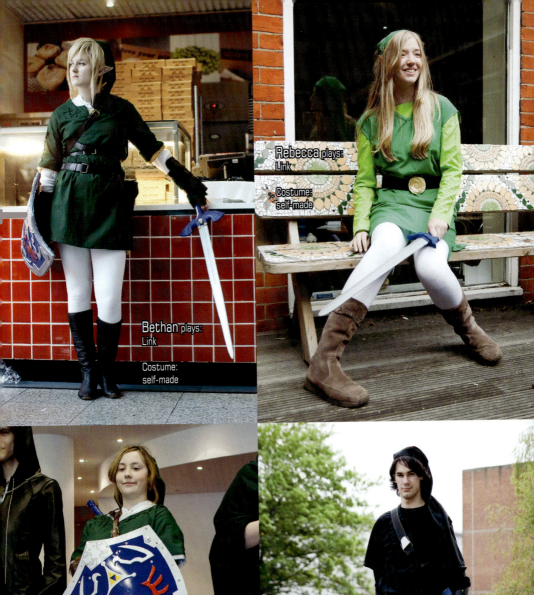

Bethan plays:
Link

Costume:
self-made

Rebecca plays:
Link

Costume:
self-made

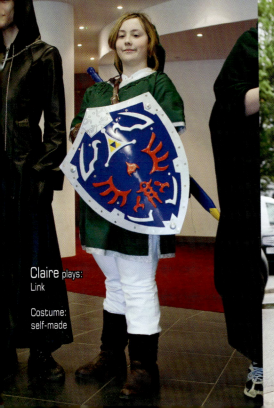

Claire plays:
Link

Costume:
self-made

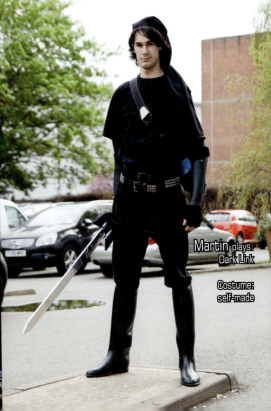

Martin plays:
Dark Link

Costume:
self-made

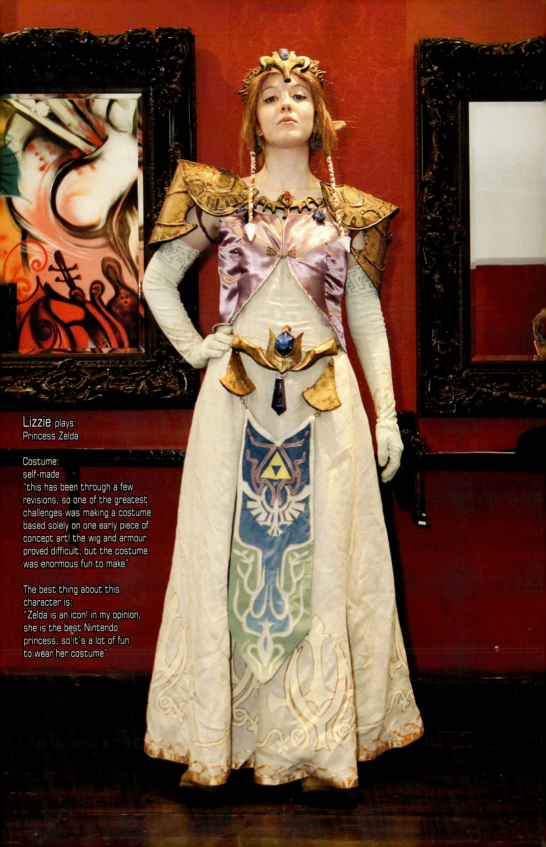

Lizzie plays:
Princess Zelda

Costume:
self-made
"this has been through a few
revisions, so one of the greatest
challenges was making a costume
based solely on one early piece of
concept art! the wig and armour
proved difficult, but the costume
was enormous fun to make"

The best thing about this
character is:
"Zelda is an icon! in my opinion,
she is the best Nintendo
princess, so it's a lot of fun
to wear her costume"

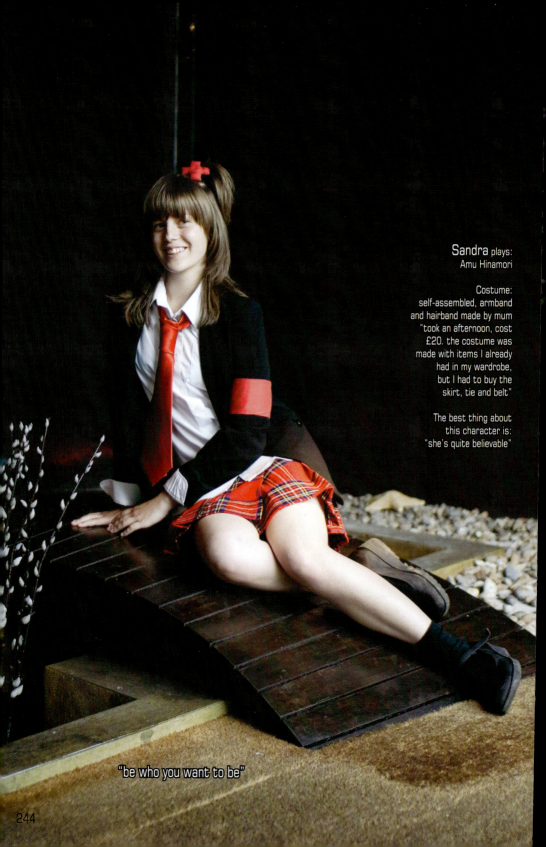

Sandra plays:
Amu Hinamori

Costume:
self-assembled, armband
and hairband made by mum
"took an afternoon, cost
£20. the costume was
made with items I already
had in my wardrobe,
but I had to buy the
skirt, tie and belt"

The best thing about
this character is:
"she's quite believable"

"be who you want to be"

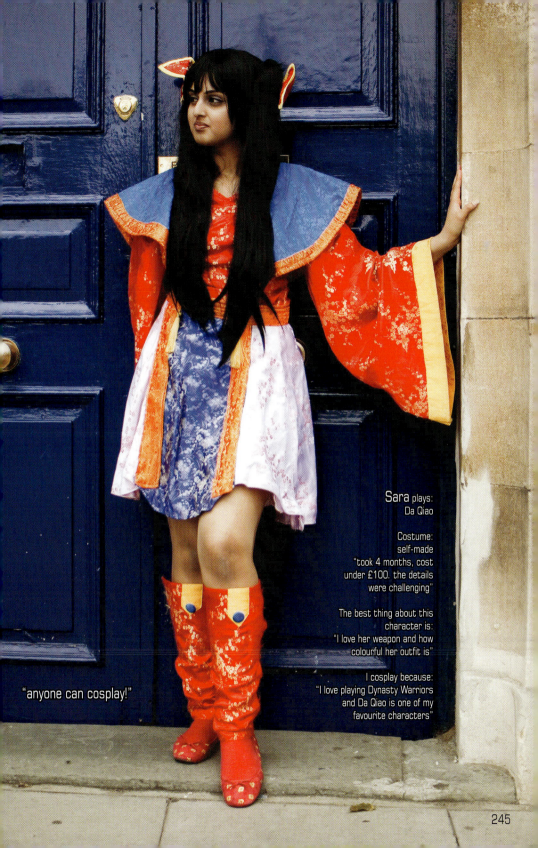

Sara plays:
Da Qiao

Costume:
self-made
"took 4 months, cost
under £100. the details
were challenging"

The best thing about this
character is:
"I love her weapon and how
colourful her outfit is"

I cosplay because:
"I love playing Dynasty Warriors
and Da Qiao is one of my
favourite characters"

"anyone can cosplay!"

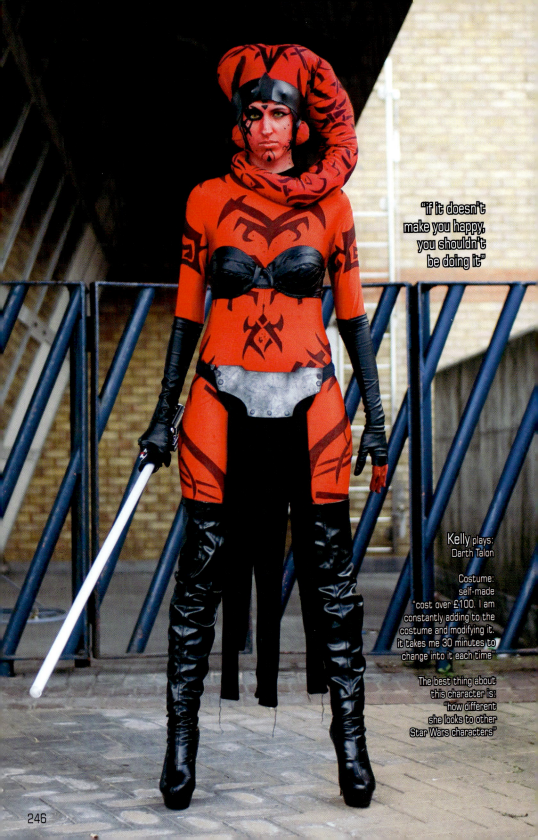

"if it doesn't make you happy, you shouldn't be doing it"

Kelly plays:
Darth Talon

Costume:
self-made
"cost over £100. I am constantly adding to the costume and modifying it. it takes me 30 minutes to change into it each time"

The best thing about this character is:
"how different she looks to other Star Wars characters"

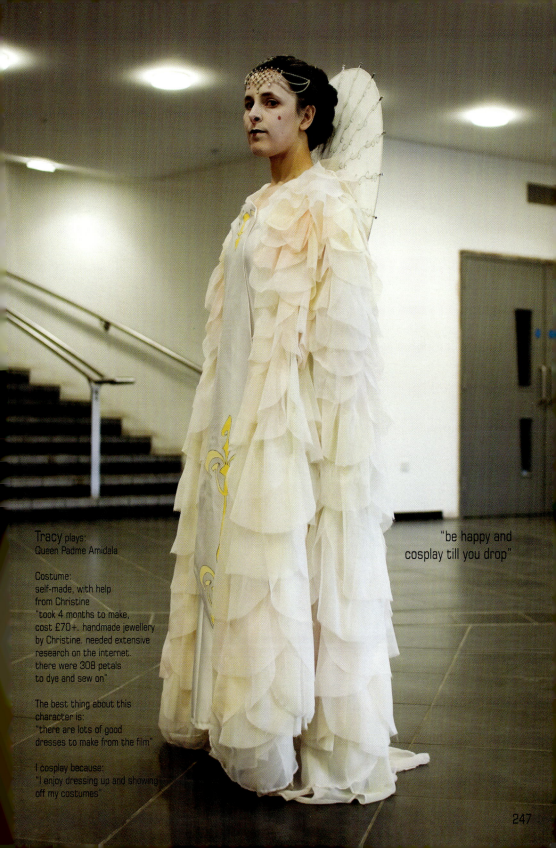

Tracy plays:
Queen Padme Amidala

Costume:
self-made, with help
from Christine
"took 4 months to make,
cost £70+. handmade jewellery
by Christine. needed extensive
research on the internet.
there were 308 petals
to dye and sew on"

The best thing about this
character is:
"there are lots of good
dresses to make from the film"

I cosplay because:
"I enjoy dressing up and showing
off my costumes"

"be happy and
cosplay till you drop"

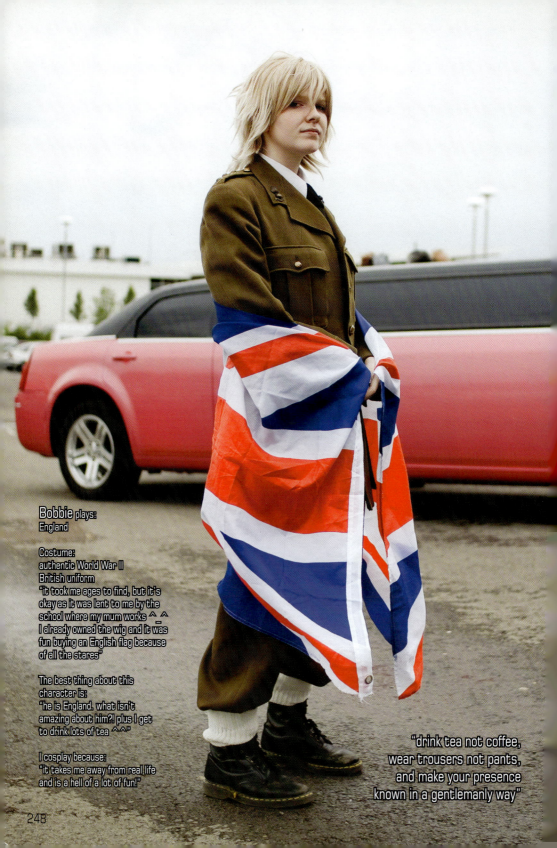

Bobbie plays:
England

Costume:
authentic World War II
British uniform
"it took me ages to find, but it's
okay as it was lent to me by the
school where my mum works ^_^
I already owned the wig and it was
fun buying an English flag because
of all the stares"

The best thing about this
character is:
"he is England. what isn't
amazing about him?! plus I get
to drink lots of tea ^_^"

I cosplay because:
"it takes me away from real life
and is a hell of a lot of fun!"

"drink tea not coffee,
wear trousers not pants,
and make your presence
known in a gentlemanly way"

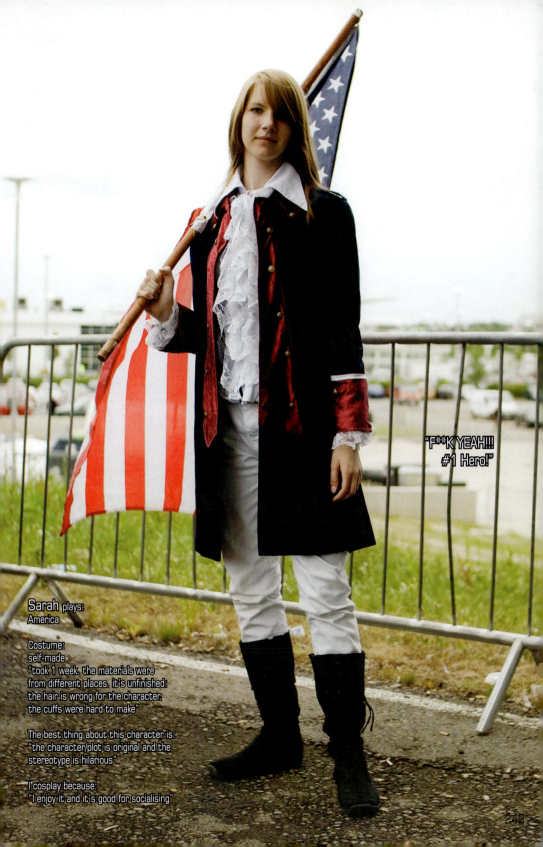

"F**K YEAH!!!
#1 Hero!"

Sarah plays:
America

Costume:
self-made
"took 1 week. the materials were
from different places. it's unfinished:
the hair is wrong for the character.
the cuffs were hard to make"

The best thing about this character is:
"the character/plot is original and the
stereotype is hilarious"

I cosplay because:
"I enjoy it and it's good for socialising"

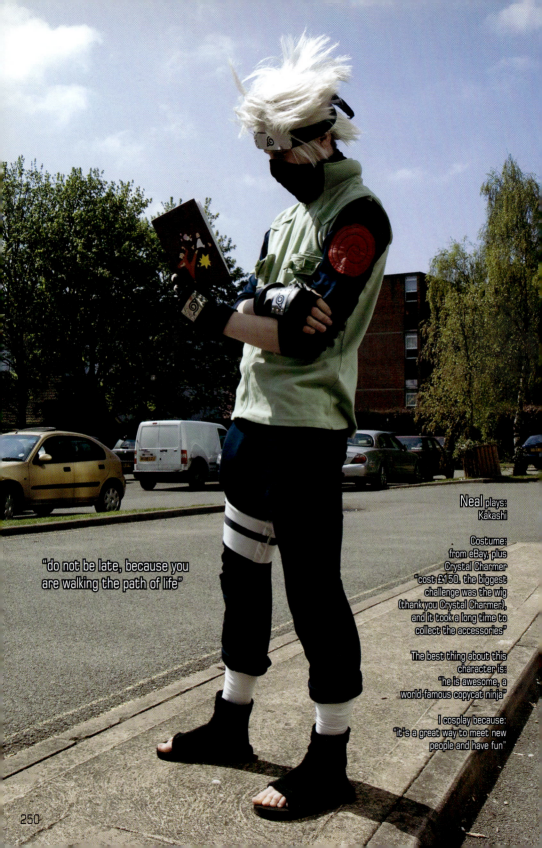

"do not be late, because you are walking the path of life"

Neal plays:
Kakashi

Costume:
from eBay, plus
Crystal Charmer
"cost £150. the biggest
challenge was the wig
(thank you Crystal Charmer),
and it took a long time to
collect the accessories"

The best thing about this
character is:
"he is awesome, a
world-famous copycat ninja"

I cosplay because:
"it's a great way to meet new
people and have fun"

and relax

Acknowledgments

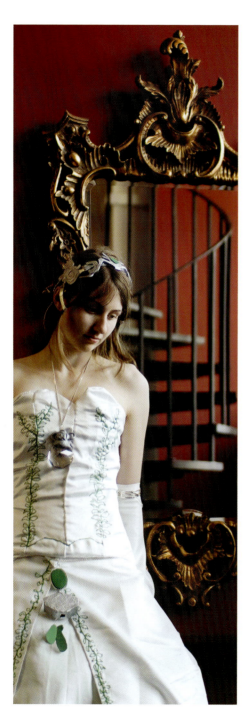

We are grateful for the incredible support we've received from the cosplay community and from the organisers of the events we've attended.

Special thanks go to:

Kerry Francis for believing in our project, giving us advice and building our website, and thanks to you and Joe for helping us out at the shows. We are so happy to have you involved in Cosplay Fever.

Kez, Kelly, Robin, Darrin, Jojo and Louise, for being so gorgeous that we had to put you on the cover!

Sonia Leong, for sharing your passion, giving us your support and agreeing to write the foreword.

The stunning cosplayers who dedicated their time and energy to take part in our photo shoots in Spitalfields and Camden this summer.

Geoffrey Leong at Hi Sushi and Vinz Trip at Mie Mani, for letting us take photographs in your beautiful establishments.

All the wonderful cosplayers who have posed for us. There would be no book at all without you.

All the parents and legal guardians who have let their children be part of Cosplay Fever.

Bryan Cooney, Paul Miley, Akemi Solloway, Mike Allwood, the Kitacon organisers, Jason Joiner and Mike Towers, for your continued support and cooperation.

For much-needed advice and encouragement, thanks to Susie, Julie and Catherine Dunlop, Emily Bastian, Russell Waterman, Kristy leong, Zoé Powell, Eddie Deighton, Joe Sutton, Lucy Guthrie, Ruth Walter, Foxy, Kevin Pack and Missy Tetra.

Thanks to Bill Godber at Turnaround Publisher Services, and Steve Leaf, Keith Davidsen and Andy Martin at Diamond Comic Distributors.

And thanks to Cherie Donovan, for the cosplay that started it all.

The photos in this book were taken between March and July of 2009, at the following events:

LONDON MCM EXPO
www.londonexpo.com

MEMORABILIA
www.memorabilia.co.uk

KITACON
www.kitacon.org

LONDON FILM AND COMIC CON
www.londonfilmandcomiccon.com

COLLECTORMANIA MILTON KEYNES
www.collectormania.com

COLLECTORMANIA MIDLANDS
www.collectormania.com

JAPANESE ART FESTIVAL
www.japaneseartfestival.com

BRISTOL COMICS EXPO
www.fantasyevents.org/index2.html

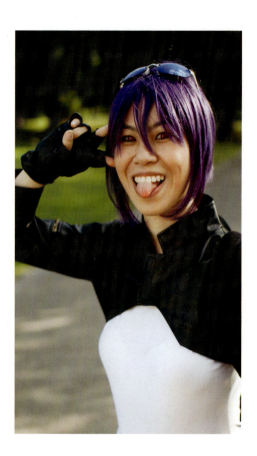

Additional photos were taken at the following locations:

MIE MANI HAIRDRESSING
www.miemani.co.uk
10a Great Eastern Street, London EC2A 3NT
020 76508841

HI SUSHI SALSA
www.hisushi.net
3a Camden Wharf, Camden Lock, London NW1
020 74827088

A huge thank-you to the staff, volunteers and management of these events and locations.

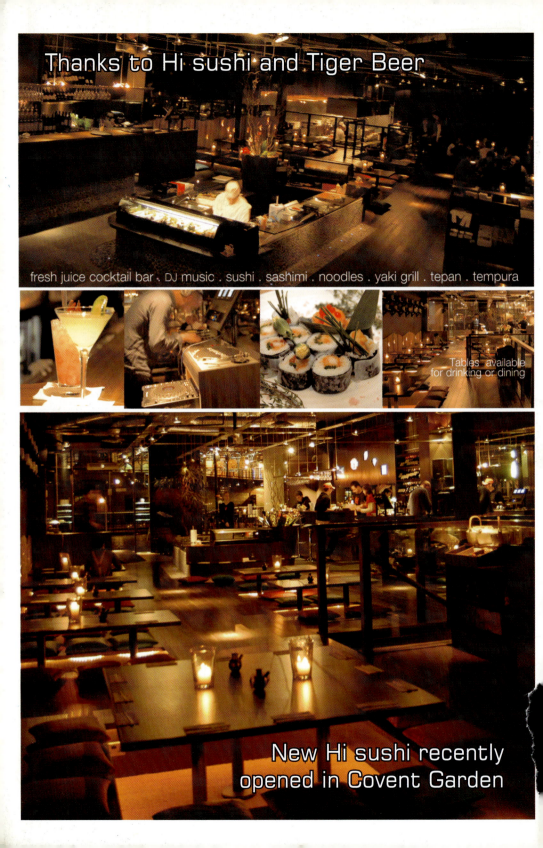

Hi sushi

Izakaya

²⁷ Catherine Street

Opera Quarter

Covent Garden

Tiger

Rob Dunlop studied illustration at the University of Westminster, during which time he supplemented his student income as a caricaturist at parties and corporate events. After graduating in 1997, he was a freelance illustrator, working in book, newspaper and magazine publishing. In 2000, he turned to writing, his first job being the writer of the *Carmageddon* online comic for games company SCi. He has since written and published three graphic novels: *Tozzer and the Invisible Lapdancers*, *Tozzer 2: Special Edition* and *Peckerwood: 24 minutes*. He is currently writing the weekly *Tozzer* web strip (drunkduck.com/Tozzer/), and travelling round the UK with his digital SLR in search of rare, exotic cosplayers.

Peter Lumby studied illustration at the University of Westminster, graduating in 1997. In 2000, he was the artist on the *Carmageddon* online comic, for video games publisher SCi. He has illustrated and published three graphic novels: *Tozzer and the Invisible Lapdancers*, *Tozzer 2: Special Edition* and *Peckerwood: 24 minutes*. Over the last ten years, he has worked extensively as a freelance storyboard and concept artist, designing characters, creatures and environments for high-profile video game publishers, including EA, Konami, Codemasters and Marvel Interactive. He is currently illustrating the *Tozzer* web strip, and taking more photographs at UK conventions for the *Cosplay Fever* sequel...

For more work by Rob and Pete visit:
tozzer.com
cosplayfever.com
cosplayfever.deviantart.com